The Art of Drawing
Manga & Comic
Book Characters

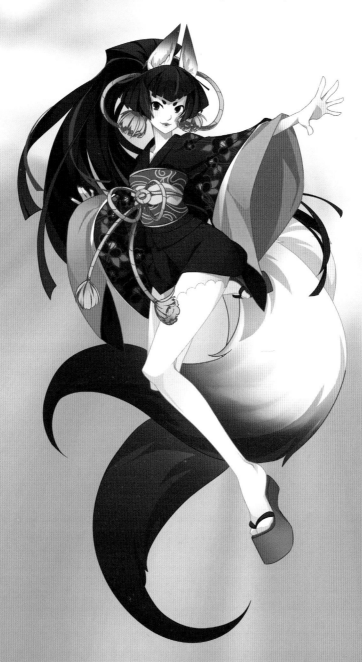

Artwork on front cover (middle right), back cover, and pages 1, 5 (bottom right), 18, and 20–75 © 2013 Jeannie Lee. Artwork on front cover (center, top right, bottom right) and pages 3, 5 (top right), 14–17, 76, and 78–143 © 2013 Bob Berry. Artwork on pages 6–8 © Shutterstock, except illustration (light box) on page 7 © 2008 Jack Keely. Photographs on page 9 © 2010 Mike Butkus. Artwork on pages 10–13 © WFP, except artwork on page 11 ("Creating Value Scales") © 2006 Diane Cardaci. Artwork on page 10 © Christopher Speakman.

Authors: Bob Berry and Jeannie Lee
Publisher: Rebecca J. Razo
Art Director: Shelley Baugh
Project Editor: Stephanie Meissner
Associate Editor: Jennifer Gaudet
Assistant Editor: Janessa Osle
Production Designers: Debbie Aiken, Amanda Tannen
Production Manager: Nicole Szawlowski
Production Coordinator: Lawrence Marquez
Production Assistant: Jessi Mitchelar

www.walterfoster.com
Walter Foster Publishing, Inc.
3 Wrigley, Suite A
Irvine, CA 92618

Printed in China.
10 9 8 7 6 5 4 3 2 1
18292

The Art of Drawing
Manga & Comic
Book Characters

with Bob Berry and Jeannie Lee

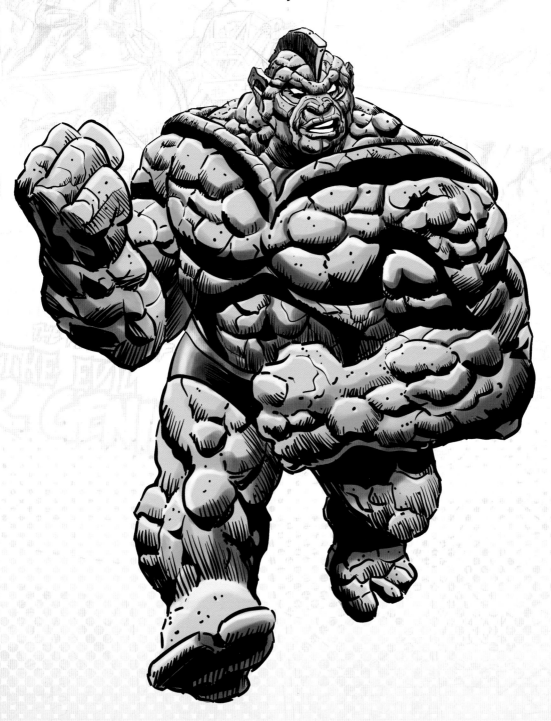

CONTENTS

INTRODUCTION

Welcome, artist! We are excited that you've chosen *The Art of Drawing Manga & Comic Book Characters* as a guide for your journey into comics and manga. We are a small group of creative individuals, like yourself, who have endeavored to collect our knowledge and experience to create a source of reference and knowledge for you as you learn more about the world of comics—and yourself as an artist.

"Comics" are a hybrid genre in which illustrations and written words work together to tell a story. While a children's storybook technically has a similar definition, comics are a very special and unique art form. Each page is filled with action, with "frame-by-frame" drawings each playing their part to keep the narrative going as you follow along. While it is a relatively new art form, today it exists with enormous representation and variety and serves as the occupation of tons of creative individuals. It even inspires other art forms, such as TV, film, and animation. With the advancement of technology, comics have also transcended beyond their origins in black-and-white newspaper prints to full-color graphic novels and digital formats, such as webcomics.

As the art of comics has gained popularity over the years, different countries have developed their own styles and titles, many of which have become internationally recognized. Heroes such as "Batman" and "The X-Men" are international hits, drawn by artists from all over the world. In Japan, *mangaka*, such as *Osamu Tezuka*, take the comic art form in its own amazing direction. France, the United Kingdom, and Korea also make up a small handful of many countries that have made monumental contributions to this art genre.

In this book, we will look specifically at two different and very specific comic styles: the "Western" comic style and the Japanese comic style, which will be referred to as "manga" in the next chapters. Even though comics and manga have very different characteristics, the fundamentals are the same: strong storylines and memorable characters.

As you delve into this creative world with the help of this book, it is our hope that you will glean a deeper understanding and respect for the art form and eventually even create your own work. The lessons and projects in this book will help you build a strong foundation from the ground up: learning how to create a story; finding inspiration; and, most importantly, creating the characters that will make your story come to life for you and your audience.

Learning how to draw and, specifically, how to make your own comic, will take patience, practice, and time. Remember that everyone starts at the beginning—even the best of us—so don't lose motivation!

TOOLS & MATERIALS

Manga and comic book art can be created using a variety of tools and materials. Most of the artwork in this book was colored on a computer, but don't worry if you're not set up for that. You can use plenty of traditional media such as pencils, colored pencils, crayons, and paint. Below are the supplies you may want to have to get started.

PAPER

Sketch pads and inexpensive printer paper are great for sketching and working out your ideas. Tracing paper can be useful for creating a clean version of a sketch using a light box. Just be sure to use quality tracing paper that is sturdy enough to handle erasing and coloring. Cardstock is sturdier than thinner printer paper, which makes it ideal for drawing repeatedly or for heavy-duty artwork. You may also want to have illustration board on hand.

PENCILS

Pencil lead, or graphite, varies in darkness and hardness. Pencils with a number and an H have harder graphite, which marks paper more lightly. Pencils with a number and B have softer graphite, which makes darker marks. A good pencil for sketching is an H or HB, but you can also use a regular No.2 pencil.

COLORED PENCILS

Colored pencils layer over each other easily. They come in wax-based, oil-based, and water-soluble versions. Oil-based pencils complement wax-based pencils nicely. Water-soluble pencils react to water in a manner similar to watercolor. In addition to creating finished art, colored pencils are useful for enhancing small details.

ERASERS

Vinyl and kneaded erasers are both good to have on hand. A vinyl eraser is white and rubbery and is gentler on paper than a pink eraser. A kneaded eraser is like putty. It can be molded into shapes to erase small areas. You can also use it to lift graphite off paper to lighten artwork.

PAINT

Have fun exploring acrylic and watercolor paint. Watercolor paints are available in cakes, pans, and tubes. Tube paints are fresher and the colors are brighter. Acrylic paint dries quickly, so keep a spray bottle of water close to help keep the paint on your palette fresh. It's a good idea to have two jars of water when you paint: one for diluting your paints and one for rinsing your brushes.

ART MARKERS

Alcohol-based art markers are perfect for adding bold, vibrant color to your artwork. They are great for shading and laying down large areas of color. Markers and colored pencils can be used in combination with paint to enhance and accent your drawings.

LIGHT BOX

A light box is a useful and generally inexpensive tool with a transparent top and a light inside. The light illuminates paper placed on top, allowing dark lines to show through for easy tracing. Simply tape your rough drawing on the surface of the light box, place a clean sheet of paper on top of your sketch, and turn the light on.

QUILL OR DIP PEN

Quill and dip pens provide some flexibility with line when inking. You can purchase different sizes of nibs. Be careful when inking with these tools. They often leave lines that stay wet for several minutes. Make sure you allow for plenty of drying time!

INDIA INK

India ink is black ink made of carbon. It has been used in various forms since ancient times and became standard for writing and printing in the Western world around the turn of the 20th century. India ink is a traditional inking material for comic book artists, but you do not have to use it to ink your art.

INKING BRUSH

Inking with a brush can create smoother, livelier lines and is great for creating thick-to-thin strokes. Working with a brush takes more time and requires a lot of practice to become proficient. Look for a sable brush with a sharp point. When inking with a brush, dip it in water first and roll the excess water onto a paper towel. Then dip it in ink.

TEMPLATES & CURVES

You can find circle, ellipse, and curve templates at any art supply store. These templates are perfect for making dialogue balloons. It's also helpful to have a flexible drawing curve, which you can bend to match curved lines in your sketches. You can use this helpful tool to create a thick-and-thin line quality by stroking your line several times and adjusting the position of the curve to build a line that is thicker in the middle and thinner at the ends.

DIGITAL ILLUSTRATION

Digital illustration can result in highly detailed dynamic artwork. Unlike drawing or painting, digital illustration allows you to make dramatic enhancements with just a few clicks of a mouse. It helps to have an understanding of the basic tools and functions of image-editing software. In this book, we use Photoshop®. Here are some basic Photoshop functions you'll find helpful.

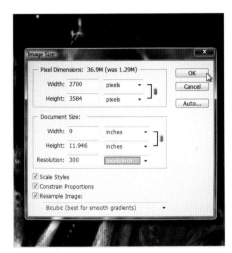

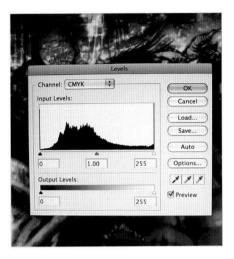

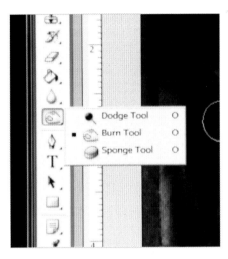

IMAGE RESOLUTION

When scanning your drawing or painting into Photoshop, it's important to scan it at 300 dpi (dots per inch) and 100% the size of the original. A higher dpi carries more pixel information and determines the quality at which your image will print. However, if you intend for the image to be a piece of digital art only, you can set the dpi as low as 72. View the dpi and size under the menu Image > Image Size.

LEVELS

With this tool (under Image > Adjustments), you can change the brightness, contrast, and range of values within an image. The black, midtone, and white of the image are represented by the three markers along the bottom of the graph. Slide these markers horizontally. Moving the black marker right will darken the overall image, moving the white marker left will lighten the overall image, and sliding the midtone marker left or right will make the midtones darker or lighter respectively.

DODGE AND BURN TOOLS

The dodge and burn tools, photography terms borrowed from the old dark room, are also found on the basic tool bar. Dodge is synonymous with lighten; burn is synonymous with darken. On the settings bar under "Range" you can select highlights, midtones, or shadows. Select which of the three you'd like to dodge or burn, and the tool will only affect these areas. Adjust the width and exposure (or strength) as desired.

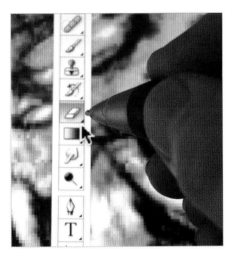

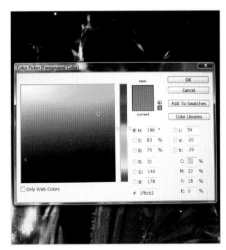

ERASER TOOL

The eraser tool is found in the basic tool bar. When working on a background layer, the tool removes pixels to reveal a white background. You can adjust the diameter and opacity of the brush to control the width and strength of the eraser.

PAINTBRUSH TOOL

The paintbrush tool allows you to apply layers of color to your canvas. Like the eraser, dodge, and burn tools, you can adjust the diameter and opacity of the brush to control the width and strength of your strokes.

COLOR PICKER

Choose the color of your "paint" in the Color Picker window. Select your hue by clicking within the vertical color bar; then move the circular cursor around the box to change the color's tone.

DRAWING BASICS

MOVING FROM SHAPE TO FORM

The first step in creating an object is establishing a line drawing or outline to delineate its flat area. This is known as "shape." The four basic shapes—the rectangle, circle, triangle, and square—can appear to be three-dimensional by adding a few carefully placed lines that suggest additional planes. By adding ellipses to the rectangle, circle, and triangle, you give the shapes dimension and begin to produce a form within space. The shapes become a cylinder, a sphere, and a cone. Add a second square above and to the side of the first square, connect them with parallel lines, and you create a cube.

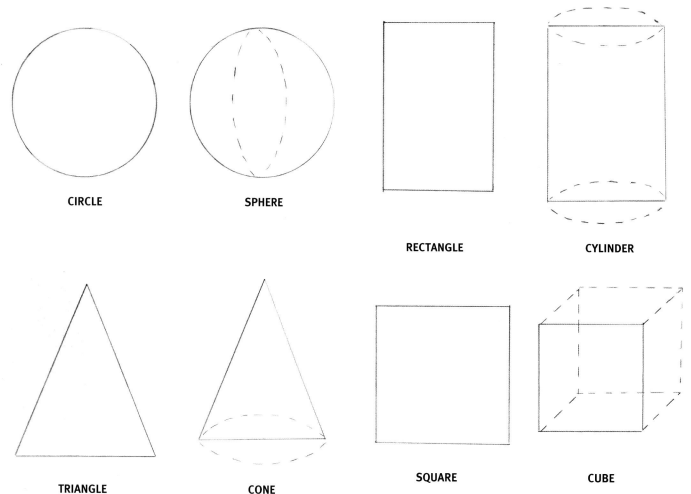

CIRCLE SPHERE RECTANGLE CYLINDER

TRIANGLE CONE SQUARE CUBE

ADDING VALUE TO CREATE FORM

A shape can be further defined by showing how light hits the object to create highlights and shadows. First note from which direction the source of light is coming. In this example, the light source is beaming from the upper right. Then add the shadows accordingly. The *core shadow* is the darkest area on the object and is opposite the light source. The *cast shadow* is what is thrown onto a nearby surface by the object. The *highlight* is the lightest area on the object, where the reflection of light is strongest. *Reflected light,* often overlooked by beginners, is surrounding light that is reflected into the shadowed area of an object.

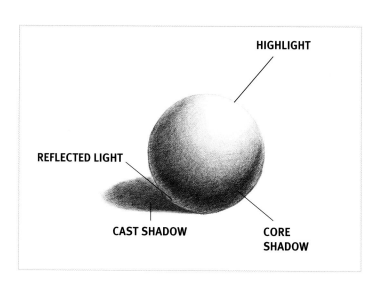

HIGHLIGHT

REFLECTED LIGHT

CAST SHADOW CORE SHADOW

CREATING VALUE SCALES

Artists use scales to measure changes in value and to gauge how dark to make dark values and how light to make highlights. Value scales also serve as a guide for transitioning from lighter to darker shades. Making your own value scale will help familiarize you with the different variations in value. Work from light to dark, adding more and more tone for successively darker values (as shown below left). Then create a blended value scale by using a blending stump to blend each value into its neighboring value from light to dark to create a gradation (as shown below right).

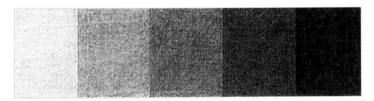 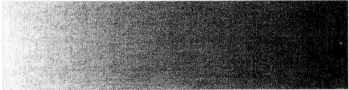

BASIC TECHNIQUES

The basic pencil techniques below can help you learn to render everything from people to machines. Whatever techniques you choose, remember to shade evenly in a back-and-forth motion over the same area, varying the spot where the pencil point changes direction.

HATCHING This technique consists of a series of parallel strokes. The closer the strokes, the darker the tone will be.

CROSSHATCHING For darker shading, layer parallel strokes on top of one another at varying angles.

GRADATING To create gradated values (from dark to light), apply heavy pressure with the side of your pencil, gradually lightening as you go.

SHADING DARKLY Apply heavy pressure to the pencil to create dark, linear areas of shading.

SHADING WITH TEXTURE For a mottled texture, use the side of the pencil tip to apply small, uneven strokes.

BLENDING To smooth out the transitions between strokes, gently rub the lines with a blending tool or your finger.

COLOR BASICS

Color can help bring your drawings to life, but first it helps to know a bit about color theory. There are three *primary* colors: red, yellow, and blue. These colors cannot be created by mixing other colors. Mixing two primary colors produces a *secondary* color: orange, green, and purple. Mixing a primary color with a secondary color produces a *tertiary* color: red-orange, red-purple, yellow-orange, yellow-green, blue-green, and blue-purple. Reds, yellows, and oranges are "warm" colors; greens, blues, and purples are "cool" colors. See the color combinations below for more mixing ideas.

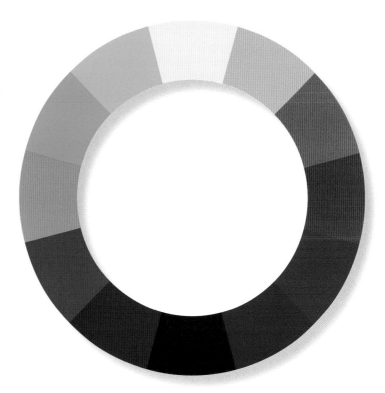

THE COLOR WHEEL

A color wheel is useful for understanding relationships between colors. Knowing where each color is located on the color wheel makes it easy to understand how colors relate to and react with one another.

EASY COLOR COMBINATIONS

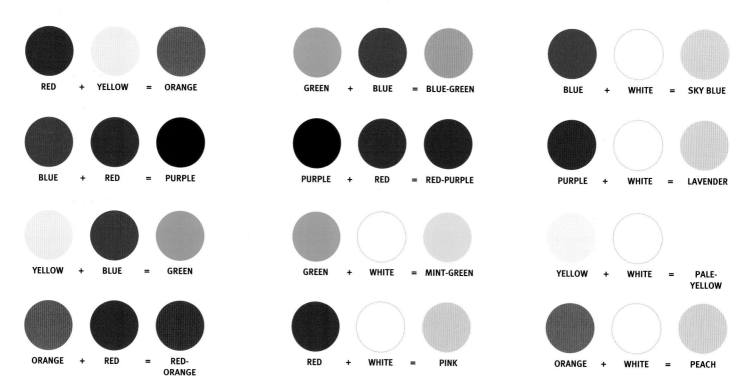

RED + YELLOW = ORANGE

BLUE + RED = PURPLE

YELLOW + BLUE = GREEN

ORANGE + RED = RED-ORANGE

GREEN + BLUE = BLUE-GREEN

PURPLE + RED = RED-PURPLE

GREEN + WHITE = MINT-GREEN

RED + WHITE = PINK

BLUE + WHITE = SKY BLUE

PURPLE + WHITE = LAVENDER

YELLOW + WHITE = PALE-YELLOW

ORANGE + WHITE = PEACH

ADDING COLOR TO YOUR DRAWING

Some artists draw directly on illustration board or watercolor paper and then apply color directly to the original pencil drawing; however, if you are a beginning artist, you might opt to preserve your original pencil drawing by making several photocopies and applying color to a photocopy. This way, you'll always have your original drawing in case you make a mistake or you want to experiment with different colors or mediums.

PERSPECTIVE

Knowing the principles of perspective (the representation of objects on a two-dimensional surface that creates the illusion of three-dimensional depth and distance) allows you to draw more than one person in a scene realistically. Eye level changes as your elevation of view changes. In perspective, eye level is indicated by the horizon line. Imaginary lines receding into space meet on the horizon line at what are known as "vanishing points." Any figures drawn along these lines will be in proper perspective. Study the diagrams below to help you.

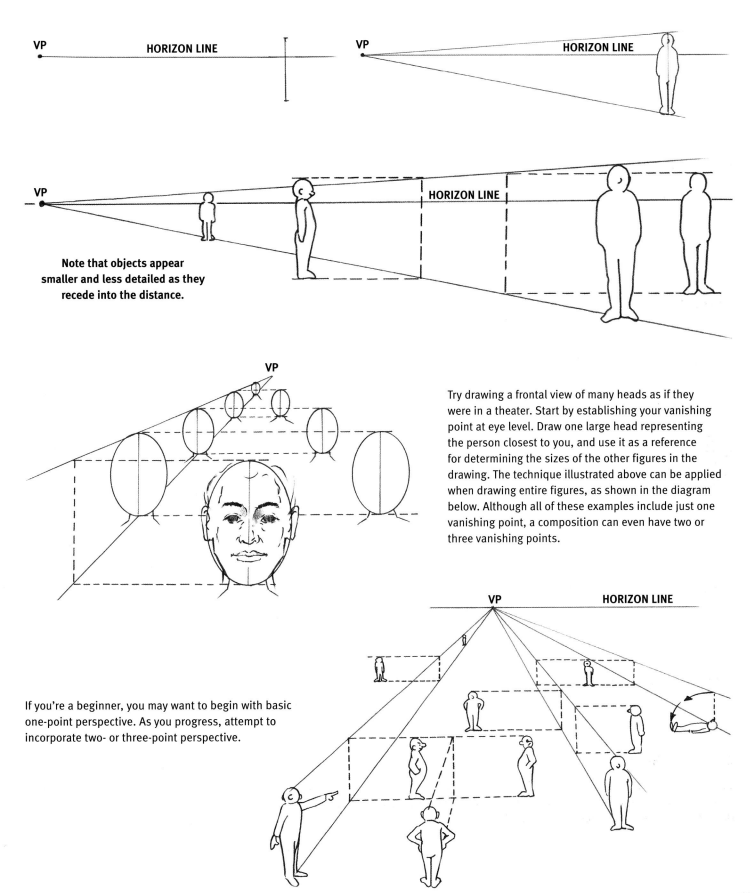

Note that objects appear smaller and less detailed as they recede into the distance.

Try drawing a frontal view of many heads as if they were in a theater. Start by establishing your vanishing point at eye level. Draw one large head representing the person closest to you, and use it as a reference for determining the sizes of the other figures in the drawing. The technique illustrated above can be applied when drawing entire figures, as shown in the diagram below. Although all of these examples include just one vanishing point, a composition can even have two or three vanishing points.

If you're a beginner, you may want to begin with basic one-point perspective. As you progress, attempt to incorporate two- or three-point perspective.

INKING TECHNIQUES

Inking is as important an element in creating great comic and manga art as character design, penciling, or storytelling. Great inking can add style and visual dynamics, even to less-than-perfect pencils.

In the early days, inking was a necessity. Inking allowed images to be reproduced inexpensively using a very simple black-and-white photographic process. Early artists used rendering techniques borrowed from engraving to simulate tonality. Most inking was done with india ink—preferred for its extremely dense black. To create subtle tonal changes from solid black shadows to lighter areas, artists used hatching, crosshatching, or "feathered" brush strokes or pen strokes (see examples below).

As the industry grew, more sensitive production techniques came into use. Artists started using other mediums, such as marker pens and even soft pencils. Still, the iconic look of manga- and comics-style art owes much to those early inking techniques. Today, improved reproduction techniques have also allowed artists to explore various inking styles in order to make their art stand out from the crowd.

TRADITIONAL TECHNIQUES

Master these basic inking techniques, and you'll be off to a great start in the fine art of inking! Once you have these traditional techniques down, try experimenting with different media and line-making. You can achieve a variety of looks with just a few tools and techniques.

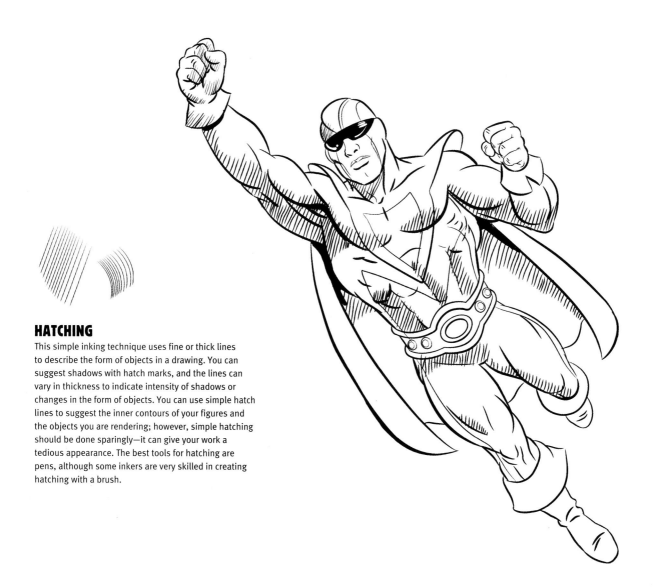

HATCHING
This simple inking technique uses fine or thick lines to describe the form of objects in a drawing. You can suggest shadows with hatch marks, and the lines can vary in thickness to indicate intensity of shadows or changes in the form of objects. You can use simple hatch lines to suggest the inner contours of your figures and the objects you are rendering; however, simple hatching should be done sparingly—it can give your work a tedious appearance. The best tools for hatching are pens, although some inkers are very skilled in creating hatching with a brush.

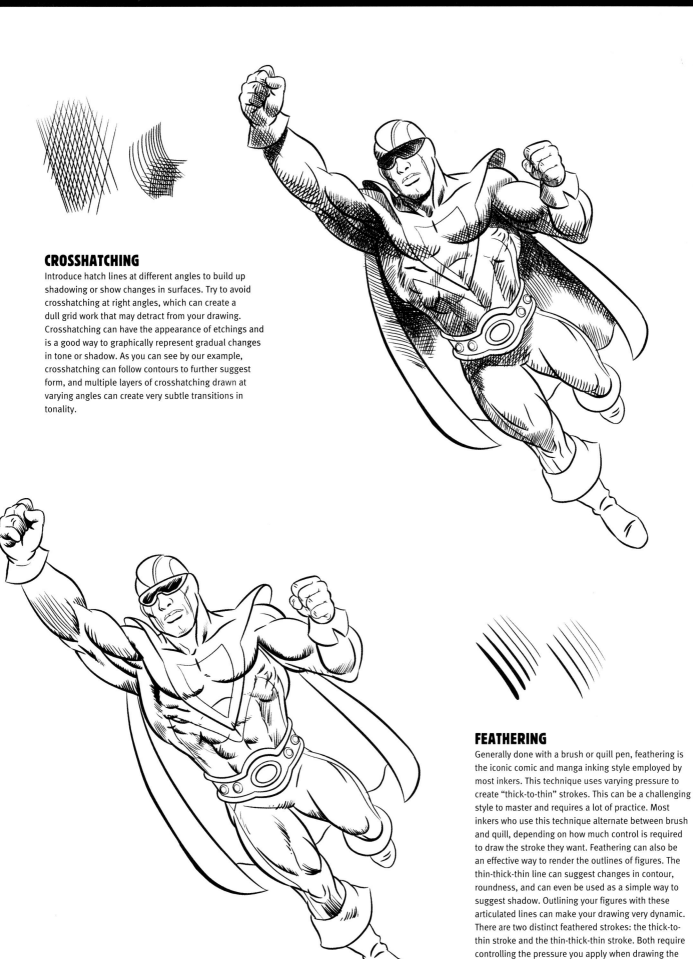

CROSSHATCHING

Introduce hatch lines at different angles to build up shadowing or show changes in surfaces. Try to avoid crosshatching at right angles, which can create a dull grid work that may detract from your drawing. Crosshatching can have the appearance of etchings and is a good way to graphically represent gradual changes in tone or shadow. As you can see by our example, crosshatching can follow contours to further suggest form, and multiple layers of crosshatching drawn at varying angles can create very subtle transitions in tonality.

FEATHERING

Generally done with a brush or quill pen, feathering is the iconic comic and manga inking style employed by most inkers. This technique uses varying pressure to create "thick-to-thin" strokes. This can be a challenging style to master and requires a lot of practice. Most inkers who use this technique alternate between brush and quill, depending on how much control is required to draw the stroke they want. Feathering can also be an effective way to render the outlines of figures. The thin-thick-thin line can suggest changes in contour, roundness, and can even be used as a simple way to suggest shadow. Outlining your figures with these articulated lines can make your drawing very dynamic. There are two distinct feathered strokes: the thick-to-thin stroke and the thin-thick-thin stroke. Both require controlling the pressure you apply when drawing the line. Whether you use a pen or a brush, the greater the pressure you apply as you draw, the thicker the line.

CONTEMPORARY TECHNIQUES

Many contemporary inkers and artists choose less traditional inking methods. Because they require less skill and drying time, many artists prefer various fine and medium marker pens. Some marker pens can respond to changes in pressure and represent like feathering.

Some inkers prefer a "blunt" or "dead" line without any variation because it breaks the traditional inking look and looks more modern.

Many artists choose to use black liberally, with minimum use of line, to define their drawing. Depending on how individual artists handle this technique, this style can look very bold and graphic.

There are also rendering techniques such as *stippling*—fine dots used to shade a drawing—which may be used as a "special effect," or to indicate a certain kind of texture. This technique can look great, but it would be tedious to maintain over an entire drawing or comic.

Some artists choose to use little or no rendering in their work and rely only on the outlines to define their drawings. This can also be a very effective method, especially when color is used to further define the forms. This method is usually used for lighter subjects, such as cartoon-type characters.

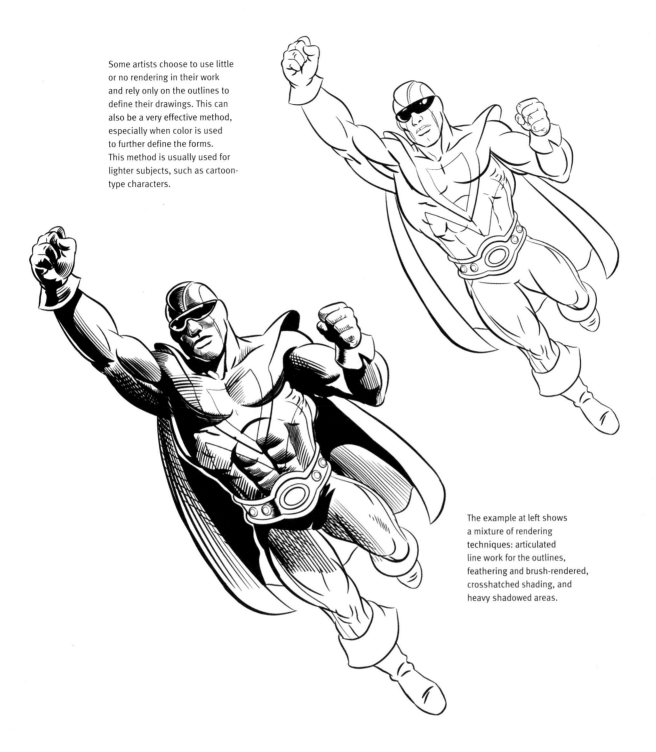

The example at left shows a mixture of rendering techniques: articulated line work for the outlines, feathering and brush-rendered, crosshatched shading, and heavy shadowed areas.

Inking Tips

- Use dense or solid blacks or bolder, thicker lines to create the illusion of depth.

- Use light tones or thinner lines in the background to complete the effect.

- When inking "mechanical" objects, such as vehicles or buildings, you can work freehand (if you have a very steady hand), or you can use rulers or circle and ellipse templates.

The most successful inkers use a variety of marks and techniques to create eye-catching work. The most important thing to remember is that your inking should enhance the pencil drawing and story. Don't get too distracted by style or adding too much detail. Most of all, practice and experiment with the various tools and techniques to discover your favorite style.

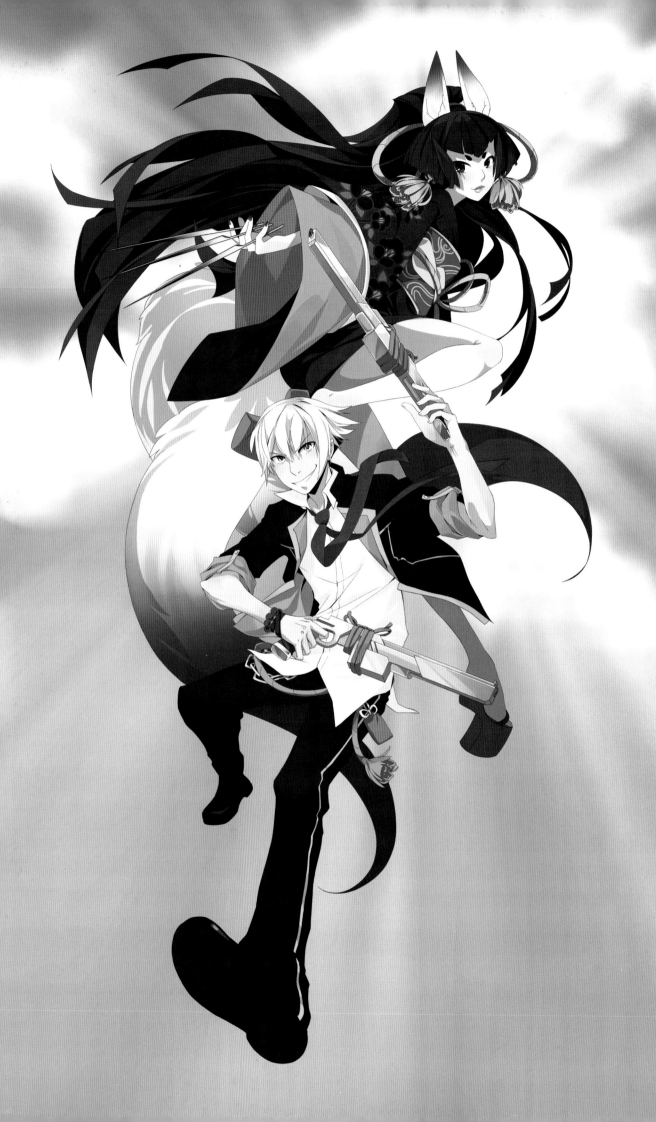

DRAWING MANGA CHARACTERS

WITH JEANNIE LEE

The world of anime and manga is colorful, diverse, and full of endless opportunities. As anime and manga have grown in popularity, they've permeated many types of media: television series, films, video games, commercials—the list goes on. The lessons and projects in this chapter will help you build a foundation, an understanding, and respect for this art form. Before we begin, let's go over some basic knowledge about anime and manga.

WHAT IS ANIME?

Anime (pronounced a-nee-mei) is officially defined as Japanese cartoons and animations. Anime is often derived from a manga. Some anime and manga are completely different, with different characters and storylines. Other anime may follow its manga "parent" closely. We encourage you to explore both: If you have a favorite manga, check out its anime version, and vice-versa. Consider it research!

WHAT IS MANGA?

Manga (pronounced mahn-gah) is defined as comics created in Japan, or works created by Japanese artists in the Japanese language. You can find manga of any genre—action, adventure, horror, sports, history, comedy, science fiction, etc. Manga has become so diverse and expansive, that it has given birth to identifiable sub-genres within itself!

Some artists who are not Japanese call themselves *mangaka*, which is the Japanese word for "manga artist," and their works "manga." While the term "manga" has the flexibility to be used in this fashion, in the professional comic industries, "manga" is typically reserved for comics that are produced in Japan. In the U.S., terms like "amerimanga" and "original English-language manga" (OEL) have been developed to refer to comics that have a strong manga/Japanese-comic style influence but are not produced in Japan. If you plan on being a professional comic artist someday, it is good to know these differences.

As an artist, we encourage you to know your medium—especially if you plan to one day make your own comic. Do your research: read lots of manga and watch lots of anime. Consider it homework—really, really fun homework! The more you know, the more inspiration you will have to draw from as you begin to develop your own characters and story for the world to enjoy.

CHARACTER ARCHETYPES

An "archetypal character" is a character or personality that is universally identifiable because it appears time and time again in stories throughout history. Archetypal characters, no matter how often they appear, never become stale or cliché—they are considered classic.

Typical Character Archetypes

PROTAGONIST The protagonist is the main character. Protagonists are usually "good guys," but there are always exceptions.

ANTAGONIST The antagonist is the main opposing force to the protagonist.

HERO A "hero" (or "heroine") is usually the protagonist, and is generally on the "good side."

VILLAIN A "villain" is usually the evil character in a story and is often also the antagonist. A villain has a negative effect on other characters and always tries to derail the hero.

ANTIHERO An "antihero" (or "anti-heroine") is generally a protagonist who is not "heroic." He or she is not necessarily "good" and may have both a light and dark side.

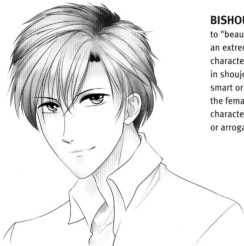

BISHOUNEN: Literally translating to "beautiful boy," a *bishounen* is an extremely attractive young male character. Bishounen often appear in shoujo manga as tall, handsome, smart or skilled, and coveted by the female characters. A bishounen character can be good or evil, kind or arrogant.

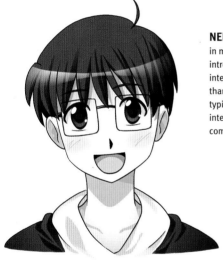

NERD: "Nerd" characters in manga are usually timid, introverted males who are more interested in a geeky hobby than in girls. Nerd characters are typically good-natured, with good intentions. They often act as the comedic relief in manga stories.

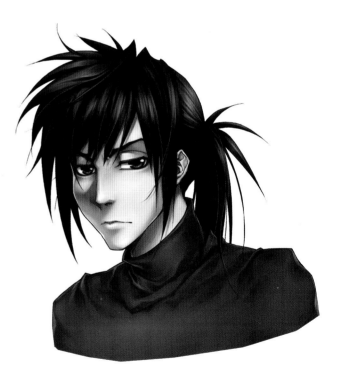

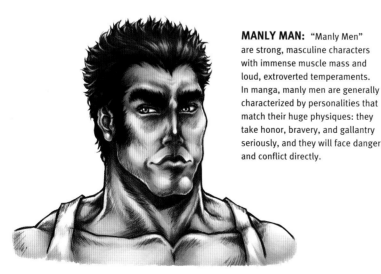

MANLY MAN: "Manly Men" are strong, masculine characters with immense muscle mass and loud, extroverted temperaments. In manga, manly men are generally characterized by personalities that match their huge physiques: they take honor, bravery, and gallantry seriously, and they will face danger and conflict directly.

STRONG, SILENT TYPE: "Strong, Silent Type" characters typically have some kind of internal struggle; they may carry emotional trauma from a dark past or be protecting a secret. Strong, Silent Types can be good or evil or a mixture of both.

FEMALE HEROINE: Female heroines are strong, leading characters. They are confident, energetic, and cheerful, and they are usually good. They face life with a positive attitude and always seek meaning in their lives.

MOE GIRL: A "moe" character is usually young, perky, energetic, and cute, with an air of innocence and dependency. Most "moe" characters are young females.

Manga Genres

Manga "genres" are categories of stories or character types that collectively share a similar plotline, appeal to a specific audience, or have other such comparative similarities. Many manga genres have become iconic due to their immense popularity. Here are a few major manga genres that you should know:

SHOUJO These stories typically focus on romance or human and social interactions, friendship, and emotions, but can vary greatly in terms of style and narrative.

SHOUNEN These stories emphasize action and adventure, with strong male leads and attractive female characters.

SCHOOL LIFE This manga focuses on student characters and their day-to-day lives in school.

MAGICAL GIRL Also called *mahou shoujo*, "magical girl" stories usually feature a young female protagonist who obtains magical or superhuman abilities and fights evil to protect the world.

SLICE OF LIFE "Slice-of-Life" stories are down-to-earth and have characters who are focused on the everyday experience.

HAREM "Harem" manga stories center around a single male character (usually timid and introverted) who coincidentally ends up surrounded by many female characters of various personalities.

MYSTERIOUS GIRL: "Mysterious Girls" usually have very little to say. Their lives are a mystery and very little of their pasts may be revealed. Typically, mysterious girl characters are just misunderstood and are usually good characters who end up learning a great deal about themselves as their stories progress.

POSING & EXPRESSION

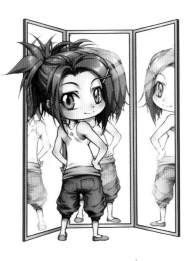

Manga requires you to draw your characters from different angles and views.

Imagine your character standing in front of a three-sided mirror. Each mirror shows the character from a different angle, but it is still the same character. Keep this in mind when creating your own manga characters.

It isn't just clothes, hair, and accessories that define a character's unique look, but facial and other physical attributes as well. The differences in the face below are dramatic, but imagine more subtle variations in your manga. If a female character in a frame is looking forward, but looks sideways in the next frame, her look should be consistent.

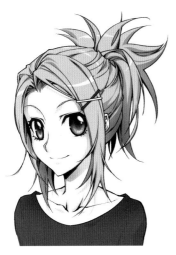

This young female character's face is depicted with slim cheeks, a slender neck, and big, bright, energetic eyes.

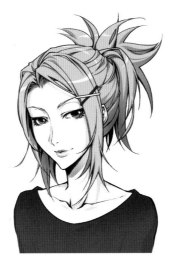

By making the eyes smaller and drawing a longer, more detailed nose and fuller lips, we have a more mature, adult female with a charming and seductive air, rather than innocent and energetic.

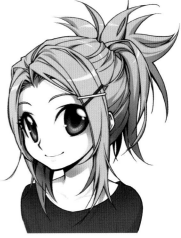

The clothes, hair, and neck are exactly the same, while the face is not. Bigger eyes, a chubbier, rounder face, and a smaller nose and mouth have modified this character to a younger female child.

It's also important to achieve consistency in emotional expressions.

Here the same female character expresses three different emotions. Even though various facial features (eyes, mouth, eyebrows, etc.) are positioned differently, and even change shape, the character looks the same.

Exaggeration is an important factor in effectively drawing expressions. There are various "levels" to any emotion: a character can be mildly pleased or so happy that she jumps up and down and shouts for joy. Experiment with how to draw emotions at various levels of exaggeration.

Choose carefully which features you exaggerate. It wouldn't make sense if this female character's eyebrows became thicker or bushier when she was angry. You want to change the angle and the shape from happy to angry, but not the size. Conversely, making the eyes smaller and more angled when the character is squinting makes sense.

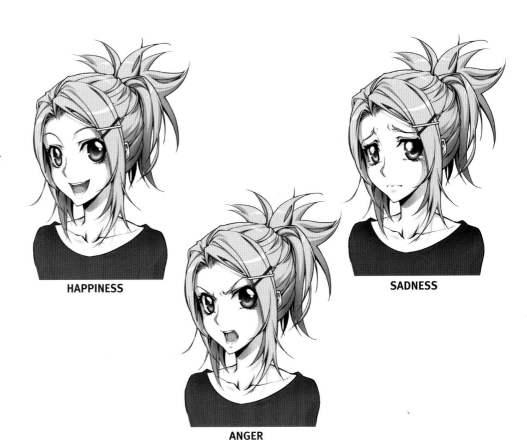

HAPPINESS

ANGER

SADNESS

Bodies can also express a character's feelings and emotional state.

Check out this upset male character. On the left, his body is in a neutral pose. Only his face expresses his emotions. Now hide his face with your hand. Do you get any sense of anger from his body language?

Now look at the image on the right. He has the exact same facial expression, but his body language corresponds with it. Hide his face with your hand; the angry emotion still comes across. This is the power of body language!

Below are three faceless mannequins expressing three different emotions. Ideally, you want to draw body language that is effective enough to express an emotional state, even without a face.

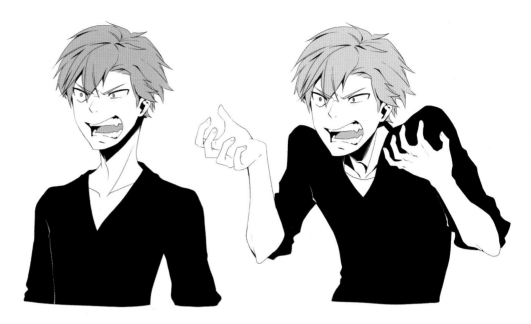

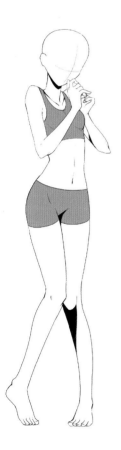

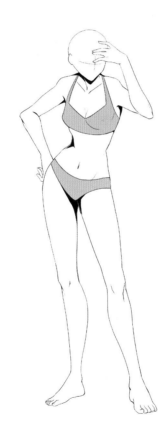

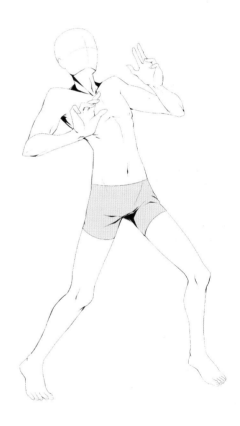

EMBARRASSED This female mannequin is embarrassed. Her head is tilted slightly downward, as if she is too shy to make eye contact with someone. Her hands are near her face—an instinctive reaction when we feel embarrassed or vulnerable. The tucked-in knees and inward-pointing toes convey an off-balance and withdrawn feeling.

ANNOYED This female mannequin is annoyed. One hand is on her forehead. The other hand is on her hip, which is tilted to one side, as if she is tired. Her body is facing the opposite direction from her head, as if she doesn't want to fully face what is annoying her.

SURPRISED This male mannequin has just been surprised. His upper body is reared back, an instinctive reaction when something shocks us. Both arms are up with palms out as if to protect himself. His face is pointed upwards since his head has just rolled back from being surprised.

CHARACTER DEVELOPMENT

Now that we've covered a wide range of fundamentals about creating manga characters, it's time to get into the technical details.

When you're ready to design a manga character, start by making a *turnaround sheet*. A turnaround sheet, also called a "character turnaround," is a composition of drawings of a character from specific angles. Character turnarounds help you draw a character accurately from multiple angles and act as your go-to source for your character design. This is where you do all of your conceptualizing and brainstorming on what your character looks like.

Before you start a turnaround sheet, grab some blank sheets of paper, or open new blank canvases in Photoshop®, and loosely doodle your character. Work out the kinks and do some brainstorming.

Let's create a turnaround sheet for Ryota, the spunky male protagonist in the first project. Feel free to either follow along and draw Ryota, or draw your own character!

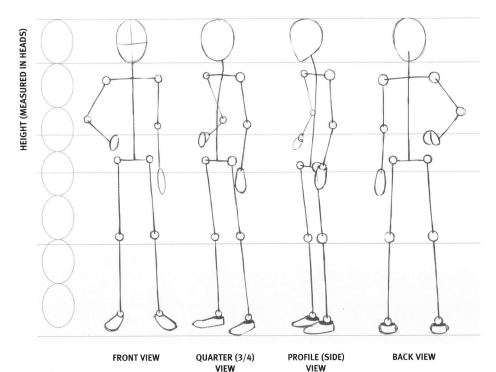

FRONT VIEW **QUARTER (3/4) VIEW** **PROFILE (SIDE) VIEW** **BACK VIEW**

STEP 1 GUIDELINES The four main angles on a turnaround are FRONT, QUARTER (3/4), PROFILE (SIDE), and BACK. Draw horizontal guidelines to help you keep the proportions on track as you draw each angle. The blue lines in this turnaround indicate the top of the head, bottom of the chin, waistline, bottom of the crotch, knees, and the bottom of the feet. You can add or remove lines, depending on what is helpful for you. Next draw guidelines for the character's pose in each angle. Use straight lines to indicate body parts and circles to indicate joints.

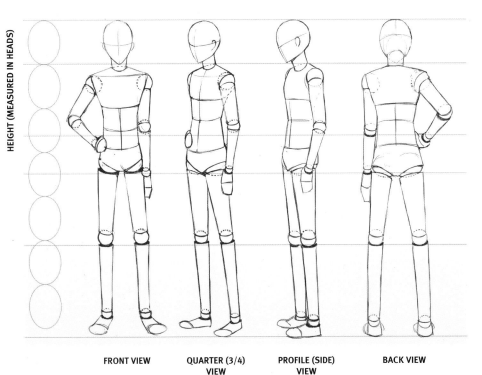

FRONT VIEW **QUARTER (3/4) VIEW** **PROFILE (SIDE) VIEW** **BACK VIEW**

STEP 2 BASIC SHAPES Next use basic shapes to "flesh out" your character's body parts. Circles, cylinders, and squares are simple shapes that are easy to identify and envision, so try using those first. Add a crossed horizontal and vertical line on the face to indicate the facial features.

STEP 3 BODY SKETCH Next follow the basic shapes to draw your character's body from each angle, without clothes. Some artists skip this step, but it can helpful, especially in trying to keep body proportions accurate. Drawing the body underneath gives you something to "wrap" clothes around. Start drawing in the basic facial features and hairstyle too!

Artist's Tip

An easy unit of measurement for a character's height is his head. Multiply the length of his head and stack them vertically to see how tall your character is. Male characters typically average 7-8 heads.

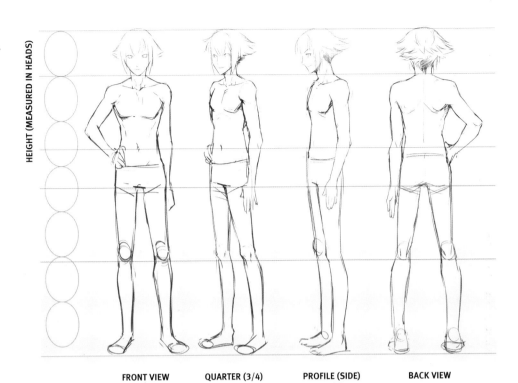

HEIGHT (MEASURED IN HEADS)

| FRONT VIEW | QUARTER (3/4) VIEW | PROFILE (SIDE) VIEW | BACK VIEW |

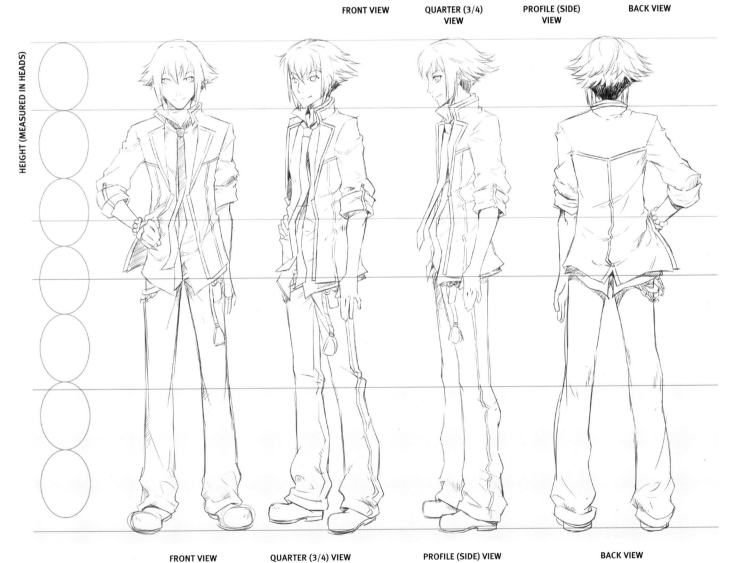

HEIGHT (MEASURED IN HEADS)

| FRONT VIEW | QUARTER (3/4) VIEW | PROFILE (SIDE) VIEW | BACK VIEW |

STEP 4 DETAILED SKETCH Using your body sketches as a guideline, fine-tune the details. Draw your character's clothes, accessories, hairstyle, and any other character quirks. Focus on details and work out all the kinks. This is the last step before inking and coloring. If you want to change something, this is the time to do it!

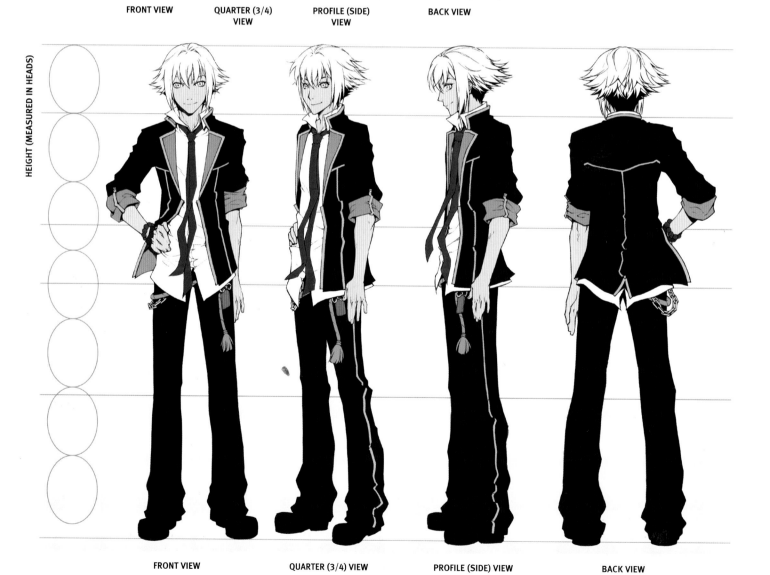

HEIGHT (MEASURED IN HEADS)

STEP 5 LINEART In this step, finalize your sketches by inking them, either traditionally or digitally. Inking grounds the image, and allows you to clean up and refine sketches.

Artist's Tip

It's a good idea to create turn-around sheets for any props or accessories that your character will have all the time.

FRONT VIEW QUARTER (3/4) VIEW PROFILE (SIDE) VIEW BACK VIEW

HEIGHT (MEASURED IN HEADS)

FRONT VIEW QUARTER (3/4) VIEW PROFILE (SIDE) VIEW BACK VIEW

STEP 6 COLOR FLATS Finally add color flats to your turnaround. Color flats are a flat layer of color without any shading.

OTHER MANGA BODIES

While human bodies are similar to each other in size and proportion in real life, there are endless ways to draw figures in manga. There is no right or wrong way to style a manga character!

Another type of style is *chibi*, a unique stylistic element in manga and anime. Chibi, also called "super-deformed" (SD), is a type of Japanese caricature where characters are grossly simplified, with specific exaggerated details that make them look childlike. A chibi is a "cartoon-ified" version of a character. Typically, chibi caricature is used to depict characters in light-hearted, comedic situations, though some manga is done entirely in chibi.

Chibi is versatile. Like any other manga style, each artist has his or her own twist. There are also various "levels" of chibi.

Let's look at a "full-sized" katana-wielding schoolgirl in various chibi stages.

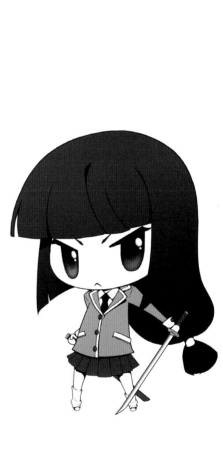

FULL BODY PROPORTIONS
Here is the schoolgirl in "regular" proportions, typically average to that of real human beings.

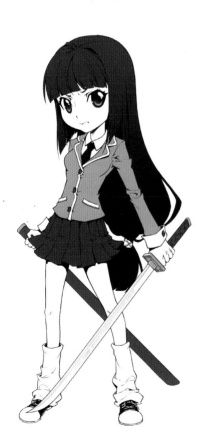

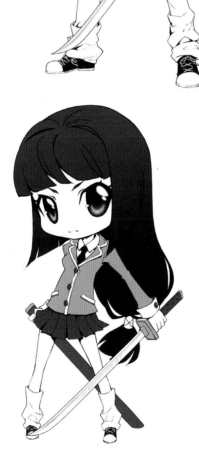

DETAILED CHIBI Some details are simplified, and her body proportions have changed. The head, eyes, and hands are bigger, while the feet are smaller. She looks more childlike, but visually retains her personality.

SIMPLE CHIBI This is the typical standard of chibi caricature. Many details are simplified, and some proportions are exaggerated, particularly the head. Her body is shorter and her feet are smaller, but the hands are still exaggerated. The face is greatly simplified: the eyes are bigger and take up a larger portion of the face and the nose is gone.

SUPER-CHIBI Here's an even more abstract and simplified chibi caricature. Her body is simplified to very basic shapes. The feet and hands are pegs. Her head is the largest part of her body, and the eyes are big but simplified. Even her accessories have been simplified to match the style of the character.

PHOTOSHOP® TUTORIAL

Here we'll go over how to digitally color in Adobe Photoshop®. Every artist works differently; if you have a different way of completing the steps illustrated in this project, that's great! This method is just one of many ways of creating awesome art in Photoshop.

Terminology

CANVAS The canvas is your working area in Photoshop. Think of it as the digital paper on which you will create your masterpiece.

DIMENSIONS The dimensions of a document are the height and width of your canvas, or working area. This is also called "Document Size" in Photoshop.

PIXELS A pixel is basically one point in an image. Digital images are comprised of many pixels sitting next to each other, forming a "grid." If an image is 5000 pixels high and 2000 pixels wide, the total number of pixels is 10,000,000. Zoom in very close to any graphic in Photoshop and you can see that the image is comprised of tiny colored squares. Each square is a pixel—the smallest possible unit of measurement in a digital image.

RESOLUTION Resolution is the number of pixels in each dimension that can be displayed. The resolution of an image is labeled with "height" and "width." The resolution of a 5000 x 2000 pixel image is "5000 x 2000."

DPI DPI (dots-per-inch) is a measure of resolution in an image, specifically for printing purposes. It is the number of pixels that can be put in a 1-inch space. The higher the DPI of an image, the more pixels per 1-inch line, which means there is more detail. Most online web images are 72 dpi. Photos or images printed in magazines are usually a minimum of 300 dpi and can be as large as 1200 dpi. If you plan to print your artwork, you should work on a canvas that is at least 300 dpi.

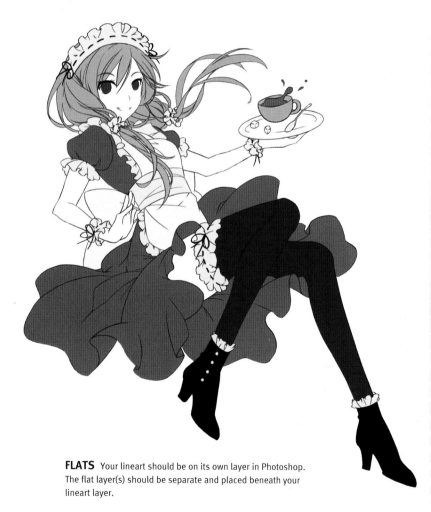

FLATS Your lineart should be on its own layer in Photoshop. The flat layer(s) should be separate and placed beneath your lineart layer.

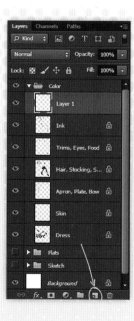

To make a new layer, click the paper-like icon on the bottom right of the Layers Palette.

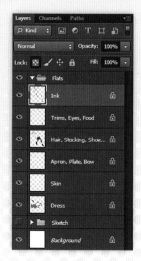

Make sure you lock the transparency on your layers as you work on them so that you don't color outside of the predetermined areas. You can do this by clicking the little checkered box on the top left of the Layers Palette.

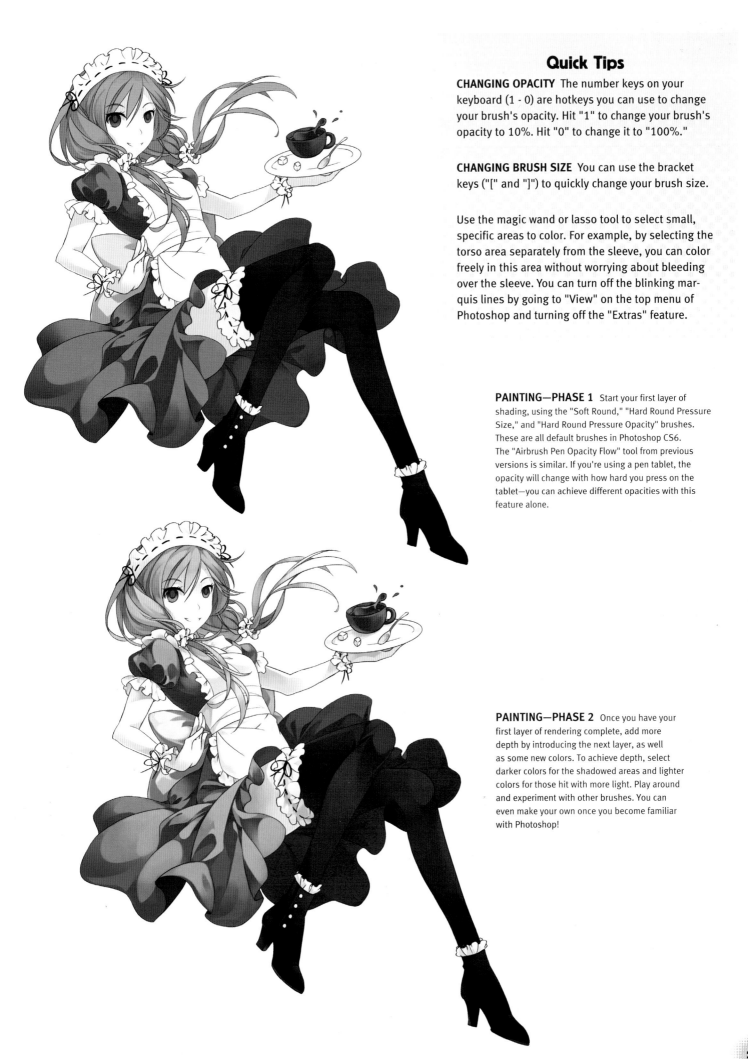

Quick Tips

CHANGING OPACITY The number keys on your keyboard (1 - 0) are hotkeys you can use to change your brush's opacity. Hit "1" to change your brush's opacity to 10%. Hit "0" to change it to "100%."

CHANGING BRUSH SIZE You can use the bracket keys ("[" and "]") to quickly change your brush size.

Use the magic wand or lasso tool to select small, specific areas to color. For example, by selecting the torso area separately from the sleeve, you can color freely in this area without worrying about bleeding over the sleeve. You can turn off the blinking marquis lines by going to "View" on the top menu of Photoshop and turning off the "Extras" feature.

PAINTING—PHASE 1 Start your first layer of shading, using the "Soft Round," "Hard Round Pressure Size," and "Hard Round Pressure Opacity" brushes. These are all default brushes in Photoshop CS6. The "Airbrush Pen Opacity Flow" tool from previous versions is similar. If you're using a pen tablet, the opacity will change with how hard you press on the tablet—you can achieve different opacities with this feature alone.

PAINTING—PHASE 2 Once you have your first layer of rendering complete, add more depth by introducing the next layer, as well as some new colors. To achieve depth, select darker colors for the shadowed areas and lighter colors for those hit with more light. Play around and experiment with other brushes. You can even make your own once you become familiar with Photoshop!

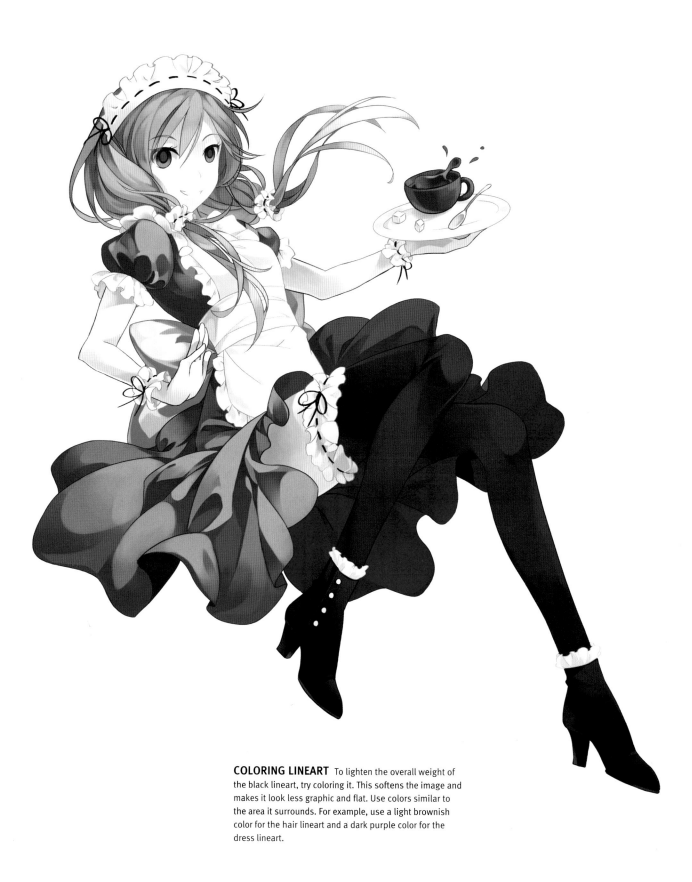

COLORING LINEART To lighten the overall weight of the black lineart, try coloring it. This softens the image and makes it look less graphic and flat. Use colors similar to the area it surrounds. For example, use a light brownish color for the hair lineart and a dark purple color for the dress lineart.

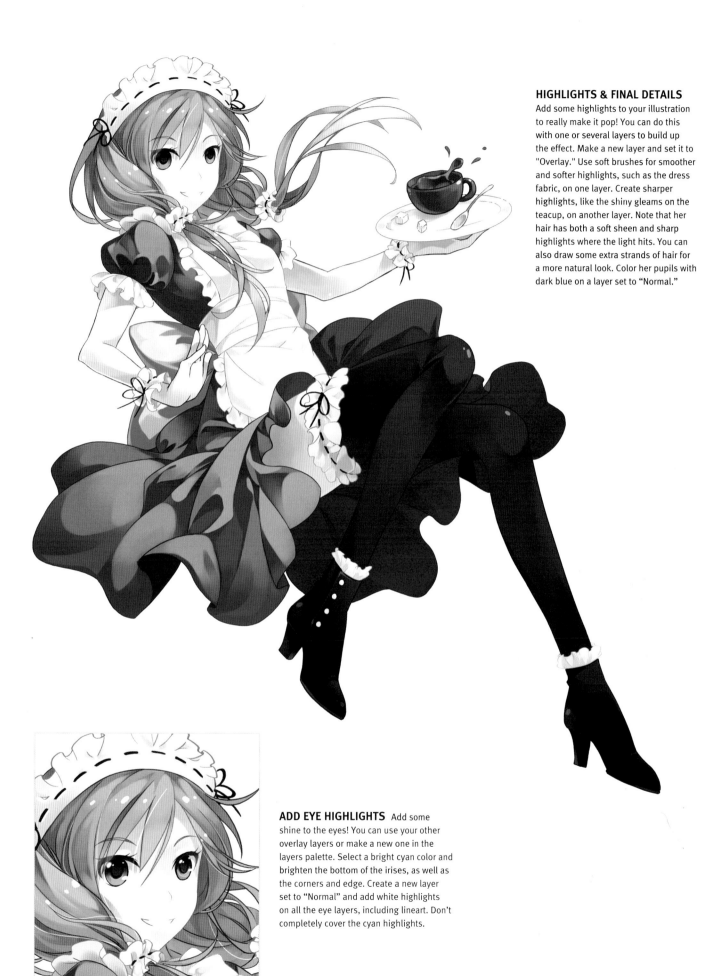

HIGHLIGHTS & FINAL DETAILS

Add some highlights to your illustration to really make it pop! You can do this with one or several layers to build up the effect. Make a new layer and set it to "Overlay." Use soft brushes for smoother and softer highlights, such as the dress fabric, on one layer. Create sharper highlights, like the shiny gleams on the teacup, on another layer. Note that her hair has both a soft sheen and sharp highlights where the light hits. You can also draw some extra strands of hair for a more natural look. Color her pupils with dark blue on a layer set to "Normal."

ADD EYE HIGHLIGHTS Add some shine to the eyes! You can use your other overlay layers or make a new one in the layers palette. Select a bright cyan color and brighten the bottom of the irises, as well as the corners and edge. Create a new layer set to "Normal" and add white highlights on all the eye layers, including lineart. Don't completely cover the cyan highlights.

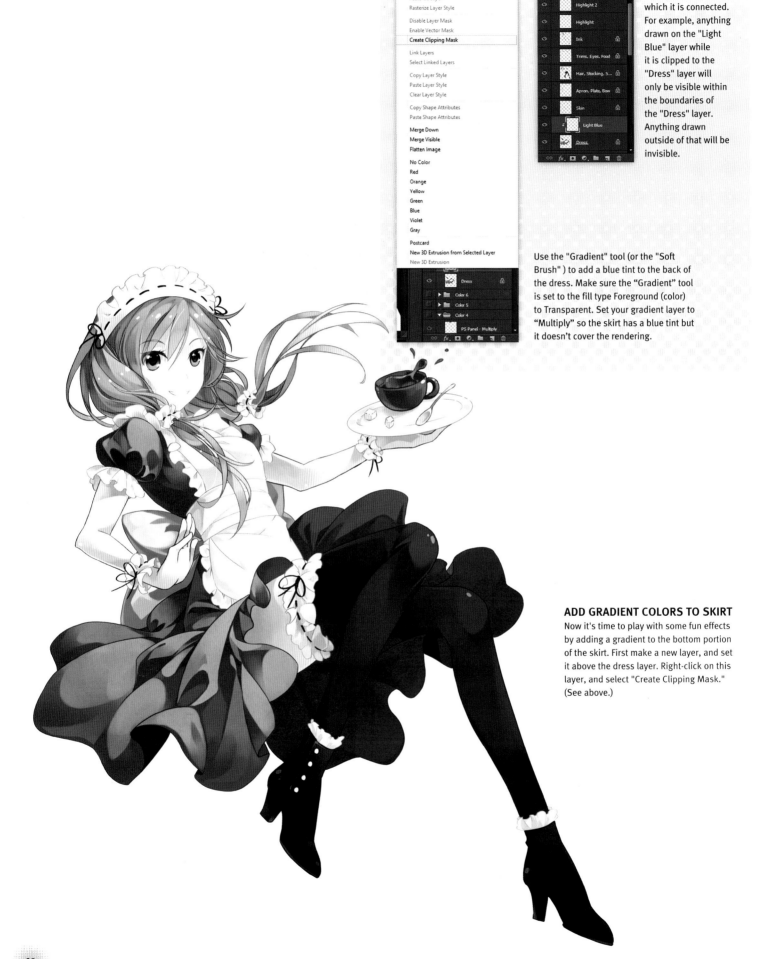

Blending Options...
Edit Adjustment...

Duplicate Layer...
Delete Layer

Convert to Smart Object

Rasterize Layer
Rasterize Layer Style

Disable Layer Mask
Enable Vector Mask

Create Clipping Mask

Link Layers
Select Linked Layers

Copy Layer Style
Paste Layer Style
Clear Layer Style

Copy Shape Attributes
Paste Shape Attributes

Merge Down
Merge Visible
Flatten Image

No Color
Red
Orange
Yellow
Green
Blue
Violet
Gray

Postcard
New 3D Extrusion from Selected Layer
New 3D Extrusion

A *clipping mask* is a setting that allows you to easily "hide" anything visible outside of the layer to which it is connected. For example, anything drawn on the "Light Blue" layer while it is clipped to the "Dress" layer will only be visible within the boundaries of the "Dress" layer. Anything drawn outside of that will be invisible.

Use the "Gradient" tool (or the "Soft Brush") to add a blue tint to the back of the dress. Make sure the "Gradient" tool is set to the fill type Foreground (color) to Transparent. Set your gradient layer to "Multiply" so the skirt has a blue tint but it doesn't cover the rendering.

ADD GRADIENT COLORS TO SKIRT

Now it's time to play with some fun effects by adding a gradient to the bottom portion of the skirt. First make a new layer, and set it above the dress layer. Right-click on this layer, and select "Create Clipping Mask." (See above.)

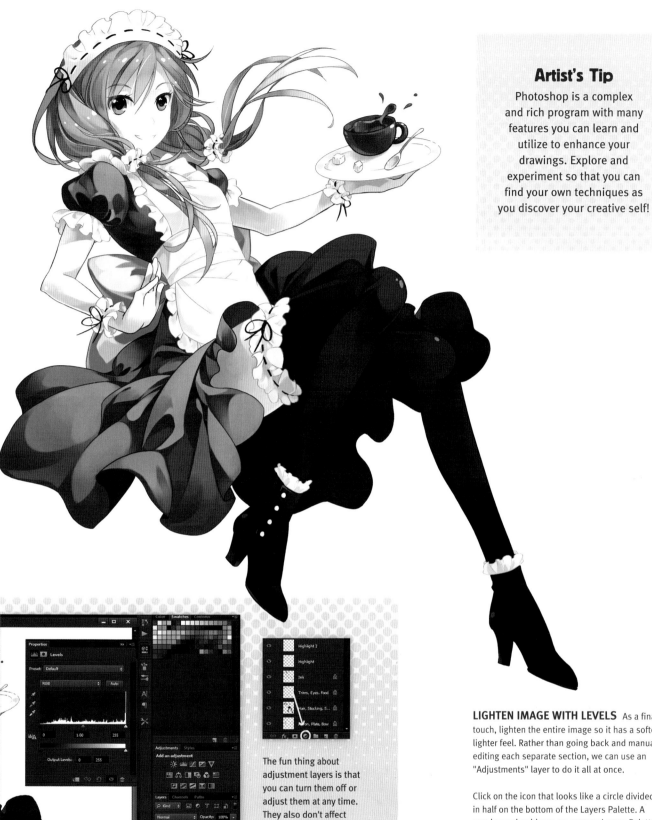

The fun thing about adjustment layers is that you can turn them off or adjust them at any time. They also don't affect the actual drawing. If you change your mind about an adjustment layer setting, you can simply remove it or alter it without altering your drawing!

LIGHTEN IMAGE WITH LEVELS As a final touch, lighten the entire image so it has a softer, lighter feel. Rather than going back and manually editing each separate section, we can use an "Adjustments" layer to do it all at once.

Click on the icon that looks like a circle divided in half on the bottom of the Layers Palette. A new layer should pop up on your Layers Palette, along with the "Levels" palette. To make your entire image lighter click on the gray arrow on the Levels Palette and slide it to the left.

RYOTA

Before beginning, I warm up by drawing a few quick sketches of my protagonist Ryota from various angles and with different facial expressions. This helps me mentally establish what he looks like in my subconscious—almost like muscle memory!

I draw a thumbnail to work out Ryota's pose and the overall composition of the piece.

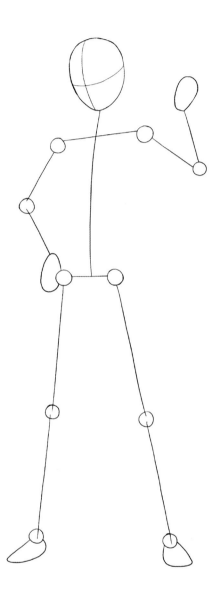

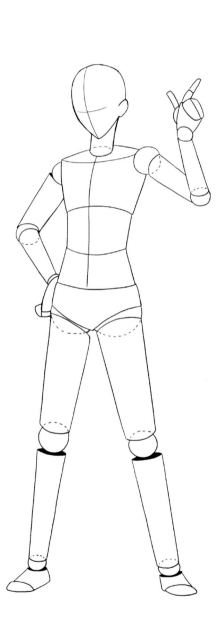

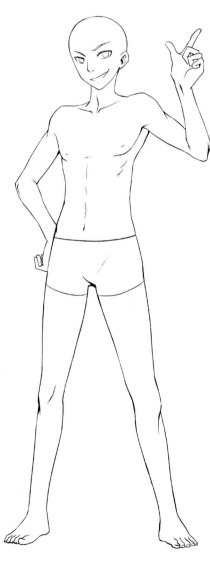

STEP 1 GUIDELINES I draw guidelines for Ryota's pose. Don't worry about drawing your circles and lines perfectly. Focus on making sure that the body proportions and pose are correct.

STEP 2 BASIC SHAPES Next I expand on my guidelines with spheres, cylinders, and other simplified geometrical shapes to fill out the body. This step better defines the pose and the body's shapes and contours.

STEP 3 BODY SKETCH I turn my basic shapes into a quick body sketch. This gives me a chance to focus on small nuances and details, like bulky shoulders or sharp elbows, which aren't always defined in the basic shapes.

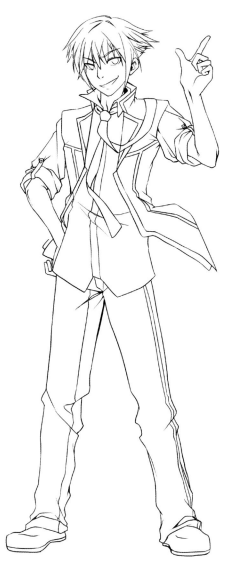

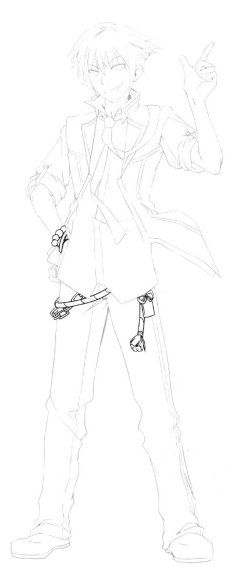

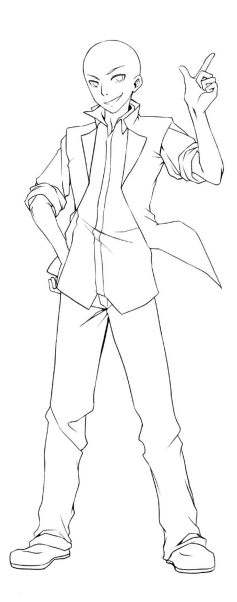

STEP 5 DETAILS AND HAIR I draw in the details for Ryota's clothing, including his tie, seams, and the detailing on his coat and pants. Next I draw in his hair.

STEP 4 BASIC CLOTHING After I've drawn the body, I move on to the clothing. I start with the largest pieces: shirt, jacket, pants, and shoes. Figure out where the main folds and creases will go and use some lines to mark these.

STEP 6 ACCESSORIES After the clothing is finished, I draw Ryota's accessories: bracelets, a belt, and his charm. Notice how drawing each major part one step at a time helps you build upon your drawing layer by layer.

STEP 7 LINEART With the sketch done, I ink the drawing—this is called lineart. Some artists have really clean pencil sketches that they use as lineart, while others go over their sketches with pens and ink.

STEP 8 COLOR FLATS I've chosen to color Ryota digitally. First I lay down *flats*. Flats are solid areas of color placed underneath the lineart. The flat colors should be the most prominent color of an area. For example, the top of Ryota's hair is blonde so the flat color should be the base color of his hair, not the color of the shadows or highlights.

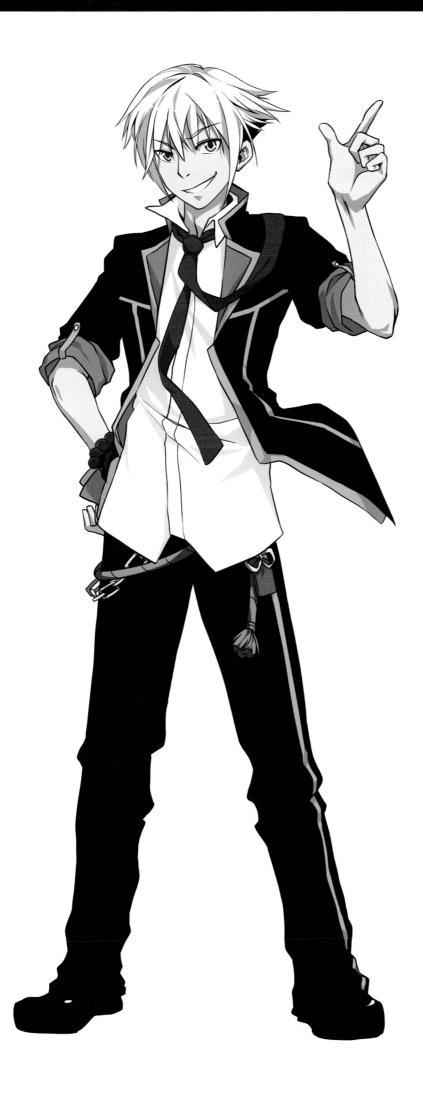

Note

The cel-shading technique uses clearly separated light and dark areas with no blending in between.

STEP 9 RENDERING AND HIGHLIGHTS Next I add shading. Remember to select a light source for your image, and have all of your shadows follow that light source. For Ryota, I use the *cel-shading* technique: a coloring style that was first used in traditional hand-drawn animation. I add highlights to the hair and shoes. Then I add white highlights to the eyes to give them more depth and make them look shiny.

CHIHARU

To complement our main protagonist, Ryota, I create a female protagonist/heroine to join him on his adventures!

STEP 1 BODY SKETCH After drawing the guidelines and basic shapes, I sketch in the contours of Chiharu's body. Then I draw in the fingers and toes and flesh out the ears. I also draw in her facial features and two tails.

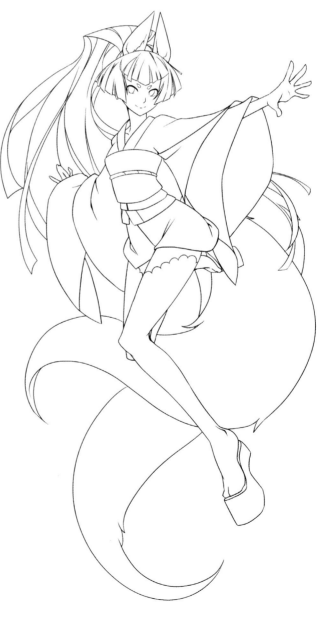

STEP 2 CLOTHING & HAIR Since Chiharu has several layers of detail on her clothing, I start with the largest pieces: the kimono, obi, and stockings. I also start fleshing out her hair, and I add the bottom platforms of her shoes.

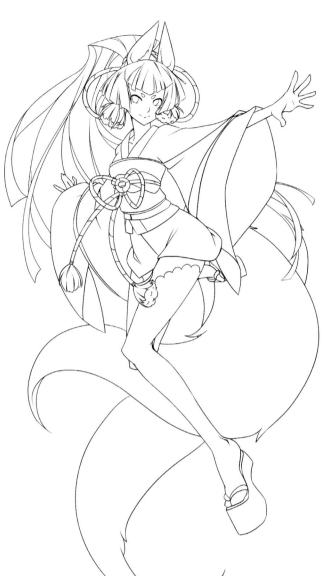

STEP 3 ACCESSORIES I add the cord and tassels that tie her hair in a ponytail. I also add a similar cord and tassels tied in a bow over her obi. I add a second sleeve layer to her kimono and the toe straps on her shoes.

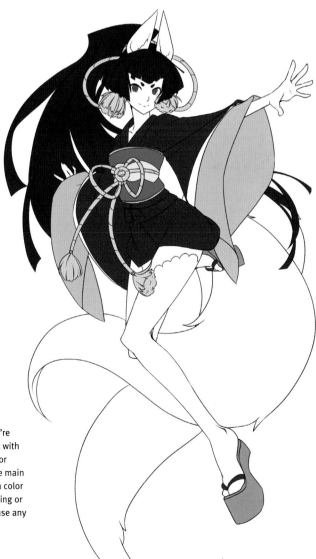

STEP 4 COLOR FLATS If you're digitally coloring your lineart, start with a new layer underneath for the color flats. Remember: color flats are the main base color of the area, so choose a color that doesn't conflict with any shading or highlights you add later. You can use any colors you like!

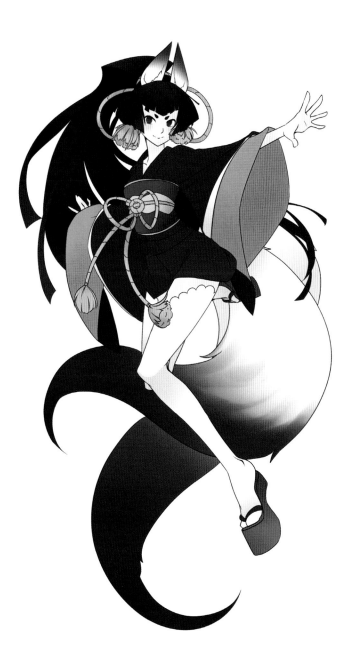

STEP 5 COLOR GRADIENTS Since Chiharu has some unique coloring effects, I add those first. I add a maroon-to-white gradient to her ears and tails. I also add some subtle gradients to her clothing and hair to start building up some soft shapes.

STEP 6 CEL-SHADING I add shading to Chiharu. Remember to select a light source and make all of the shading follow that light source. I add additional darkness to the shading that needs it, such as on her back sleeve and the bottom of her hair. Notice how the subtle gradients I added in the previous step give the cel-shading a more "hybrid" airbrush look.

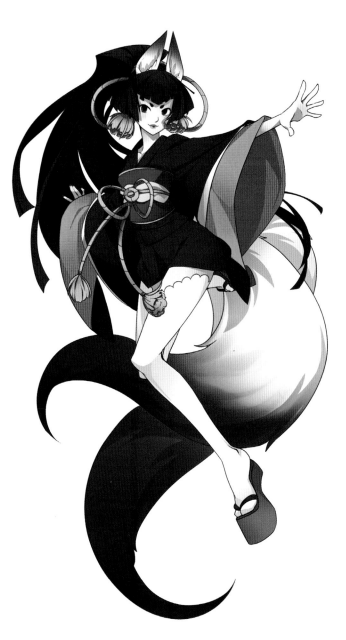

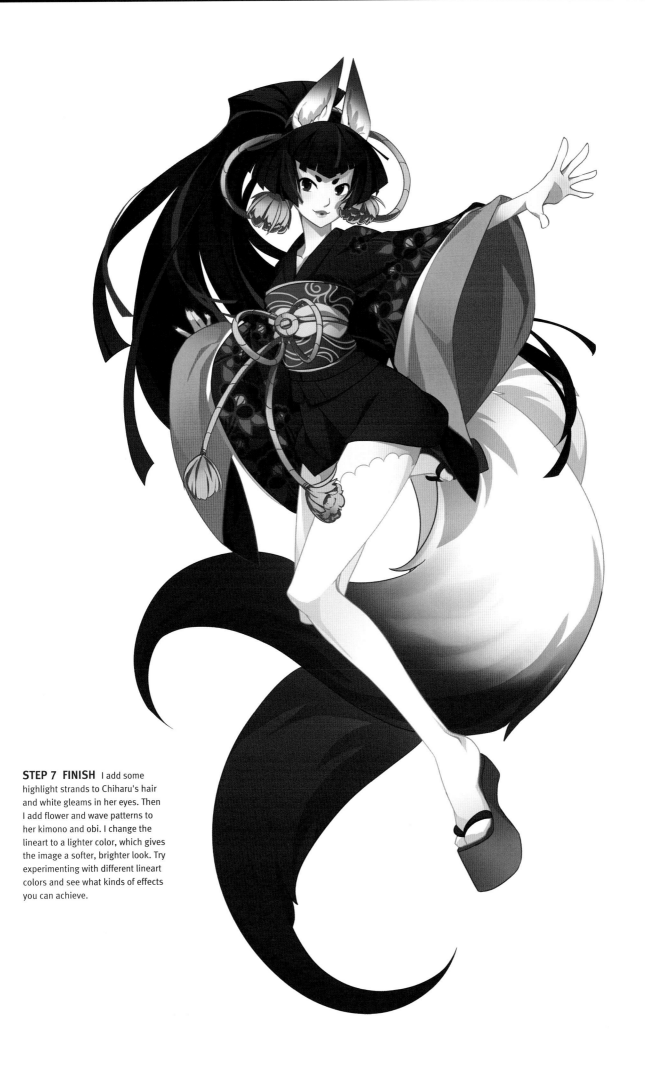

STEP 7 FINISH I add some highlight strands to Chiharu's hair and white gleams in her eyes. Then I add flower and wave patterns to her kimono and obi. I change the lineart to a lighter color, which gives the image a softer, brighter look. Try experimenting with different lineart colors and see what kinds of effects you can achieve.

ZAIM

Now that we've covered our protagonist and heroine, it's time for our villains! Conceptualizing was really important during Zaim's character development because he has so many iconic details: horns, special eyes, a demonic gauntlet on one hand, and devil's wings.

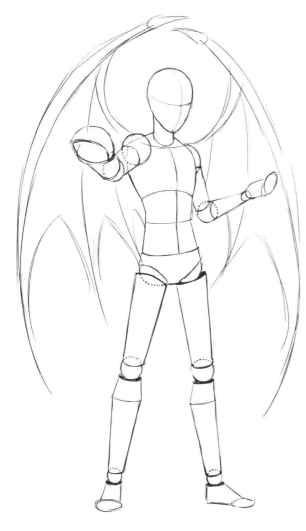

STEP 1 BASIC SHAPES After drawing guidelines, I draw basic shapes. Pay special attention to the foreshortening of his right arm in this stage, and try to get the correct proportions. I sketch in the wings as well.

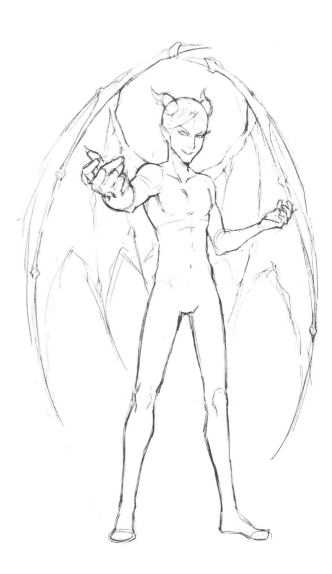

STEP 2 BODY SKETCH Using the basic shapes as a guide, I draw the contours of Zaim's body. I'm also figuring out his muscle structure. I sketch in his face, horns, and fingers. I add a little more structural detail to his wings.

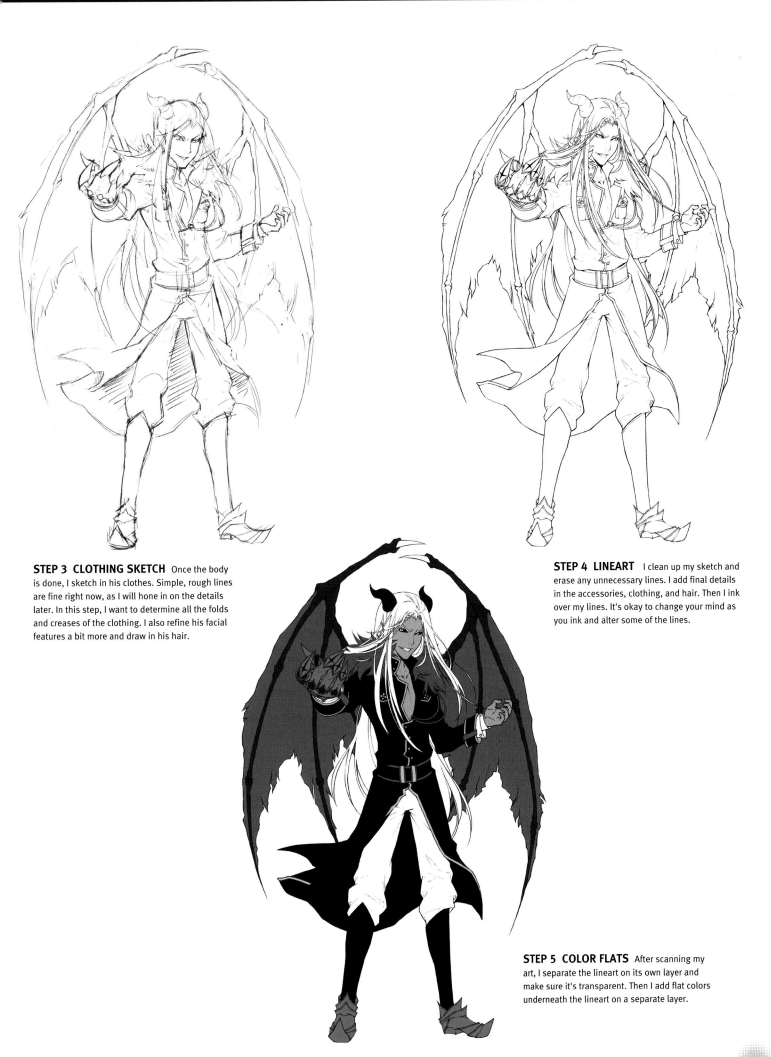

STEP 3 CLOTHING SKETCH Once the body is done, I sketch in his clothes. Simple, rough lines are fine right now, as I will hone in on the details later. In this step, I want to determine all the folds and creases of the clothing. I also refine his facial features a bit more and draw in his hair.

STEP 4 LINEART I clean up my sketch and erase any unnecessary lines. I add final details in the accessories, clothing, and hair. Then I ink over my lines. It's okay to change your mind as you ink and alter some of the lines.

STEP 5 COLOR FLATS After scanning my art, I separate the lineart on its own layer and make sure it's transparent. Then I add flat colors underneath the lineart on a separate layer.

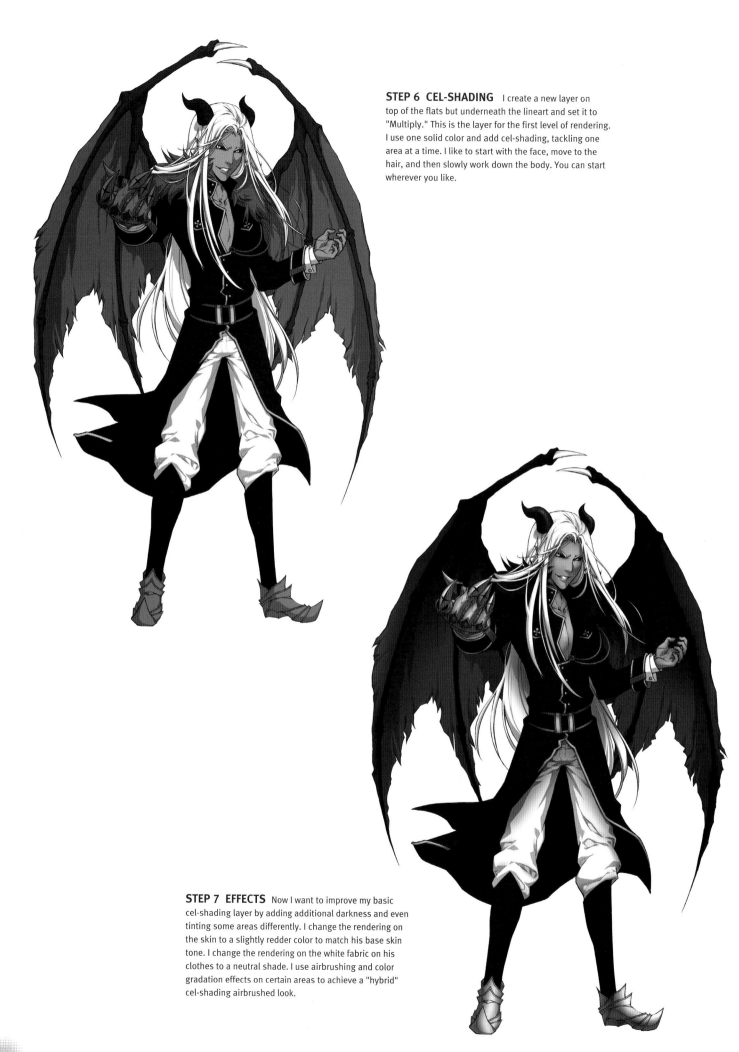

STEP 6 CEL-SHADING I create a new layer on top of the flats but underneath the lineart and set it to "Multiply." This is the layer for the first level of rendering. I use one solid color and add cel-shading, tackling one area at a time. I like to start with the face, move to the hair, and then slowly work down the body. You can start wherever you like.

STEP 7 EFFECTS Now I want to improve my basic cel-shading layer by adding additional darkness and even tinting some areas differently. I change the rendering on the skin to a slightly redder color to match his base skin tone. I change the rendering on the white fabric on his clothes to a neutral shade. I use airbrushing and color gradation effects on certain areas to achieve a "hybrid" cel-shading airbrushed look.

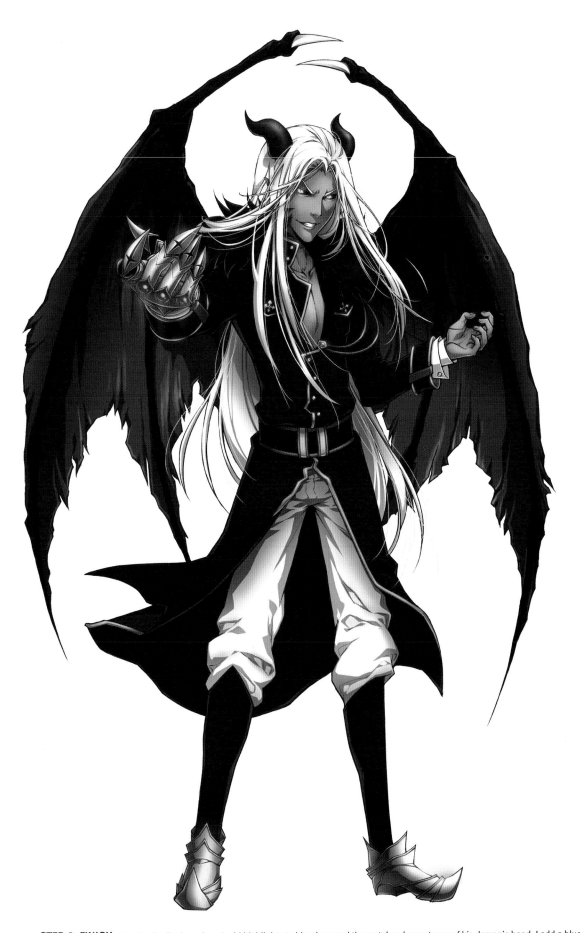

STEP 8 FINISH Now for the final touches. I add highlights to his wings and the metal and gemstones of his demonic hand. I add a blue-tinted gradation layer on the bottom of his coat so that it changes from purple to blue as it goes down. Because Zaim's clothing is mostly dark, many of the details and edges get lost and bleed into each other. To make these areas "pop out," I add subtle reflect light to the edges to break up the dark areas. Adding reflect light to edges lost in shadows brings them back to view and adds depth. Finally I add a yellow glow to his eyes and glowing red airbrush strokes to the gemstones on his hand to add a sense of movement.

VILLAINESS

Every villain mastermind needs a right-hand man—or woman. I came up with a female counterpart to complement Zaim's evil nature. This villainess is sultry and seductive with a beautiful but devious face. Her clothing, accessories, and details enhance her core personality.

STEP 1 BODY SKETCH After drawing my guidelines and basic shapes, I start sketching the body. This villainess is curvaceous, and I make sure her body reflects it. I also start sketching in her facial features, horns, ears, and fingers.

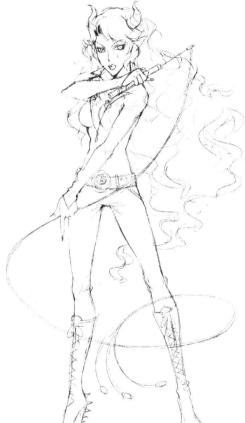

STEP 2 CLOTHING SKETCH
I sketch in her clothing on top of the completed body sketch. I add some folds and creases in key areas where a bodysuit would crease (joints, shoulders, etc.) so that the bodysuit doesn't look too skintight. I clean up the details of her face and sketch in her hair. Finally I finish sketching the whip.

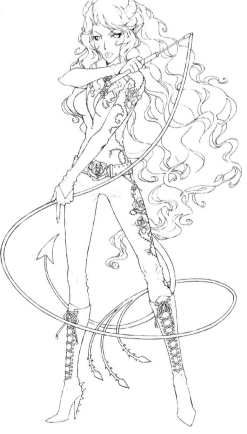

STEP 3 LINEART I clean up the sketch and refine my lines. I work out the curls and curves in her hair and define the creases in her clothes. I add a black rose and thorn design going down the left side of her bodysuit. Then I ink over my drawing.

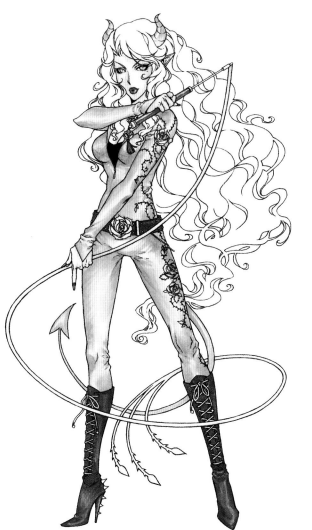

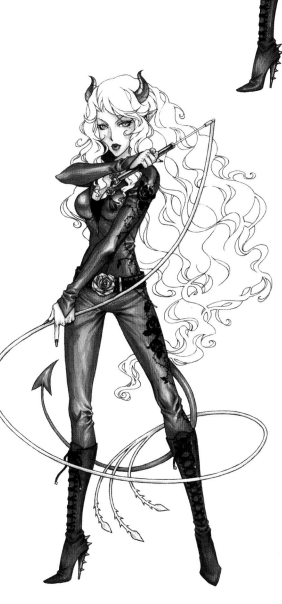

STEP 4 BASE COLORS Markers are all about layering; you want to add layers of color, one over the other, several times to make it darker and add depth. First I add the base colors for the skin, accessories, and bodysuit. Unlike flat colors in digital art, base colors in markers need to be the lightest color you plan to use. If you start with a really dark color as your first layer, you will have trouble adding layers later.

STEP 5 LAYERING COLORS I add a second layer of color over the skin, accessories, and bodysuit with slightly darker colors. Notice that some areas are significantly darker, such as the gold on her belt buckle and whip. The dark secondary color that I used to create shadows in the metal adds depth.

Artist's Tip

If you plan to color with markers, choosing the proper inking materials is key. Make sure you use ink that is waterproof and archival. Do not use ballpoint or gel pens for this stage, or your lineart will bleed when you color with markers.

STEP 6 MORE LAYERS
I continue adding layers of color with slightly darker colors each time until I achieve the desired level of depth and color for each area. Here you can see why I started with such a light color for the bodysuit; the base color is most visible in the highlighted areas. If I had used a darker color first, I would not be able to achieve these lighter areas. I fill in the rose decoration on the left side of the bodysuit with black.

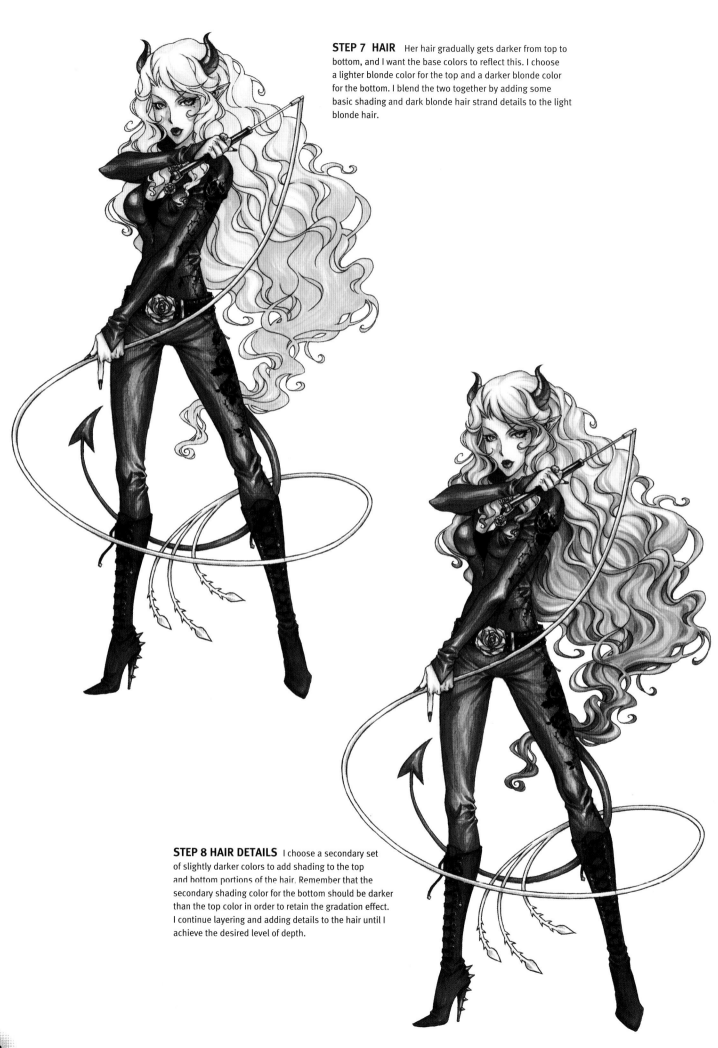

STEP 7 HAIR Her hair gradually gets darker from top to bottom, and I want the base colors to reflect this. I choose a lighter blonde color for the top and a darker blonde color for the bottom. I blend the two together by adding some basic shading and dark blonde hair strand details to the light blonde hair.

STEP 8 HAIR DETAILS I choose a secondary set of slightly darker colors to add shading to the top and bottom portions of the hair. Remember that the secondary shading color for the bottom should be darker than the top color in order to retain the gradation effect. I continue layering and adding details to the hair until I achieve the desired level of depth.

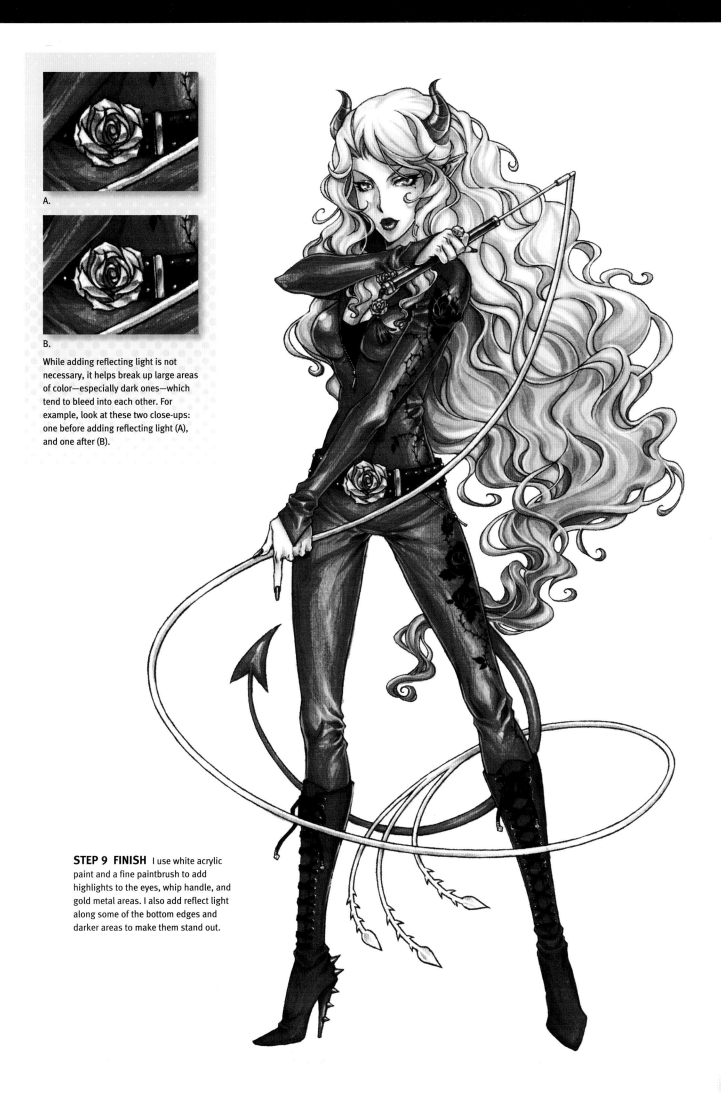

A.

B.

While adding reflecting light is not necessary, it helps break up large areas of color—especially dark ones—which tend to bleed into each other. For example, look at these two close-ups: one before adding reflecting light (A), and one after (B).

STEP 9 FINISH I use white acrylic paint and a fine paintbrush to add highlights to the eyes, whip handle, and gold metal areas. I also add reflect light along some of the bottom edges and darker areas to make them stand out.

COMIC RELIEF CHARACTER

Almost every story has a comedic relief character. Comedic relief characters are generally "lighter" and tend to crack the jokes or have a goofier role in a story. This character is intelligent but shy, especially around the ladies. And he's never too far from a book or computer. He may think he's a social failure, but deep down he has a kind and sincere heart.

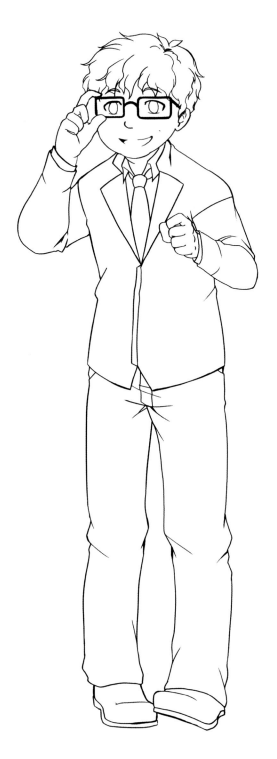

STEP 1 BODY SKETCH After drawing my guidelines and basic shapes, I work on the body contours. This geek character has a thick, stocky build.

STEP 2 DRAWING THE CLOTHING I draw in the uniform, shoes, and hair. Remember to use the body sketch as a guide as you "wrap" the clothes around him. I add thick, rectangular eyeglasses as an accessory.

STEP 3 DRAWING DETAILS Once I have the clothing down, I build on it and add more detail. I start by adding buttons to his sleeves and tailoring lines to his coat and trousers. Finally I add a shoulder bag to give him a studious, bookworm-type look.

STEP 4 FLATS Once all of my lineart is complete, I lay down the flats. Remember: flats are the most prominent color of an area. The flats should give you a general idea of what the final colored piece will look like.

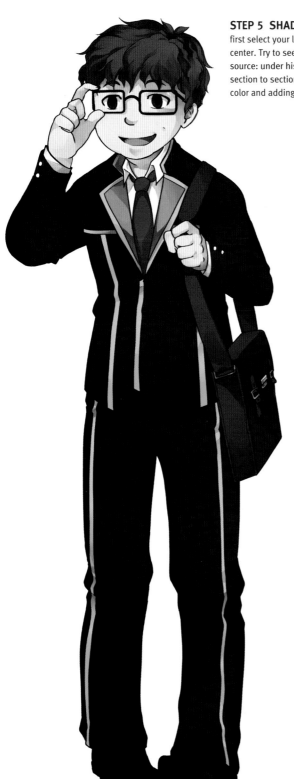

STEP 5 SHADING Next I add some basic shading. Remember to first select your light source! In my case, the light source is from the top center. Try to see where the darkest areas will be, based on the light source: under his arms and after the bend of his knees. I move from section to section, selecting a basic shading color that matches each flat color and adding some rendering.

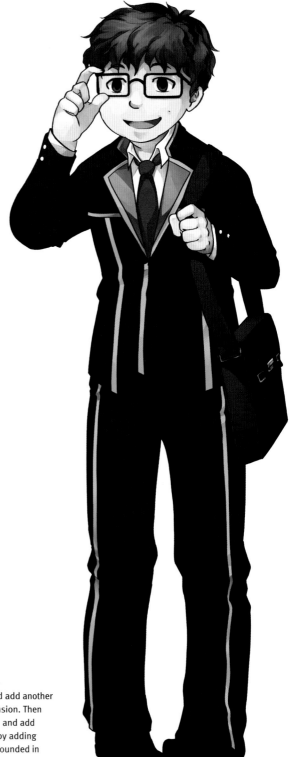

STEP 6 LIGHT SHADING I select darker colors and add another layer of shading to push the shapes and add more dimension. Then I select colors that are LIGHTER than those used in step 5 and add highlights to bring in more depth and dimension. I start by adding highlights to his hair and then lightening areas that are rounded in shape. Follow your shadows and pay attention to the light source.

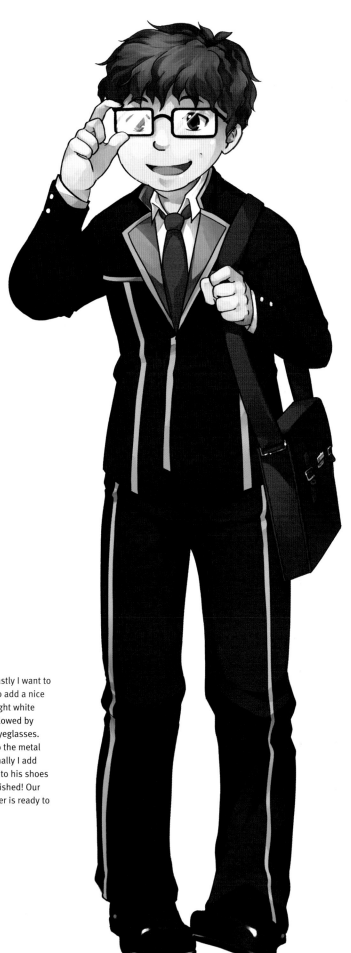

STEP 7 HIGHLIGHTS Lastly I want to
add some subtle highlights to add a nice
level of finish. I add some bright white
highlights to his eyeballs, followed by
some dramatic glare on his eyeglasses.
Then I add some highlights to the metal
parts on his shoulder bag. Finally I add
some nice white gleam spots to his shoes
to make them look shiny. Finished! Our
kind-hearted support character is ready to
tackle whatever lies ahead.

MASCOT CHARACTERS

Mascots are typically cute characters that play a wide variety of roles in a story. For example, in a magical girl story, a mascot may help guide the main heroine and imbue her with magical powers. Mascots are often *anthropomorphic*—animals with humanlike traits. They can also be objects or a human chibi character! I developed mascot characters based on creatures found in traditional Japanese folklore: a *kappa* and a *tengu*.

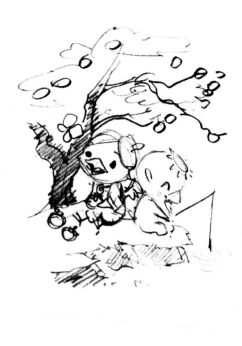

A *kappa* is a water sprite that is usually small, childlike in shape, and has green scales or skin. They are often mischievous creatures. A kappa's favorite food is cucumbers.

A *tengu* is one of the best known *yokai* (monsters/spirits) in Japanese folklore. They usually resemble crows, with birdlike characteristics and long noses. Tengus are also mischievous, and are considered guardians of the mountains and forests.

After completing some solid character design sketches, I work out a thumbnail for my final artwork. My kappa and tengu are sitting on a grassy river shore under a persimmon tree in autumn.

STEP 1 BASIC CHARACTER SKETCH I start by drawing the characters' bodies to get the proportions and poses down. Then I loosely sketch in the background.

STEP 2 DETAILED SKETCH I add the clothing and accessories on the tengu and the shell detailing on the kappa. Then I finish sketching the shoreline, tree, leaves, grass, and fruit. I add a few leaves floating in the water as well.

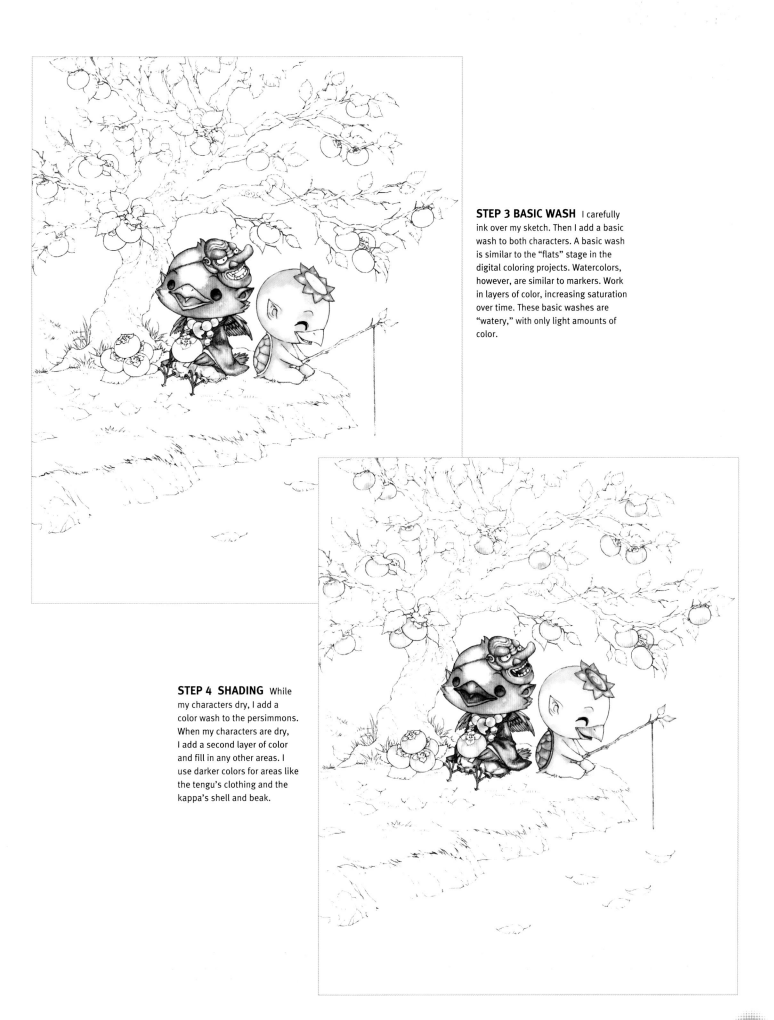

STEP 3 BASIC WASH I carefully ink over my sketch. Then I add a basic wash to both characters. A basic wash is similar to the "flats" stage in the digital coloring projects. Watercolors, however, are similar to markers. Work in layers of color, increasing saturation over time. These basic washes are "watery," with only light amounts of color.

STEP 4 SHADING While my characters dry, I add a color wash to the persimmons. When my characters are dry, I add a second layer of color and fill in any other areas. I use darker colors for areas like the tengu's clothing and the kappa's shell and beak.

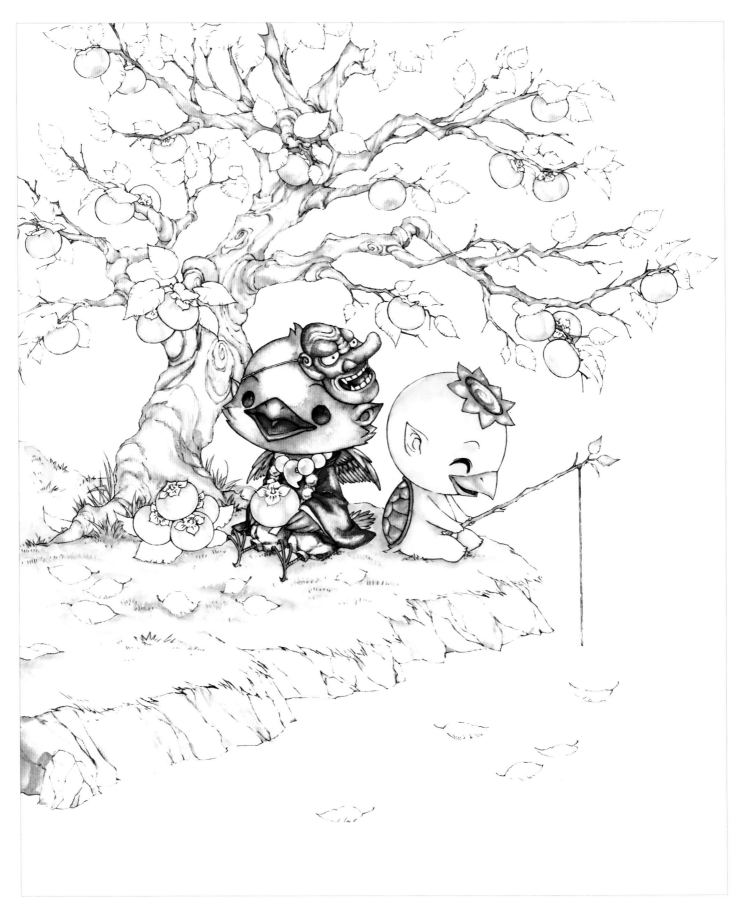

STEP 5 BACKGROUND WASH I add a basic wash on the grassy slope. Remember that this is only the first wash; don't feel like you have to cover everything. Leaving some white or lighter areas will add contrast once you start building layers. Next I add a basic wash to the tree, using a light golden brown color. I follow my lineart and use the color to define some of the gnarled details and textures on the bark. Finally I add a light wash to the rocky ledge. I use color to add detail to the rocks, rather than painting the entire section as a solid color.

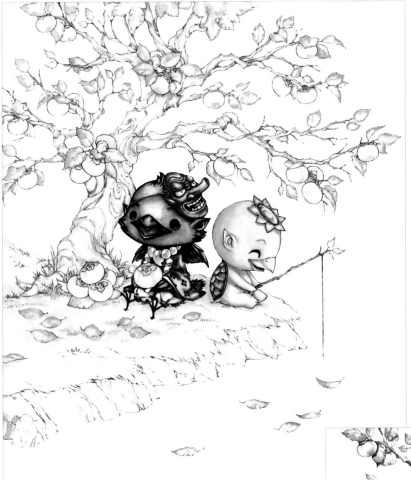

STEP 6 SHADING I return to the characters and add another level of shading to the mask, as well as the tengu's feathery body. I also add more dramatic darker colors to the jade beads around his neck. I use pure black to draw pupils in his eyes and color his beak. Then I mix a dark red and use a fine-tipped brush to add a pattern to his kimono. The kappa contains less detail, so I focus on adding depth and dimension to his body. I make the shadows under his head and arm significantly darker. Then I add green and brown gradients on each section of his turtle shell. Lastly I add a basic wash to all of the leaves. I mix a little brown and green on some of the lower leaves of the tree, as well as those on the ground and in the water to make them look like slightly rotted autumn leaves.

STEP 7 MORE SHADING I add more layers on the persimmons and leaves until I reach my desired level of depth. I use a fine tipped brush to paint veins and brown speckles in the leaves. While these areas dry, I return to the grassy slope and build additional layers of detail with a fine-tipped brush. I use a darker green to paint individual blades of grass, and I don't blend them in so I can retain the sharp edges of my brushstrokes. I use an even darker green to add clovers and other details in the grass. Finally I add several layers of color to the tree trunk and very dark brown for shadows.

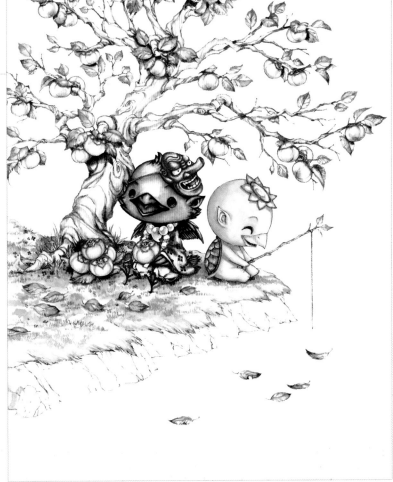

Artist's Tip

Watercolors can be challenging to use, but yield beautiful results. They are enjoyable to paint with and have a zen-like quality. Be patient, try out different techniques and materials, and enjoy this fun medium!

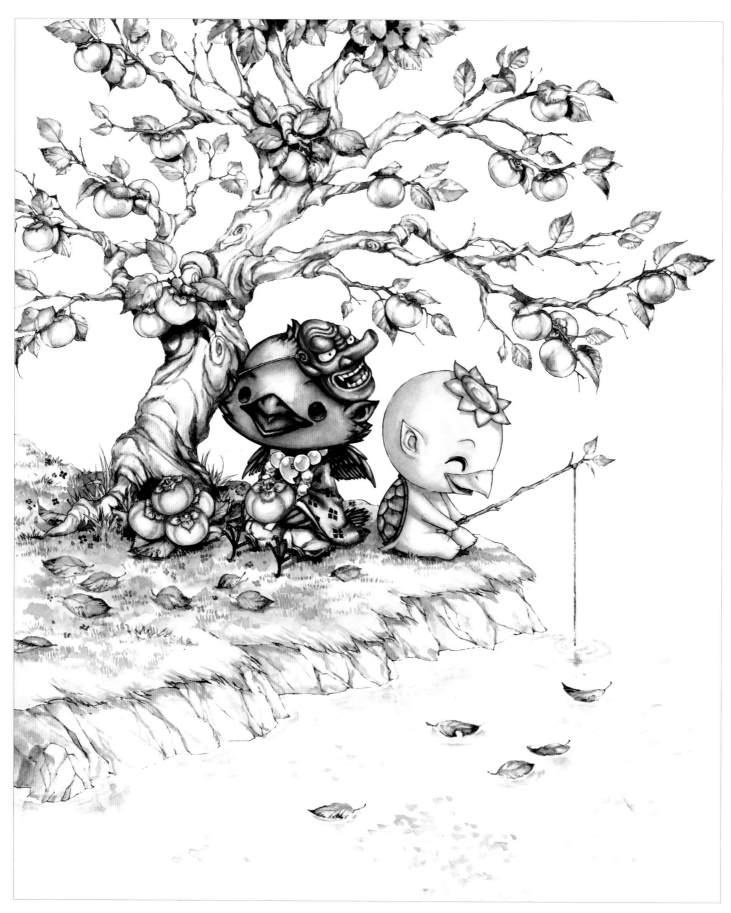

STEP 8 RIVER WASH Next I finish the river. I start with a light blue and add strokes to simulate water ripples circling around the rocky ledge, fishing line, and floating leaves. I add additional layers of darker color for more depth. While the river dries I add another layer of color and detail to the ledge. Then I add some light green speckles, blending immediately with water to look like moss. I immediately add water to a few areas so that they bleed into the blue colors, creating a nice watery texture.

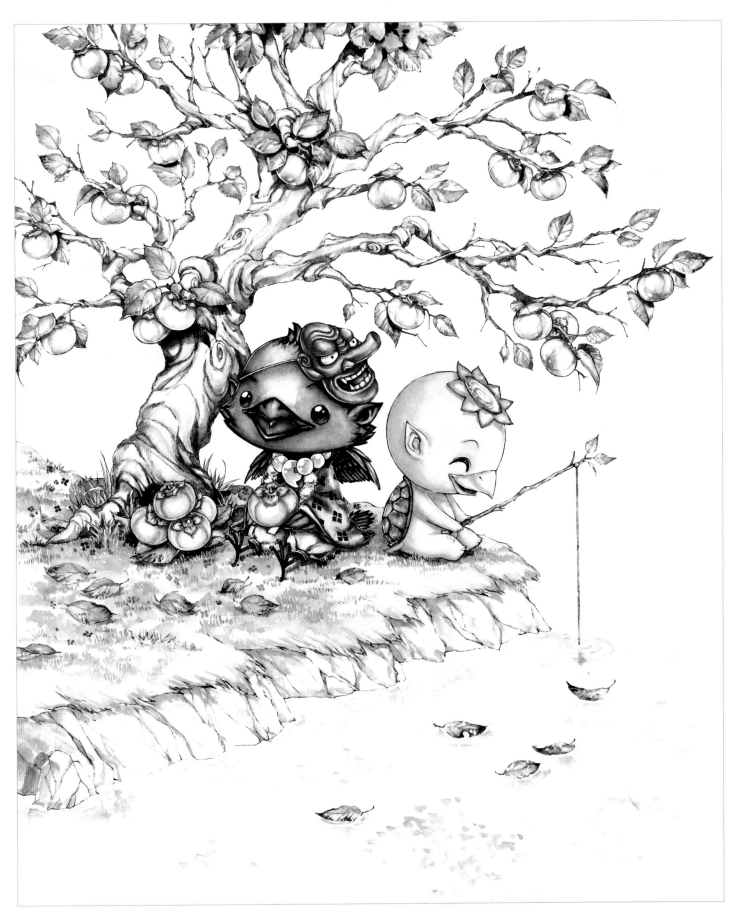

STEP 9 FINISH I keep the sky simple, adding light blue wash in patches to simulate a cloudy sky with clear spots. I blend with lots of water to keep it light and soft. For the final touches I add white gleams to the tengu's eyes and jade beads. I also add reflect light along the bottom of his clothing, accessories, mask, and the persimmon he is holding. Next I add some light strokes to the grass to create more texture and depth. I also add reflect light on some of the leaves and fruit on the tree to break apart the dark areas and make the details "pop." Finally I add some white speckles to the water and the floating leaves to simulate air bubbles and gleaming water droplets on the leaves.

HAPPY HEROINE

This happy heroine is an old friend of Ryota's. She often worries about Ryota, since he always seems to get himself into trouble, and Ryota always feels guilty when she gets involved...but ultimately, her gentle and calm personality makes her someone he can depend on.

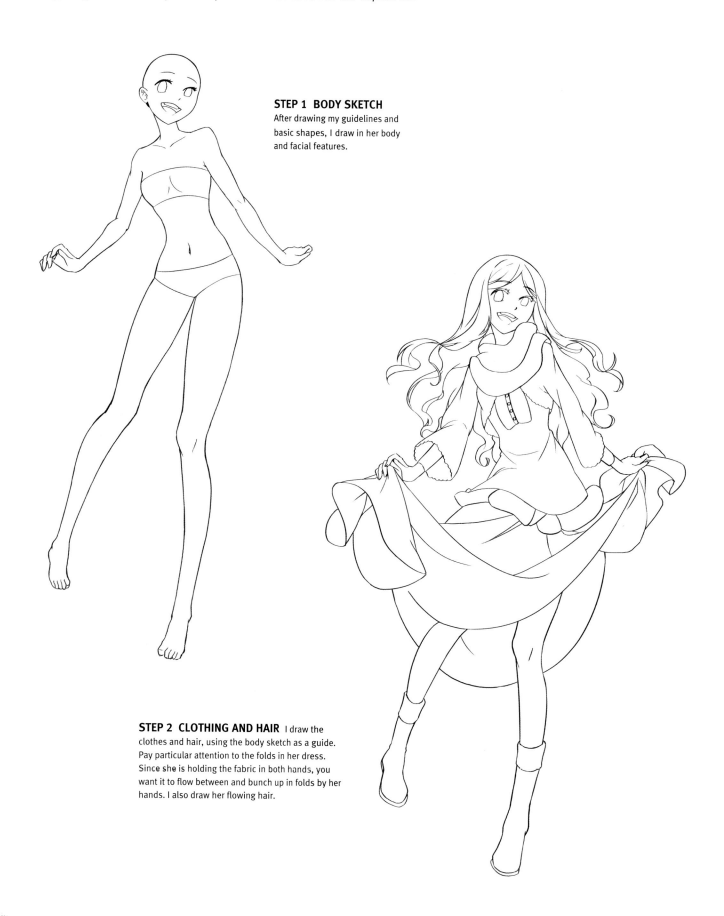

STEP 1 BODY SKETCH
After drawing my guidelines and basic shapes, I draw in her body and facial features.

STEP 2 CLOTHING AND HAIR I draw the clothes and hair, using the body sketch as a guide. Pay particular attention to the folds in her dress. Since she is holding the fabric in both hands, you want it to flow between and bunch up in folds by her hands. I also draw her flowing hair.

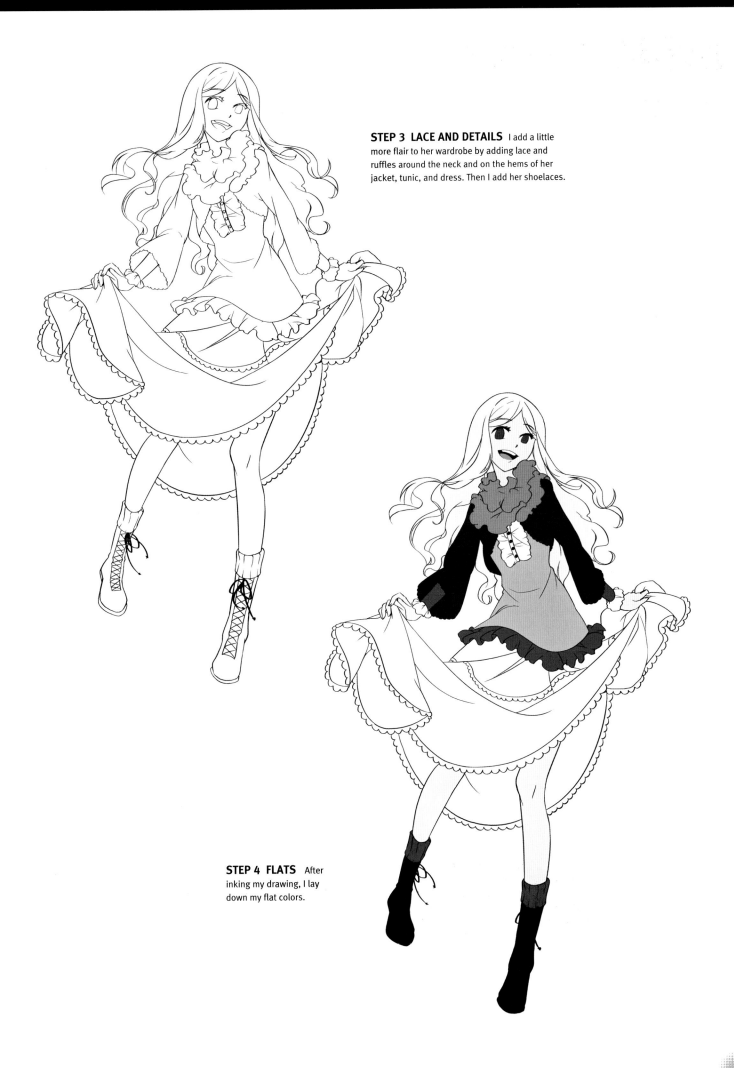

STEP 3 LACE AND DETAILS I add a little more flair to her wardrobe by adding lace and ruffles around the neck and on the hems of her jacket, tunic, and dress. Then I add her shoelaces.

STEP 4 FLATS After inking my drawing, I lay down my flat colors.

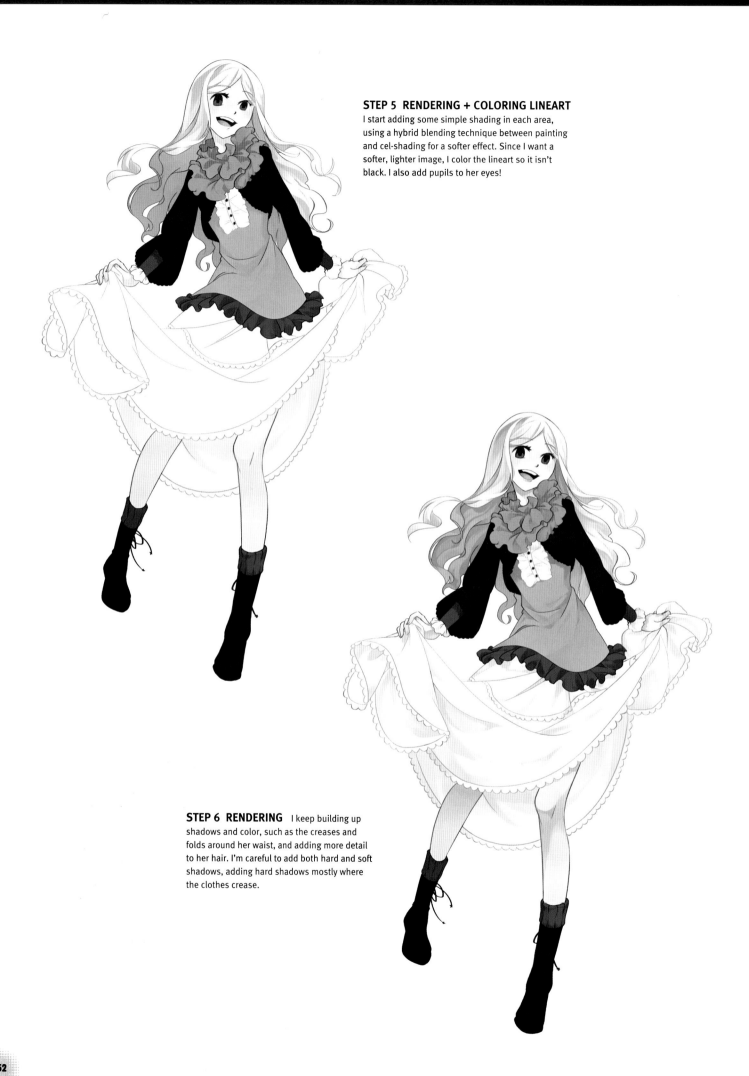

STEP 5 RENDERING + COLORING LINEART
I start adding some simple shading in each area, using a hybrid blending technique between painting and cel-shading for a softer effect. Since I want a softer, lighter image, I color the lineart so it isn't black. I also add pupils to her eyes!

STEP 6 RENDERING I keep building up shadows and color, such as the creases and folds around her waist, and adding more detail to her hair. I'm careful to add both hard and soft shadows, adding hard shadows mostly where the clothes crease.

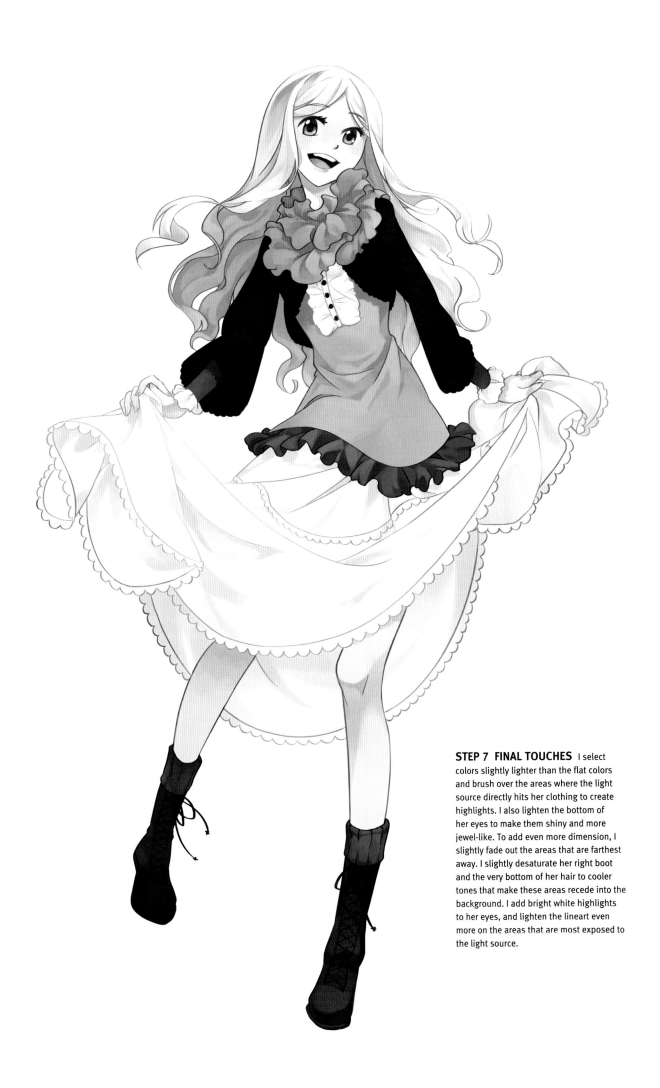

STEP 7 FINAL TOUCHES I select colors slightly lighter than the flat colors and brush over the areas where the light source directly hits her clothing to create highlights. I also lighten the bottom of her eyes to make them shiny and more jewel-like. To add even more dimension, I slightly fade out the areas that are farthest away. I slightly desaturate her right boot and the very bottom of her hair to cooler tones that make these areas recede into the background. I add bright white highlights to her eyes, and lighten the lineart even more on the areas that are most exposed to the light source.

ZAIM'S MINION

Zaim's minion is a big, brawny henchman whom Zaim frequently bosses around. Some may think he's dim-witted, but that's not so. He just prefers brute force and to break things rather than to think about it. He has a very short temper and always seems to be angry.

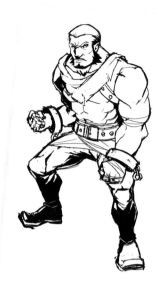

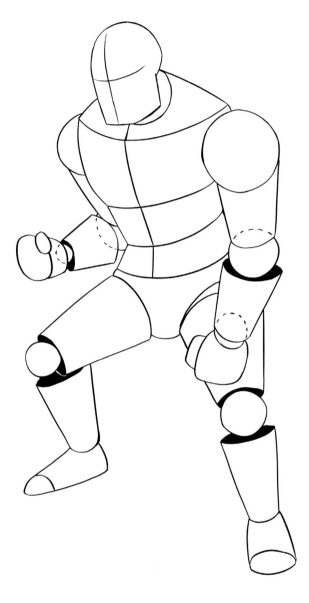

STEP 1 BASIC SHAPES
Because this character is so bulky, basic shapes play an important role for this drawing. After drawing my guidelines, I use large and chunky basic shapes to lay down the foundation for his bulky frame.

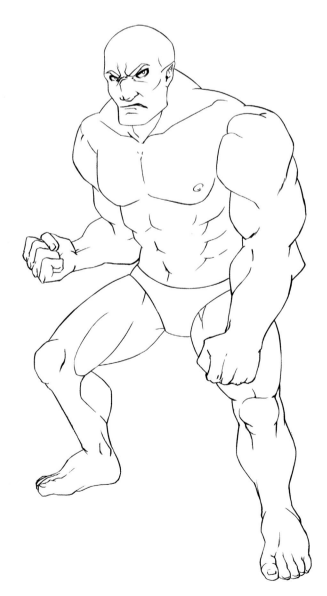

STEP 2 BODY SKETCH The body
sketch is an anatomical challenge because the brawn on this character is one of his most identifiable physical attributes. The various angles, curves, and creases in his muscular structure are important to effectively illustrate his physique. I use some reference photos of bodybuilders to help me get the right look.

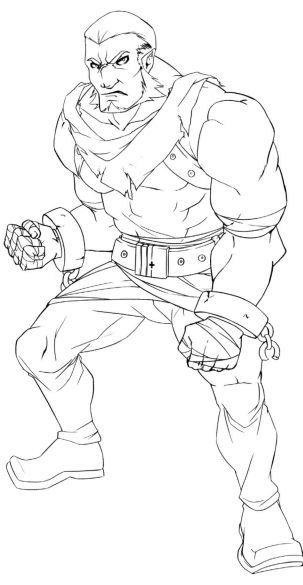

STEP 3 CLOTHING Once I have the body contours down, I draw in all of his clothing and accessories. All the detail I worked out earlier for his six-pack and buff arms make him look super strong!

STEP 4 ADD SHADOWS To change up the style, I add some very dramatic black shadows to the lineart, using ink instead of color. When you work with shadows like this, think about which areas would benefit the most from having these dramatic darks. You don't want to overdo it.

Artist's Tip

Minion or henchman characters don't always have to be weaker than the main villain. Think of ways to give supporting characters different attributes so that they balance out those with whom they interact the most.

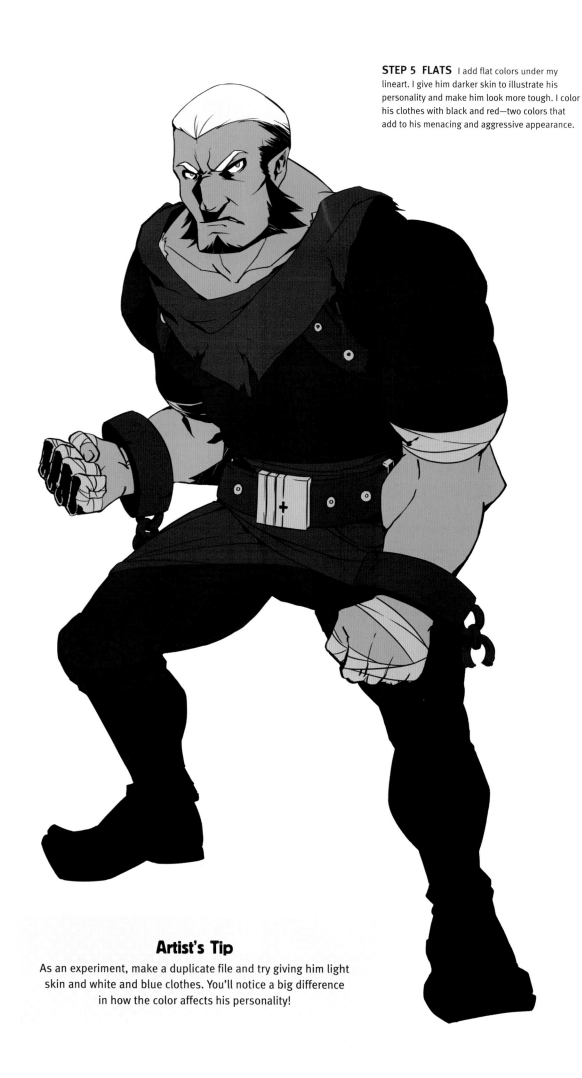

STEP 5 FLATS I add flat colors under my lineart. I give him darker skin to illustrate his personality and make him look more tough. I color his clothes with black and red—two colors that add to his menacing and aggressive appearance.

Artist's Tip

As an experiment, make a duplicate file and try giving him light skin and white and blue clothes. You'll notice a big difference in how the color affects his personality!

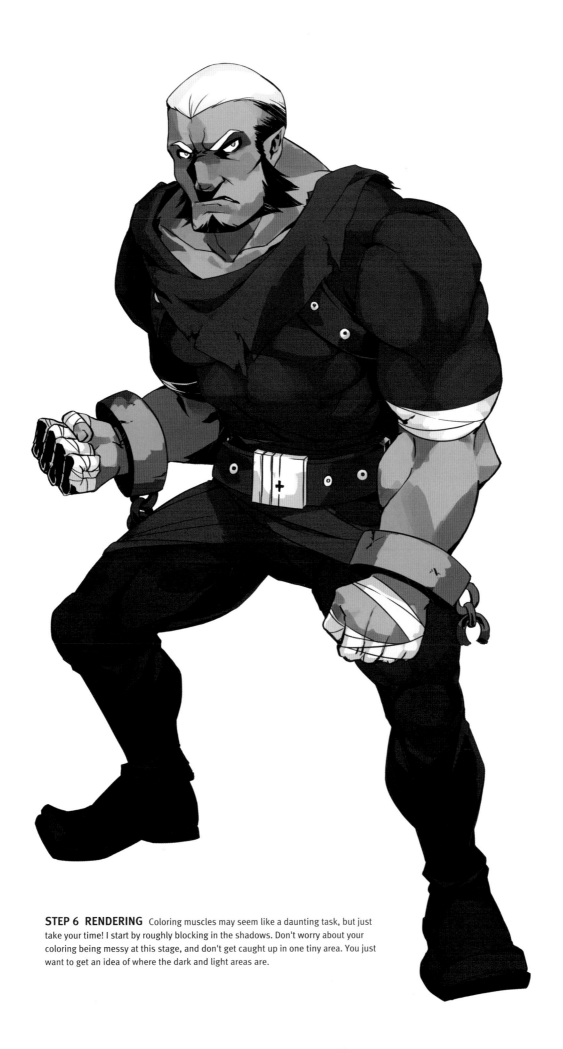

STEP 6 RENDERING Coloring muscles may seem like a daunting task, but just take your time! I start by roughly blocking in the shadows. Don't worry about your coloring being messy at this stage, and don't get caught up in one tiny area. You just want to get an idea of where the dark and light areas are.

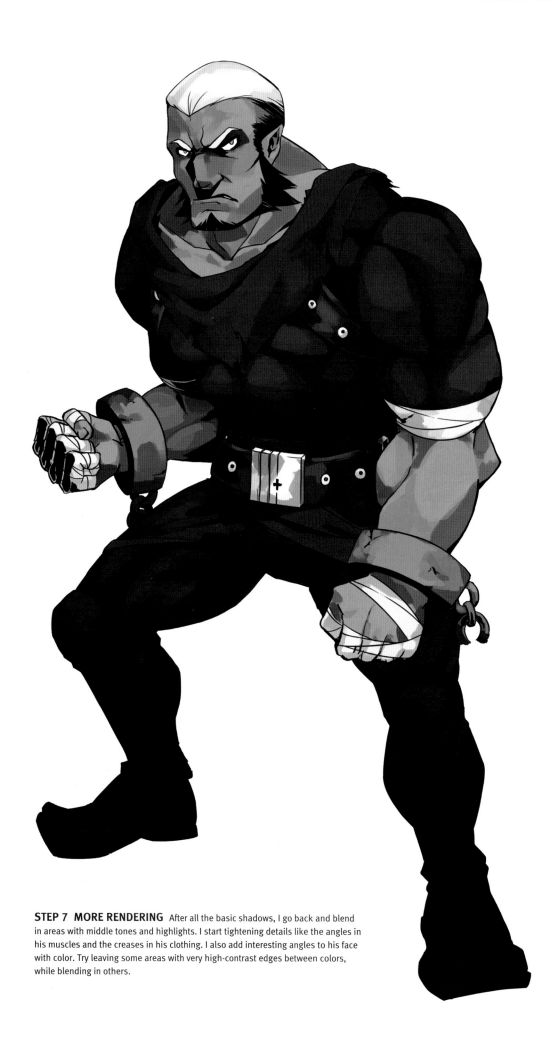

STEP 7 MORE RENDERING After all the basic shadows, I go back and blend in areas with middle tones and highlights. I start tightening details like the angles in his muscles and the creases in his clothing. I also add interesting angles to his face with color. Try leaving some areas with very high-contrast edges between colors, while blending in others.

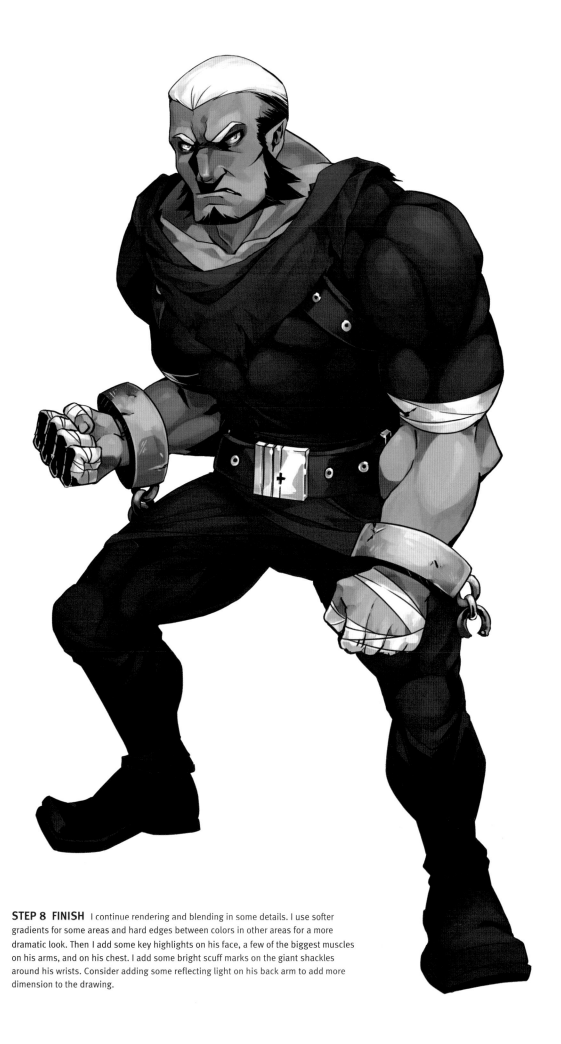

STEP 8 FINISH I continue rendering and blending in some details. I use softer gradients for some areas and hard edges between colors in other areas for a more dramatic look. Then I add some key highlights on his face, a few of the biggest muscles on his arms, and on his chest. I add some bright scuff marks on the giant shackles around his wrists. Consider adding some reflecting light on his back arm to add more dimension to the drawing.

INTERACTING CHARACTERS

Character interaction is important if you plan on making your own manga. For this project I draw a demon brother and his younger sister, who both serve under Zaim. The older brother loves to tease his younger sister and particularly likes to steal any of the delectable human treats she brings back from her excursions to Earth!

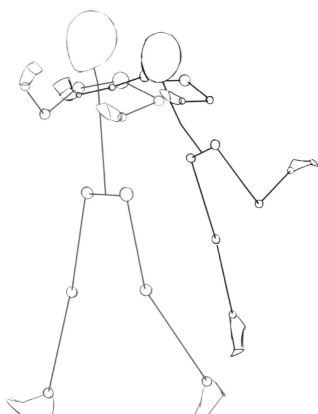

STEP 1 GUIDELINES I refer to my thumbnail sketch as I draw the guidelines for my characters. When I'm drawing digitally, I like to use different colors to differentiate between the two.

STEP 2 BODY SKETCH After drawing the basic shapes, I draw in the contours of both bodies. Step back from your sketch once in a while and observe it from a distance. You may notice mistakes that aren't so obvious when staring at it up close.

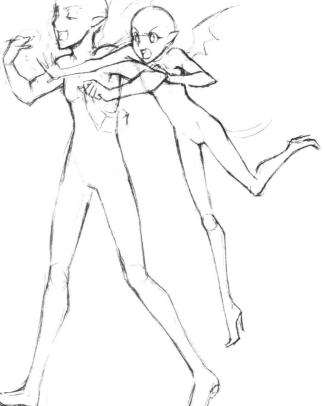

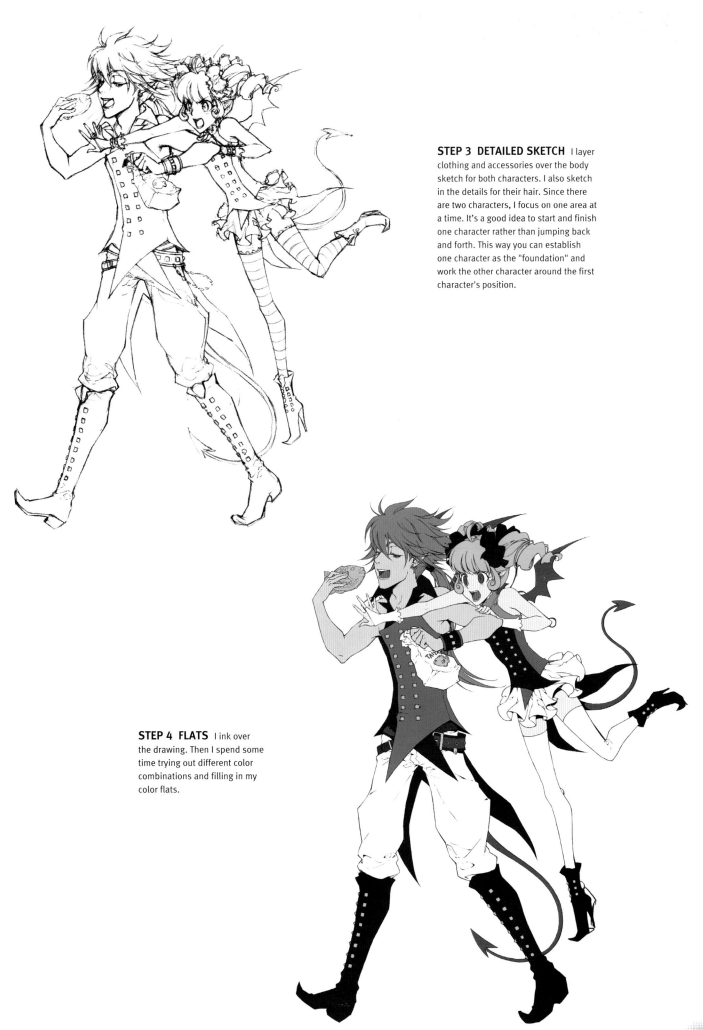

STEP 3 DETAILED SKETCH I layer clothing and accessories over the body sketch for both characters. I also sketch in the details for their hair. Since there are two characters, I focus on one area at a time. It's a good idea to start and finish one character rather than jumping back and forth. This way you can establish one character as the "foundation" and work the other character around the first character's position.

STEP 4 FLATS I ink over the drawing. Then I spend some time trying out different color combinations and filling in my color flats.

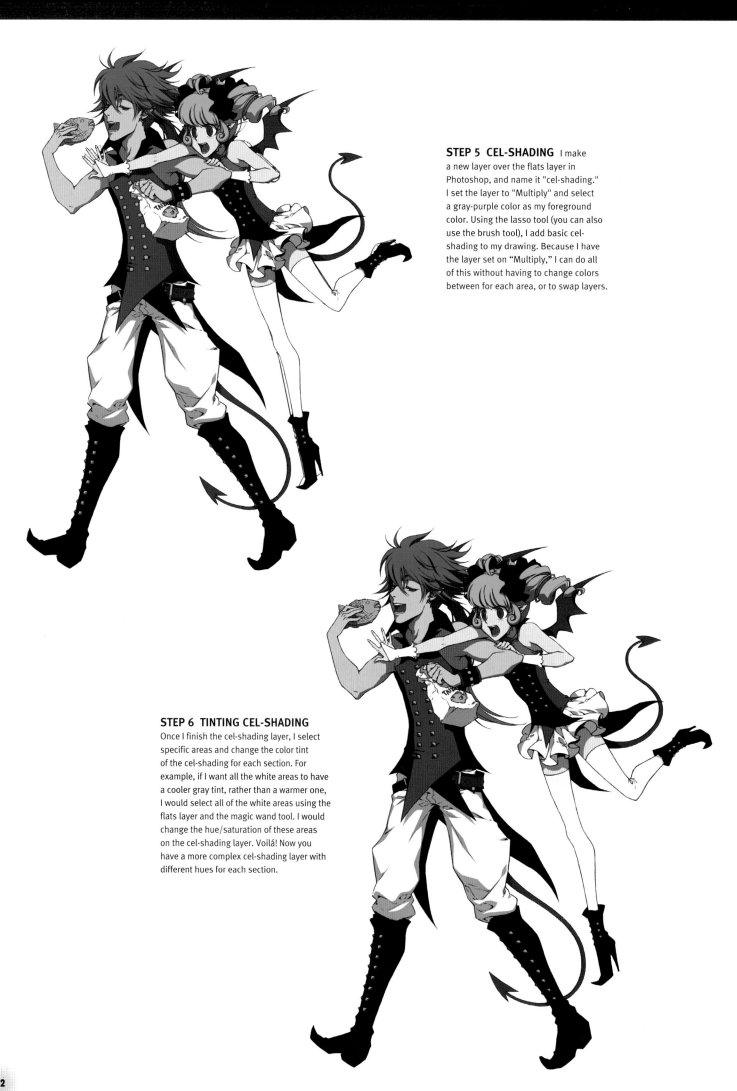

STEP 5 CEL-SHADING I make a new layer over the flats layer in Photoshop, and name it "cel-shading." I set the layer to "Multiply" and select a gray-purple color as my foreground color. Using the lasso tool (you can also use the brush tool), I add basic cel-shading to my drawing. Because I have the layer set on "Multiply," I can do all of this without having to change colors between for each area, or to swap layers.

STEP 6 TINTING CEL-SHADING
Once I finish the cel-shading layer, I select specific areas and change the color tint of the cel-shading for each section. For example, if I want all the white areas to have a cooler gray tint, rather than a warmer one, I would select all of the white areas using the flats layer and the magic wand tool. I would change the hue/saturation of these areas on the cel-shading layer. Voilá! Now you have a more complex cel-shading layer with different hues for each section.

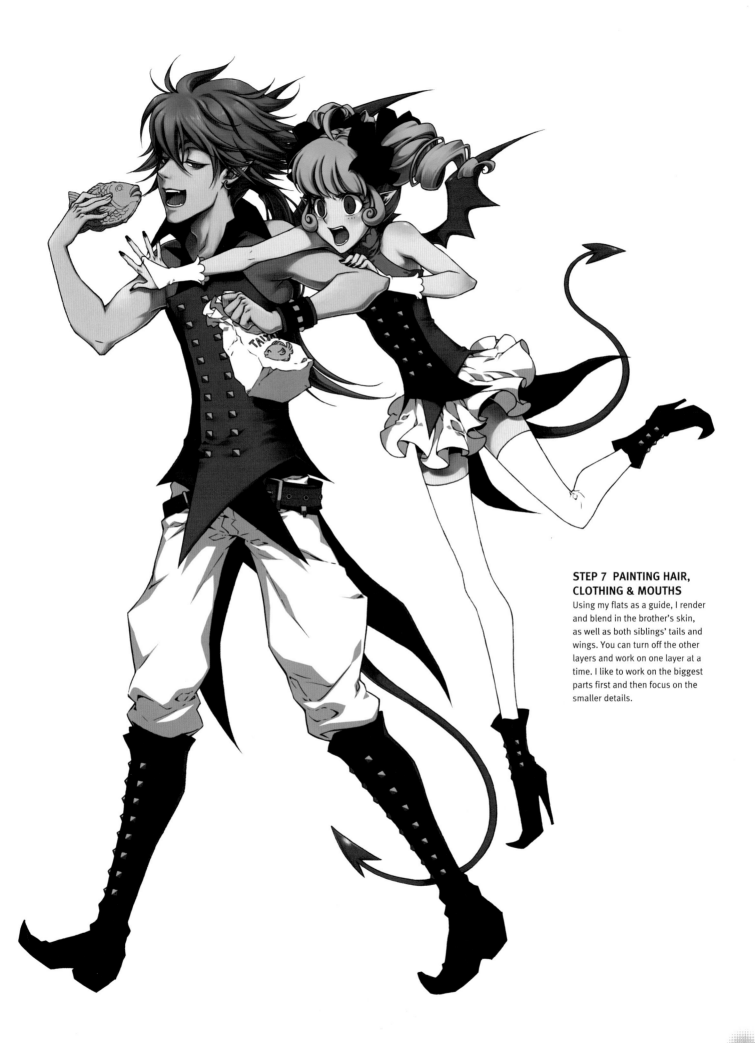

STEP 7 PAINTING HAIR, CLOTHING & MOUTHS

Using my flats as a guide, I render and blend in the brother's skin, as well as both siblings' tails and wings. You can turn off the other layers and work on one layer at a time. I like to work on the biggest parts first and then focus on the smaller details.

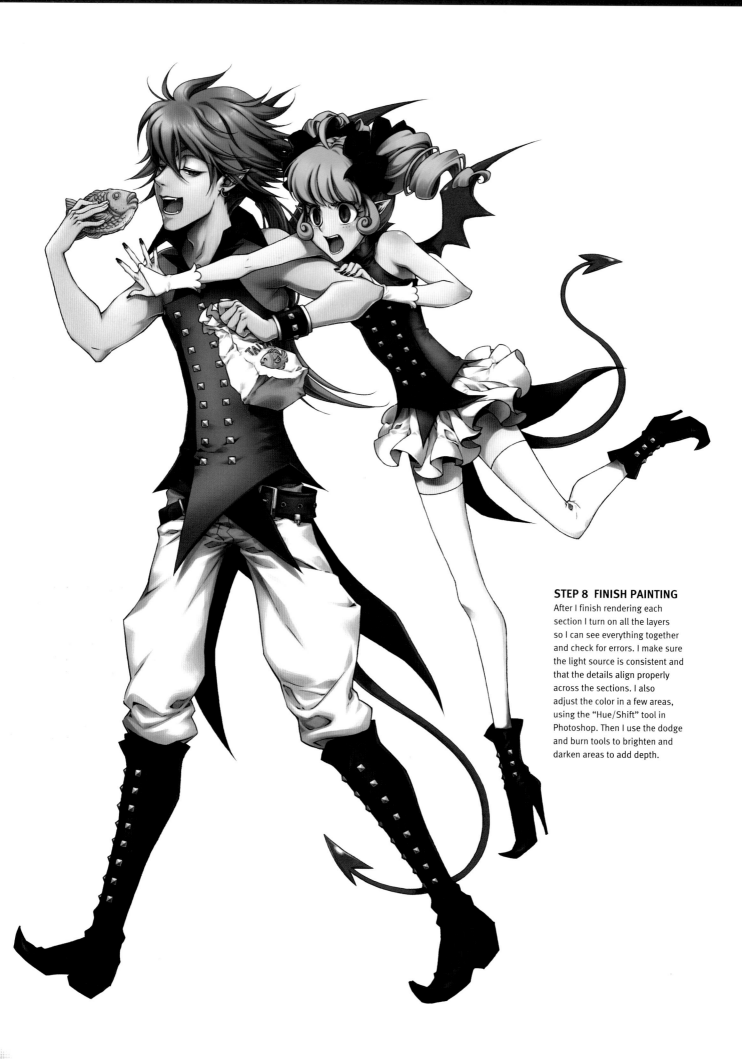

STEP 8 FINISH PAINTING

After I finish rendering each section I turn on all the layers so I can see everything together and check for errors. I make sure the light source is consistent and that the details align properly across the sections. I also adjust the color in a few areas, using the "Hue/Shift" tool in Photoshop. Then I use the dodge and burn tools to brighten and darken areas to add depth.

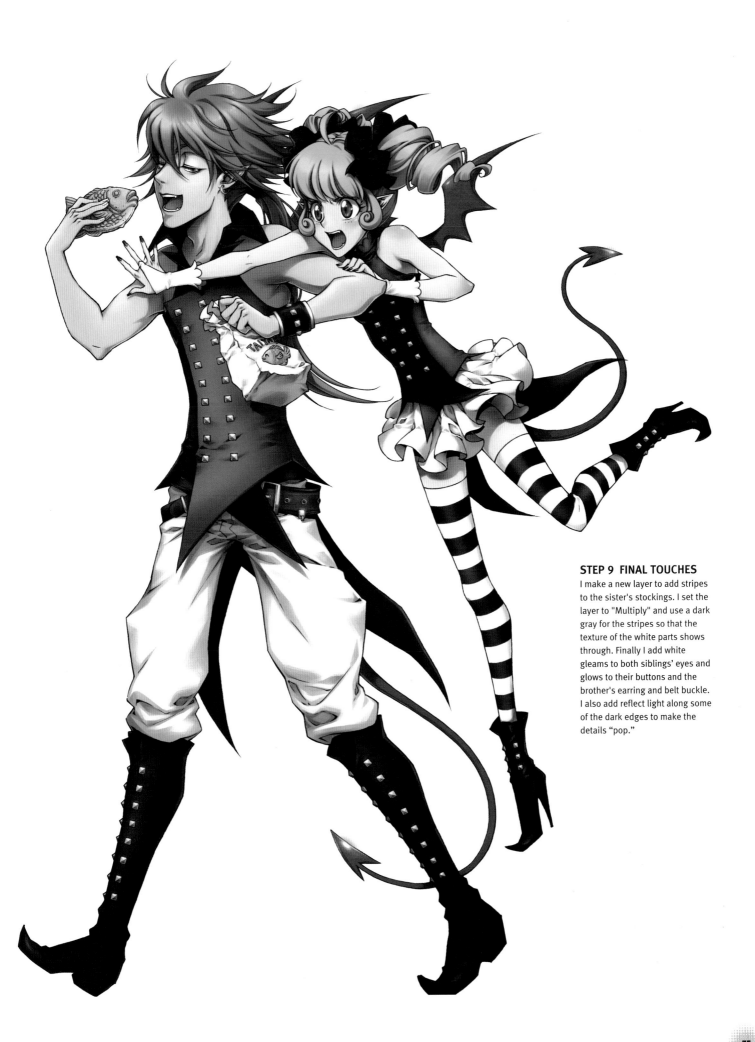

STEP 9 FINAL TOUCHES

I make a new layer to add stripes to the sister's stockings. I set the layer to "Multiply" and use a dark gray for the stripes so that the texture of the white parts shows through. Finally I add white gleams to both siblings' eyes and glows to their buttons and the brother's earring and belt buckle. I also add reflect light along some of the dark edges to make the details "pop."

DRAWING COMIC BOOK CHARACTERS

WITH BOB BERRY

What exactly are comics? The short answer is that comics are a style of storytelling that is both visual and literal. The action unfolds through words and pictures displayed sequentially. Comics can be drawn in any style, from studied realism to edgy stick figures, and they can be about anything! Though most of us envision the iconic superheroes when we think of comics, they have also been used to tell the exploits of real-life heroes and events, as well as many of the great classics of literature.

Comics are a multimillion-dollar industry that has spawned toys, games, T.V. shows, costumes, an entire collectable and convention universe, and—of course—movies. Today, we marvel at the spectacular exploits of superheroes as they flash across movie screens, fully realized in the glory of CGI imagery and THX sound. Comics are no longer humble tomes printed on cheap newsprint. They have elevated themselves to the lofty heights of the blockbuster movie and the graphic novel.

In a pre-digital, pre-blockbuster world, comics were created by dreamers using the most humble of technologies: pen, paper, sweat, and imagination. Strip away the digital prepress, digital-imaging software, and word processing used in the production of current comics, and you'll find that comics are still produced much the same way they were nearly a century ago. In this section, we'll look at an overview of that process and the art of drawing comics.

To start, you're going to need some very specialized tools—a pencil and some paper! With these tools you will sketch and render superheroes whose powers range from the stealthy to the mutated and hyper-human. You'll also create formidable foes for your superheroes.

On the following pages you'll learn how to build your characters using proportion and dynamic action. When your sketch has reached a state of perfection, you'll learn to ink your art using a pen, brush, or markers. Finally, you'll work on your own mini comic story using the characters you've drawn.

Now gather up your imagination, take a good stretch, roll up your sleeves, and prepare to draw comics!

BUILDING COMIC CHARACTERS

Building characters is one of the most interesting aspects of creating comics. Your characters can be any size or shape. They can have super-powers or be completely un-super.

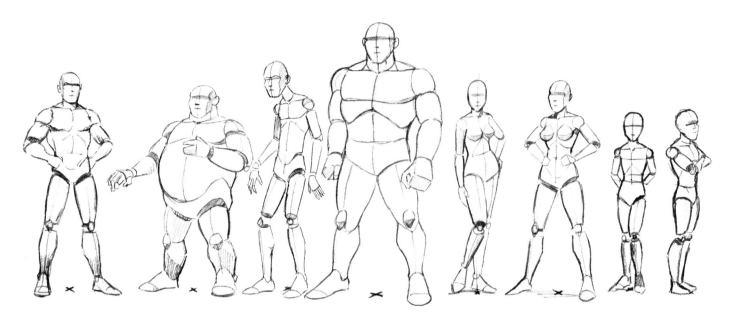

Several stereotypes recur throughout the history of comics: typical heros, rotund bad guys, spindly toadies, big lummox, femme fatales, heroic women, and juvenile sidekicks. These stereotypes can be interchangeable. The big guy in the center could easily be cast as a heroic giant or a monstrous hulk—we often see super-villains that are as heroic in stature as their good-guy counterparts. The combinations are endless—have fun mixing characters and attributes up in new and interesting ways!

PROPORTIONS

Establishing your character's proportions is important. Artists often use a character's head as a unit of measurement to establish the general body type. Most humanoid characters have roughly the same head size. For example, a typical hero measures 7 to 8 heads high; his teenage sidekick might be 5 ½ heads high, while a child, or super-powered alien with childlike proportions, might be about 3 ½ heads high.

At right is a typical superhero couple. You can see that the man is about 7 ½ heads high, and the woman is about 7 heads high.

Note the two red triangles superimposed on the couple. This is a simple reminder you can use when drawing your male and female characters. Males are predominately wider at the shoulders, with the waist and lower body tapering to the legs. Females have the greatest width in the hips, and the shoulders are in line with the hips or are slightly narrower. Feminine muscles should also be drawn less bulky and defined. When drawing female superheroes or super-villains, use less crosshatching for a more feminine look.

These guidelines aren't rigid rules but a rough framework to help you create characters and keep them consistent from drawing to drawing. Much depends on your personal preference and what looks best for your style and character.

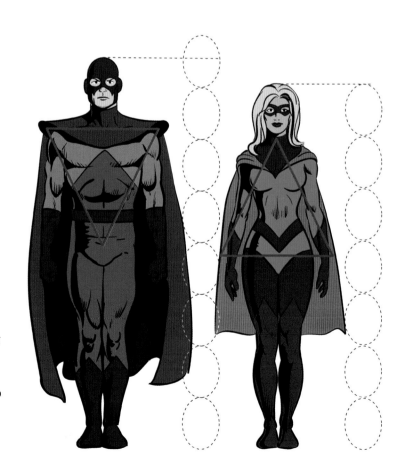

PLAYING WITH PROPORTIONS

Below are three figures with the same head size, but with bodies of different proportions. The figure on the left has heroic proportions of 7 ½ heads high. He could pass for an average human and a super. The guy in the middle has typical child proportions—about 4 heads high. The last figure is 8 ½ heads high. He could easily be seen as gigantic in proportion (when compared to figure 1). By himself he would make a very strong heroic figure. You can see that the guidelines aren't rigid rules but a rough framework to help you create characters and keep them consistent from drawing to drawing.

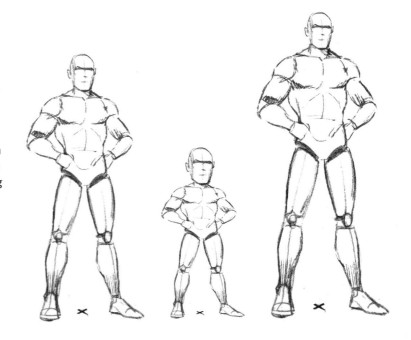

DRAWING THE FIGURE IN SPACE

Drawing your heroes and villains in static poses probably isn't something you'll be doing in your comic—especially if you write comics with a lot of action! It's important to practice drawing your characters from different angles and perspectives. The easiest way to visualize the figure in space is to use simple cylinders to draw the various parts of the body. The sketches below are just a few examples of possible angles and perspectives and illustrate how these simple forms can be used to build up complex and interesting poses.

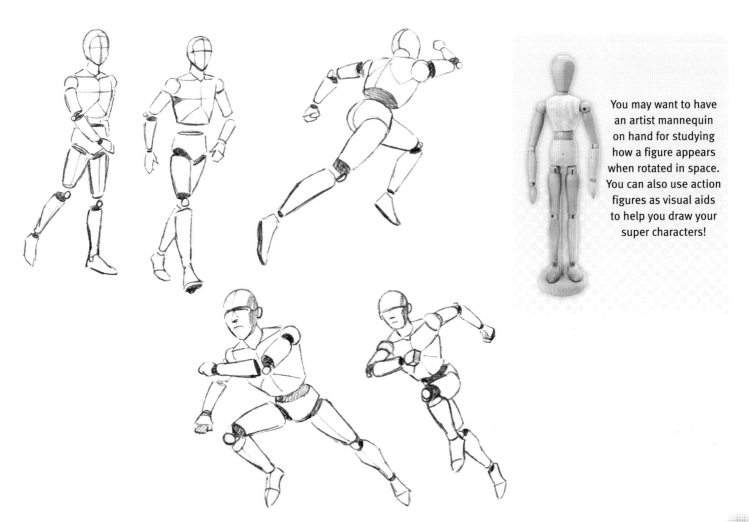

You may want to have an artist mannequin on hand for studying how a figure appears when rotated in space. You can also use action figures as visual aids to help you draw your super characters!

CHARACTER STYLING

Over the past couple decades, more and more superheroes have been featured on television as animated cartoons. Animation requires simplified character design in order to draw thousands of images per episode. Eventually this cartoon styling started to creep back into the printed versions of superheroes. Today it is common to see comics of your favorite character rendered in animation style. This style gives the comic book artist even more flexibility and expression when drawing stories.

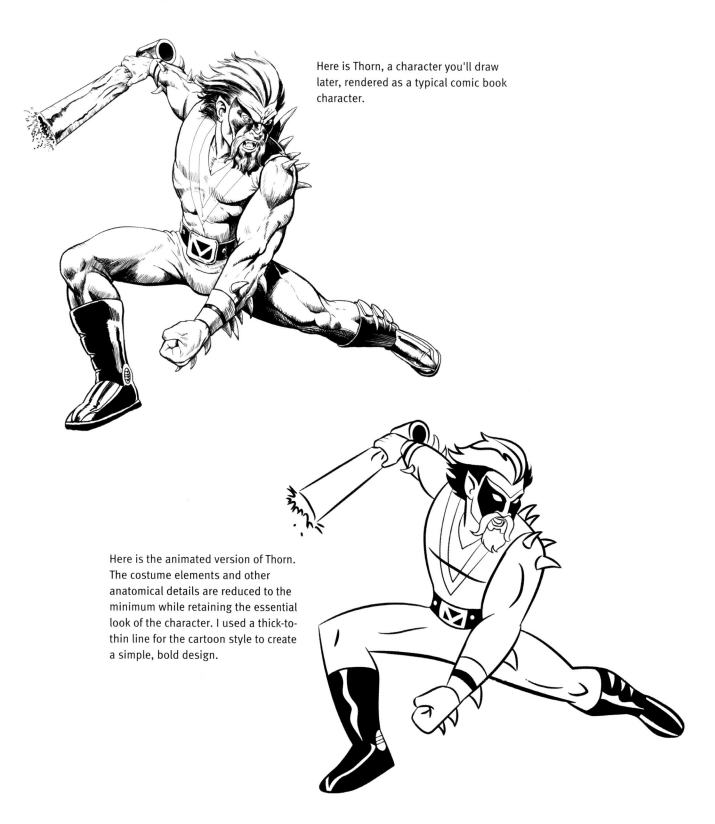

Here is Thorn, a character you'll draw later, rendered as a typical comic book character.

Here is the animated version of Thorn. The costume elements and other anatomical details are reduced to the minimum while retaining the essential look of the character. I used a thick-to-thin line for the cartoon style to create a simple, bold design.

This version of Thorn reflects the latest trends in cartooning superheroes. The design is even more exaggerated and fluid. The weight of the line work is reduced to a minimum width and has little or no variation.

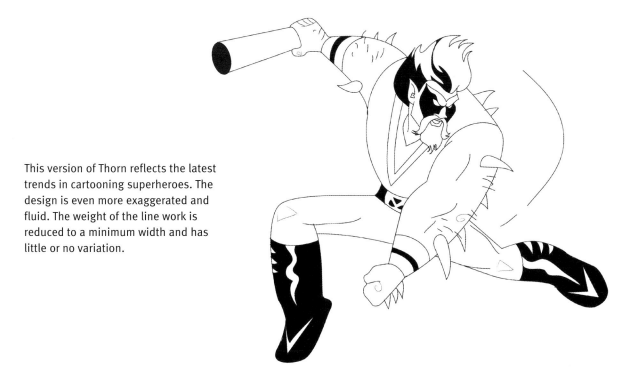

Here are the cartoon versions of Thorn in color. Compare these to the final step for Thorn on page 119. See the difference?

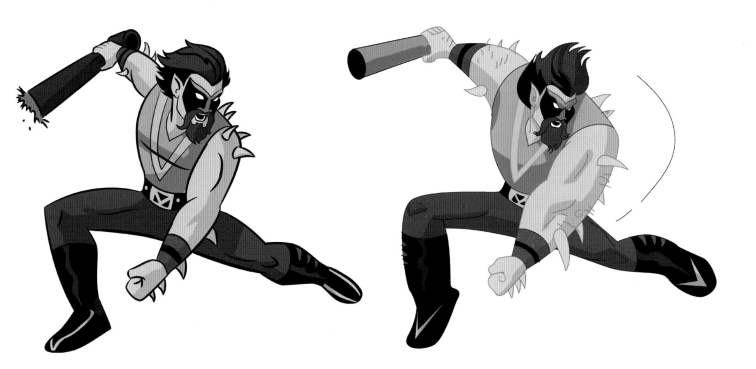

In comics there is no limit to your imagination. You can design and draw your characters in a number of ways, and your characters can possess powers that are figments of your unique imagination. The main thing is to entertain your reader and yourself...and have fun creating your own comics!

BIONIC HERO

Biomechanical armor is the latest in nerd sportswear! You don't need any superpowers, except the ability to write a huge check to pay for the technology—unless of course you are the genius who actually creates this amazing super-suit. Impervious to most weapons, this suit can fly at supersonic speeds, has a multitude of state-of-the-art weapons, and gets over 500 cable channels and internet too! So, suit up gang, let's draw this bad boy!

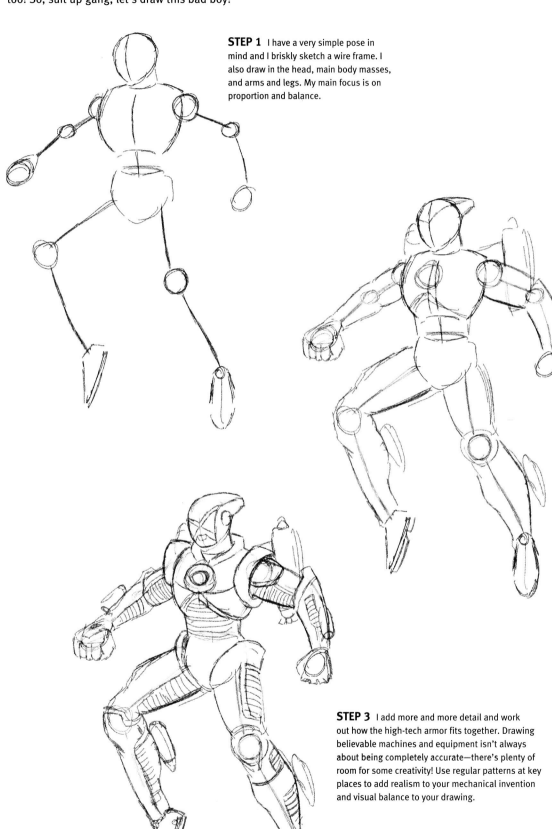

STEP 1 I have a very simple pose in mind and I briskly sketch a wire frame. I also draw in the head, main body masses, and arms and legs. My main focus is on proportion and balance.

STEP 2 I'm happy with the position and fairly confident of how I want to build this character, so I immediately start adding details to the super-suit. I also start to fill out the body. I want my bionic hero to have armor that is over-designed to withstand anything, so draw bulky shoulder joints and heavy gauntlets and leg armor. My bionic hero has an aerodynamic helmet and twin mini-jet turbines built right onto his back.

STEP 3 I add more and more detail and work out how the high-tech armor fits together. Drawing believable machines and equipment isn't always about being completely accurate—there's plenty of room for some creativity! Use regular patterns at key places to add realism to your mechanical invention and visual balance to your drawing.

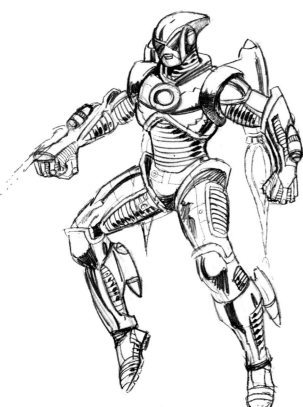

STEP 4 I'm happy with the basic details, so I decide to fully render the drawing at the pencil stage. This allows me to preview how my shading will look, and I also get an idea of what areas will be tricky when it comes to inking. Even before inking, I see that the abdomen is a little simplistic, and I will want to create some more believable detail in this area. I'm also going to need to work out exactly how the particle weapons on his gauntlets mount to his forearms.

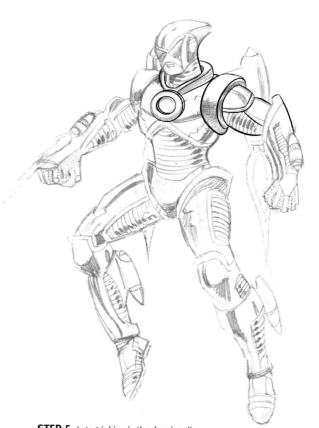

STEP 5 I start inking in the drawing. I've lightened my sketch so you can easily follow along. I use a lot of brushwork on this figure, even though he is very mechanical, because I want the lines to have the stereotypical thick/thin body rendering technique. This style of inking gives the impression of mass, contour, and volume.

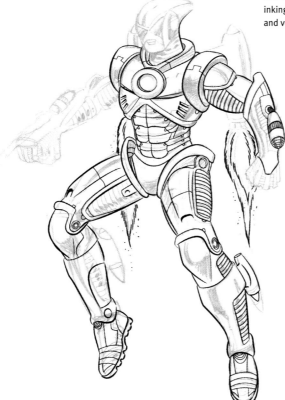

STEP 6 I like to work around my drawing to keep the process fresh and fun. I tackle the design issues with the abdomen armor, adding a lot more detail and using actual human musculature as my inspiration. I add details to the leg and chest armor that I didn't include in my original pencil drawing.

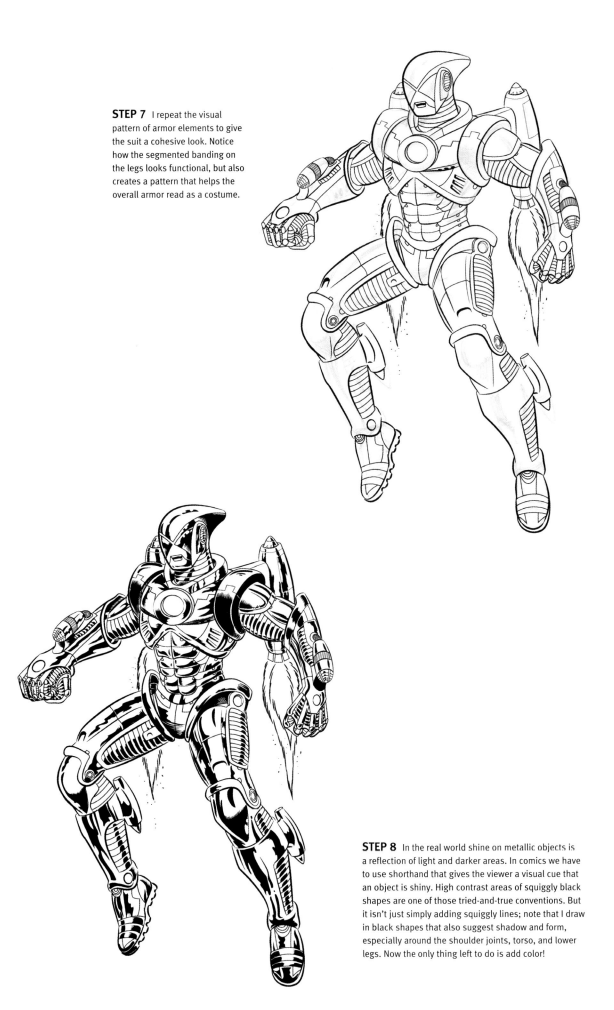

STEP 7 I repeat the visual pattern of armor elements to give the suit a cohesive look. Notice how the segmented banding on the legs looks functional, but also creates a pattern that helps the overall armor read as a costume.

STEP 8 In the real world shine on metallic objects is a reflection of light and darker areas. In comics we have to use shorthand that gives the viewer a visual cue that an object is shiny. High contrast areas of squiggly black shapes are one of those tried-and-true conventions. But it isn't just simply adding squiggly lines; note that I draw in black shapes that also suggest shadow and form, especially around the shoulder joints, torso, and lower legs. Now the only thing left to do is add color!

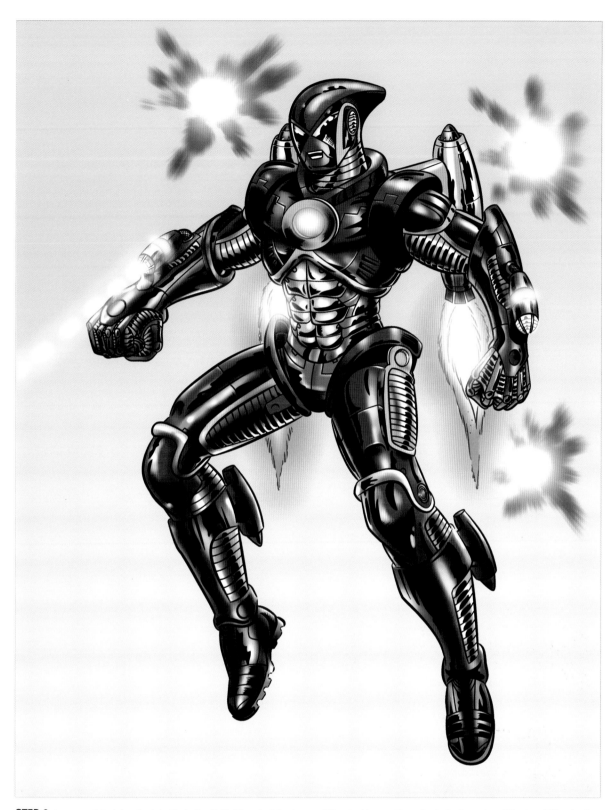

STEP 9 I scan my inked drawing into Photoshop®. First I apply flat colors, and then I add more dimension to the forms by adding in additional color-modulated shading. I also further enhance the metallic look by adding shine with the dodge and burn tools. I create a new layer for the blue sky and add in explosive mid-air bursts from some unseen enemy. Our bionic hero hovers in mid-air while his twin jet engines blaze away. His arm-mounted particle weapons return fire in a glow of electric blue haze.

Artist's Tip

Take into account various light sources when you're coloring. In particular, notice the hot orange–yellow glow from the flames reflecting on the surface of the hero's armor. This kind of rendering not only adds additional drama to your art, but also dimension and believability...and it just plain looks cool!

THE RED WRAITH

Before the Dark Knight decided to rise, there was an entire group of masked and caped mystery men. They were probably some of the first popular antiheros, some with mysterious powers to cloud men's minds, some just really good with a gun, sword, or gallivanting on rooftops. They usually went by equally dark and ominous monikers like Zorro, The Shadow, The Spirit, etc. In homage to these dark knights of yesterday, here is the Red Wraith—defender of the weak, avenger of the hapless.

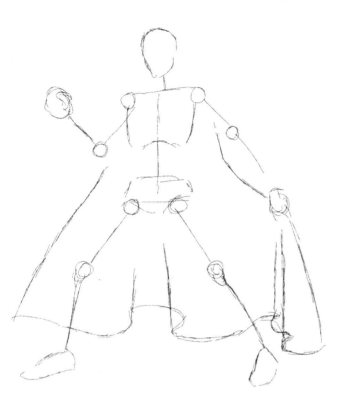

STEP 1 I start with a simple gestural sketch in a very heroic, but static, pose. When you pose your characters standing, be especially careful that the proportions are correct and balanced. I develop the figure detail and rough in the cape and the grappling hook pistol he's holding.

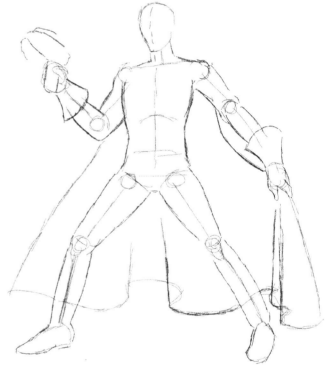

STEP 2 I fill out the body a bit more, erasing earlier sketch lines as I proceed. I start to refine his hands. This is important because his hands are doing a lot—holding his cape in a dramatic flourish and, of course, brandishing the grappler gun. I also decide how the cape will fall.

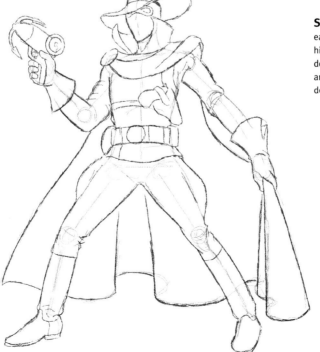

STEP 3 Time to add his costume elements: a huge fedora and an identity-hiding mask. Of course he will sport a high, vampire–like collar and gauntlets. The rest of his costume consists of riding boots and jodhpur pants. In addition, I give him a utility belt and a shoulder holster with a conventional pistol.

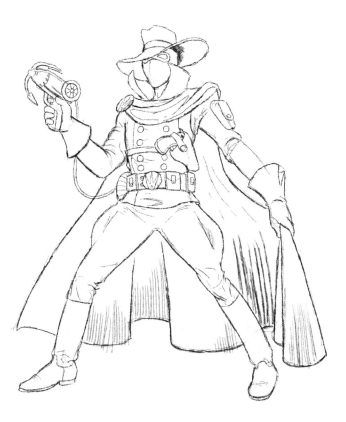

STEP 4 I start to render his cape and add some folds and wrinkles to his clothing. I also add some buttons on his tunic and fine-tune the details of his utility belt.

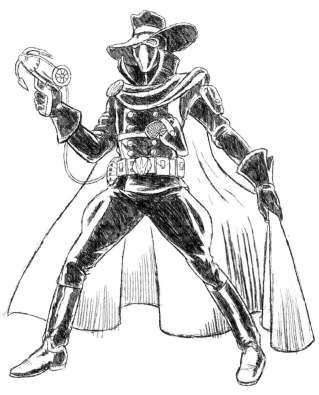

STEP 5 I like to fill in the areas that will receive full black fills. Even though this work will be covered with ink, it helps me to visualize and make sure I'm happy with the drawing.

STEP 6 I digitally lighten my sketch for demonstration purposes and start to draw the final ink lines with a very fluid brush line. When you draw clothing that isn't standard superhero spandex, have fun with the folds and be aware of how the position of the figure deforms the outer clothing.

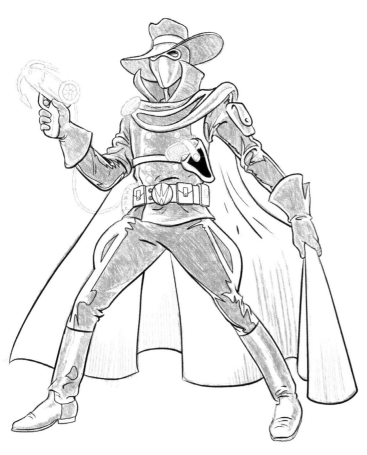

STEP 7 I like to outline the shapes of the darkest shadow, especially when there is a lot of black. You can also ink dark shadows a little more spontaneously with a larger brush.

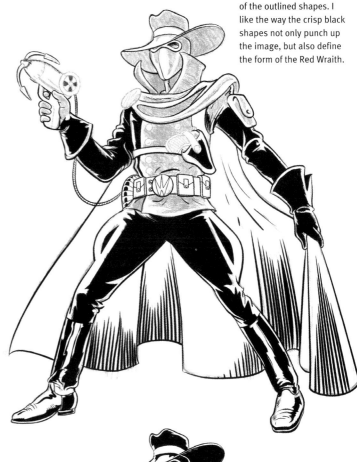

STEP 8 I fill in the rest of the outlined shapes. I like the way the crisp black shapes not only punch up the image, but also define the form of the Red Wraith.

Achieving the long, feathering lines on the cape can be tricky for a novice. Here are a few pointers:

• This kind of feathering works best with a brush, and the stroke should be done quickly.

• Experiment first on a separate piece of drawing paper.

• Try to identify which muscles you use to make the stroke. When you're confident, try it on your final inking.

• Turn your drawing in a way that works best for an easy stroke. Your inking will be better when you move the drawing to get the best position for making a stroke.

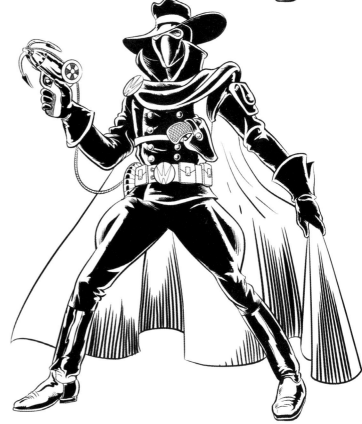

STEP 9 I finish inking the top half of the Red Wraith. Now on to the color!

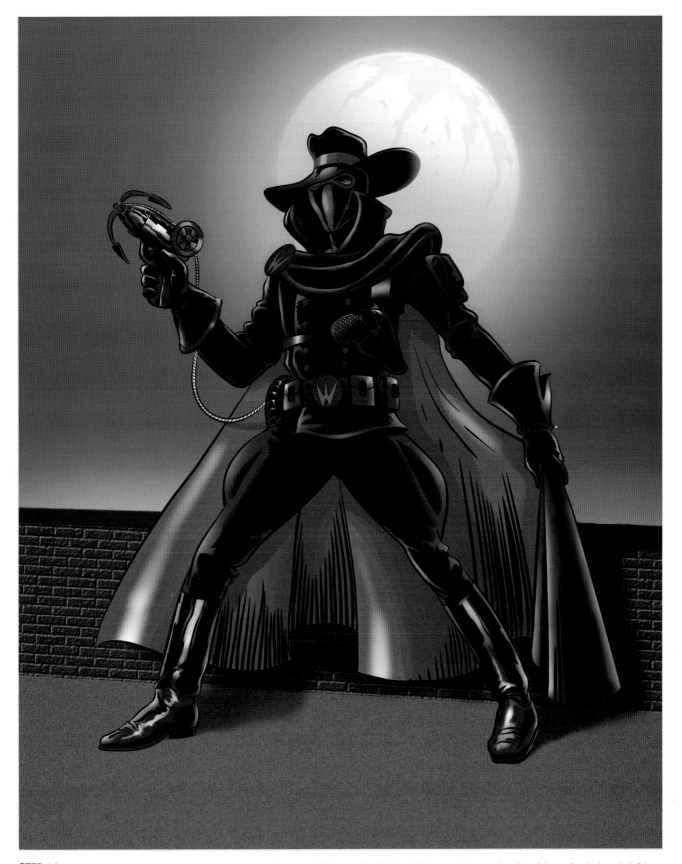

STEP 10 I decide to place the Red Wraith on a nondescript rooftop at night (of course), with the city lights peeping over the edge of the roof and a huge baleful moon partially silhouetting him.

Artist's Tip

The beauty of digital paint programs is that you can add much more depth and polish to even your most polished ink drawings. If you can purchase and learn a program like Photoshop, I promise you'll be glad you did. It will take your art to a whole new level.

EVIL GENIUS

This guy was probably the nerdy, brainiac kid that was picked on in junior high. Thanks to an experiment gone wrong and an artificially enhanced brain, this evil genius is back to make the bullies—and the world—pay. He sports a newly designed, thought-controlled exoskeleton and a handheld particle cannon that could give any superhero a super-sized wedgie!

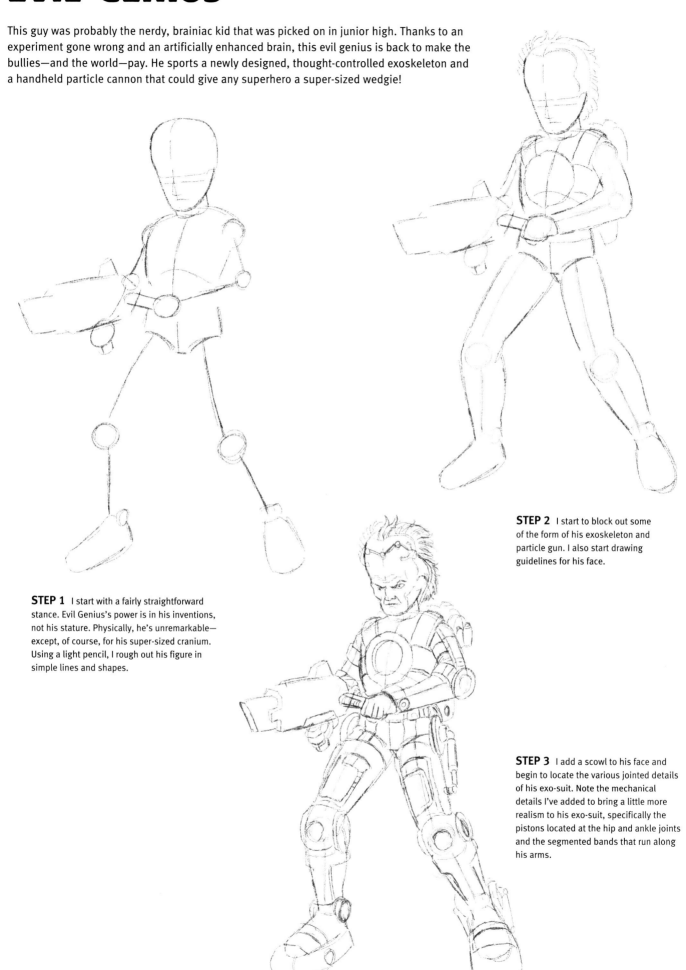

STEP 2 I start to block out some of the form of his exoskeleton and particle gun. I also start drawing guidelines for his face.

STEP 1 I start with a fairly straightforward stance. Evil Genius's power is in his inventions, not his stature. Physically, he's unremarkable—except, of course, for his super-sized cranium. Using a light pencil, I rough out his figure in simple lines and shapes.

STEP 3 I add a scowl to his face and begin to locate the various jointed details of his exo-suit. Note the mechanical details I've added to bring a little more realism to his exo-suit, specifically the pistons located at the hip and ankle joints and the segmented bands that run along his arms.

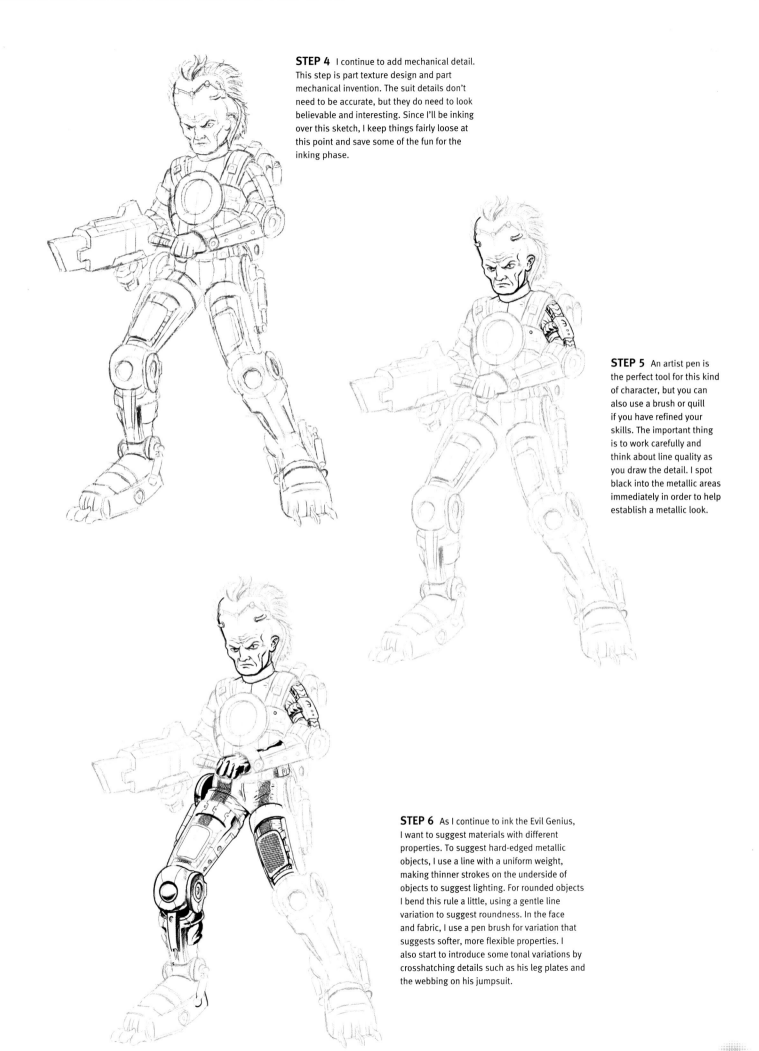

STEP 4 I continue to add mechanical detail. This step is part texture design and part mechanical invention. The suit details don't need to be accurate, but they do need to look believable and interesting. Since I'll be inking over this sketch, I keep things fairly loose at this point and save some of the fun for the inking phase.

STEP 5 An artist pen is the perfect tool for this kind of character, but you can also use a brush or quill if you have refined your skills. The important thing is to work carefully and think about line quality as you draw the detail. I spot black into the metallic areas immediately in order to help establish a metallic look.

STEP 6 As I continue to ink the Evil Genius, I want to suggest materials with different properties. To suggest hard-edged metallic objects, I use a line with a uniform weight, making thinner strokes on the underside of objects to suggest lighting. For rounded objects I bend this rule a little, using a gentle line variation to suggest roundness. In the face and fabric, I use a pen brush for variation that suggests softer, more flexible properties. I also start to introduce some tonal variations by crosshatching details such as his leg plates and the webbing on his jumpsuit.

STEP 7 I continue inking the legs, arm, and face, and I start on the chest. Instead of going through the entire figure, drafting the outlines and then adding shading and spotting blacks, I prefer to work on completing a section at a time. Using a variety of strokes and drawing tools helps to keep the drawing experience interesting!

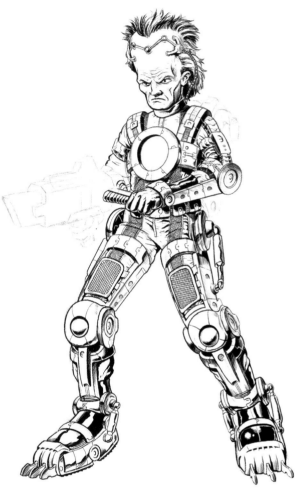

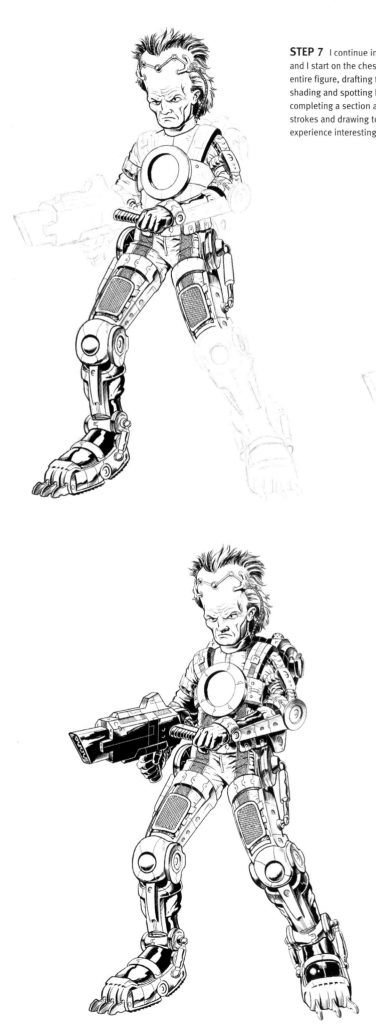

STEP 8 I finish inking the body, paying attention to light direction and shadows to keep things consistent. I decide to add a bit more hatching to his forward arm in order to keep consistent shading throughout the drawing.

STEP 9 I complete the inking, using a very high-contrast inking scheme for the particle cannon and Evil's backpack. Note that in areas of black, I also treat some of the seams on the cannon, using white lines. This allows the details to follow through the varying shaded areas and still look like a solid, machine object. You can create these white lines either by inking around a black line and keeping one side white, or—if you have a steady hand— loading a brush, quill pen, or mechanical drafting pen with diluted white paint.

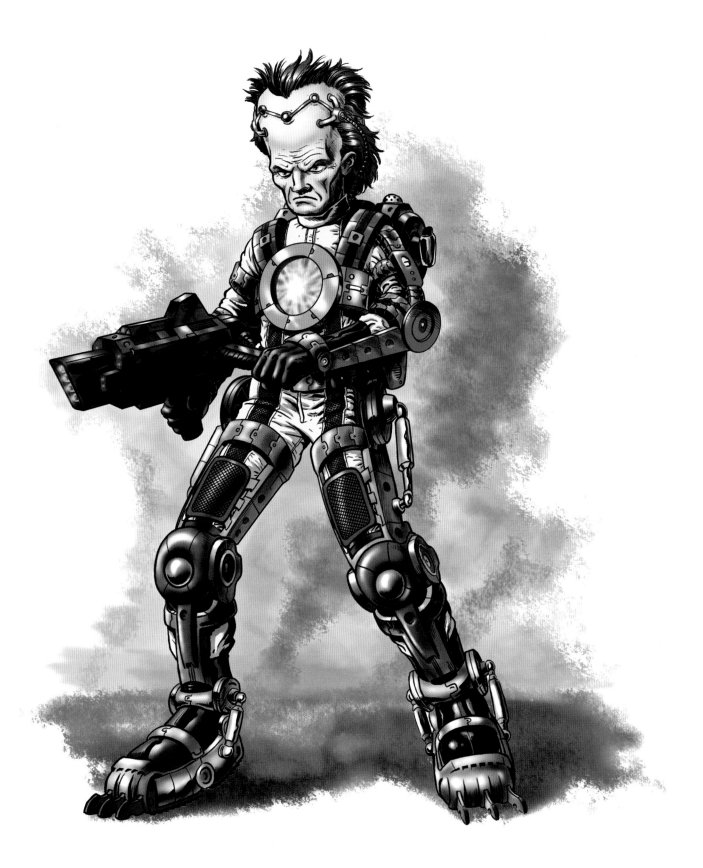

STEP 10 I scan my drawing and use Photoshop to color the evil genius. For shading on metallic areas, such as his exo-suit, I use a combination of the dodge and burn tools, which I find achieves a very realistic metal effect. For other shading I use variations of the base color for highlights and shadows.

FEMALE ASSASSIN

Yes, ladies, black is always fashionable. Whether you're going out to some swanky restaurant or kicking some bad-guy booty, it's a classic. This Ninja Girl has all the accessories, from a samurai sword to a laser-guided stun gun—not to mention a purse full of throwing stars.

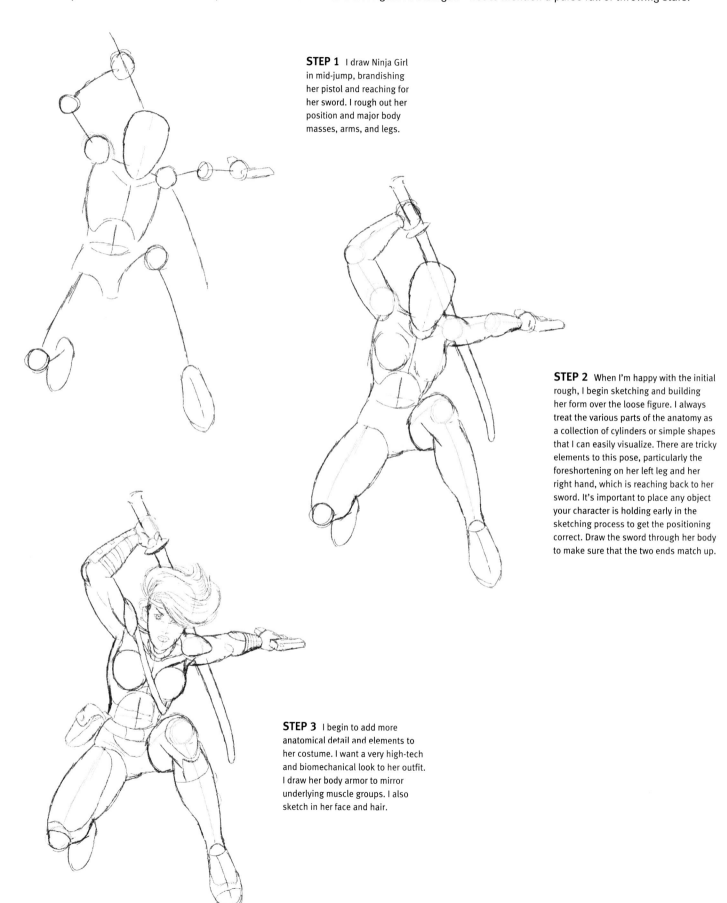

STEP 1 I draw Ninja Girl in mid-jump, brandishing her pistol and reaching for her sword. I rough out her position and major body masses, arms, and legs.

STEP 2 When I'm happy with the initial rough, I begin sketching and building her form over the loose figure. I always treat the various parts of the anatomy as a collection of cylinders or simple shapes that I can easily visualize. There are tricky elements to this pose, particularly the foreshortening on her left leg and her right hand, which is reaching back to her sword. It's important to place any object your character is holding early in the sketching process to get the positioning correct. Draw the sword through her body to make sure that the two ends match up.

STEP 3 I begin to add more anatomical detail and elements to her costume. I want a very high-tech and biomechanical look to her outfit. I draw her body armor to mirror underlying muscle groups. I also sketch in her face and hair.

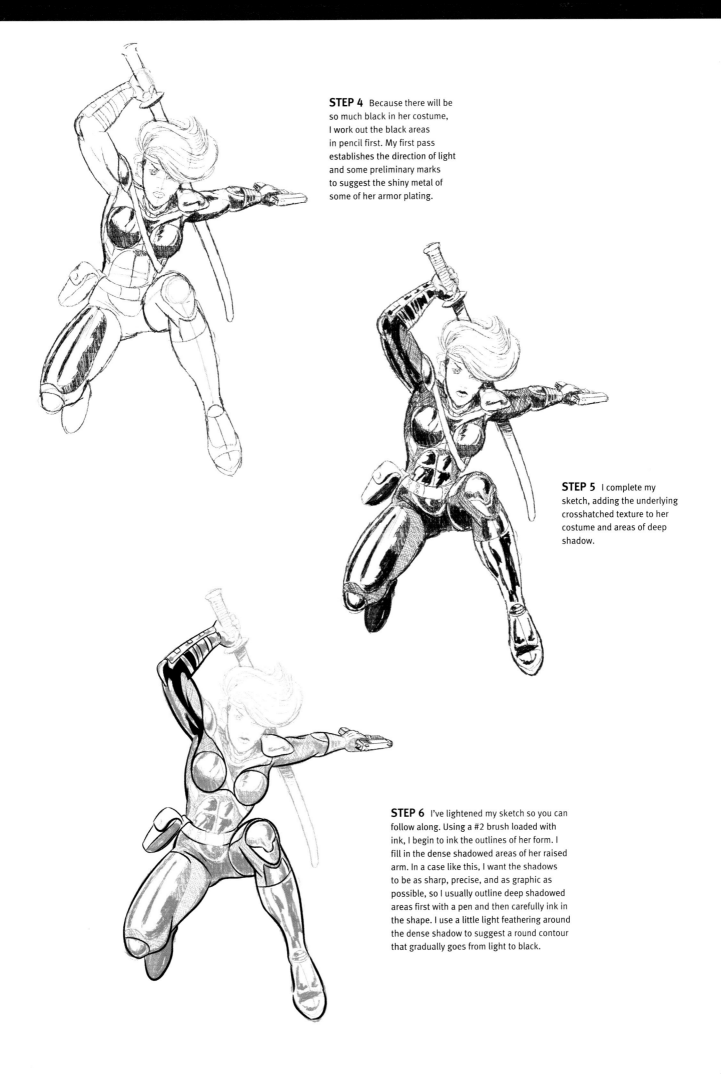

STEP 4 Because there will be so much black in her costume, I work out the black areas in pencil first. My first pass establishes the direction of light and some preliminary marks to suggest the shiny metal of some of her armor plating.

STEP 5 I complete my sketch, adding the underlying crosshatched texture to her costume and areas of deep shadow.

STEP 6 I've lightened my sketch so you can follow along. Using a #2 brush loaded with ink, I begin to ink the outlines of her form. I fill in the dense shadowed areas of her raised arm. In a case like this, I want the shadows to be as sharp, precise, and as graphic as possible, so I usually outline deep shadowed areas first with a pen and then carefully ink in the shape. I use a little light feathering around the dense shadow to suggest a round contour that gradually goes from light to black.

Artist's Tip

It's extremely important to take good care of your brushes if you use this method of inking. Never let ink or paint dry in the bristles; wash your brushes thoroughly after each use. You can extend the life of a well-made brush for years with proper care.

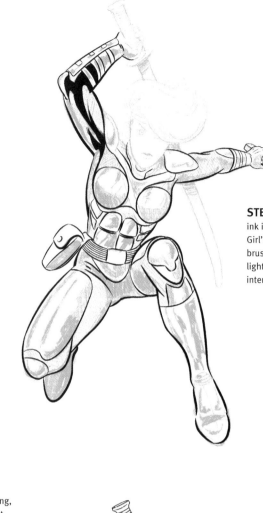

STEP 7 I continue to ink in the details of Ninja Girl's costume with my brush, using a slightly lighter touch for the interior details.

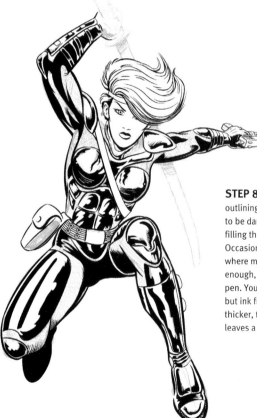

STEP 8 I continue inking, outlining the areas I want to be darkest and carefully filling them in with my brush. Occasionally there are areas where my brush isn't fine enough, so I switch to my art pen. You can also use a quill, but ink from a quill tends to be thicker, takes longer to dry, and leaves a slightly raised surface.

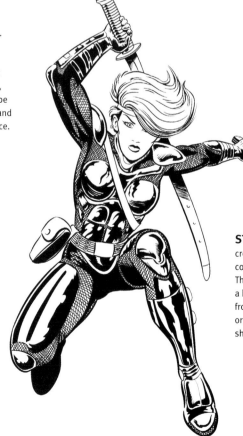

STEP 9 I draw in the crosshatched pattern of her costume with a fine art pen. Then I ink in her face with a brush but restrain myself from adding a lot of shading or hatch work because I'll add shadow at the color stage.

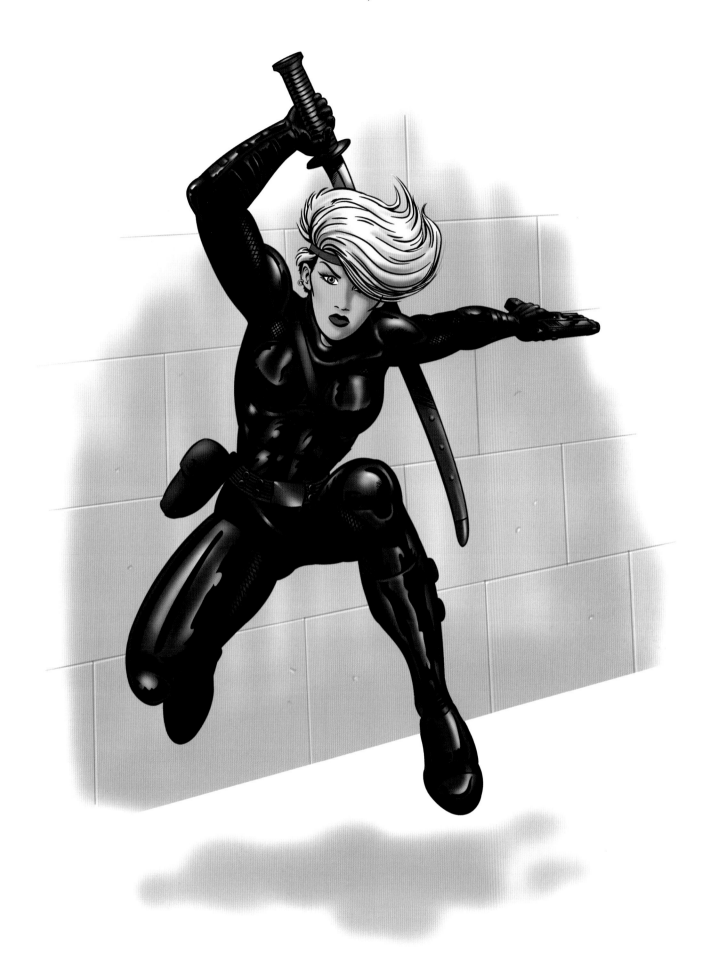

STEP 10 I scan my image into Photoshop and color it, but markers would work just as well. I take some time tweaking the various colors of her costume. While I want the overall impression of her costume to be black, the actual colors I mix are a very dark purple-gray, a dark gray-brown, and 85% black. With her fair complexion, shock of blonde hair, and shiny metal body armor, she's hardly stealthy, but at least she's making a fashion statement! I add a wall behind her to provide a backdrop.

UNCLE HAPPY THE KRIMINAL KLOWN

Uncle Happy used to have a popular kids show, until the fateful day when he was accidentally doused in chemically unstable banana cream pie filling. Uncle Happy soon realized that he wasn't as popular as he thought! Soon he was throwing his own brand of cream-filled mayhem as he began to do evil deeds all over Centropolis.

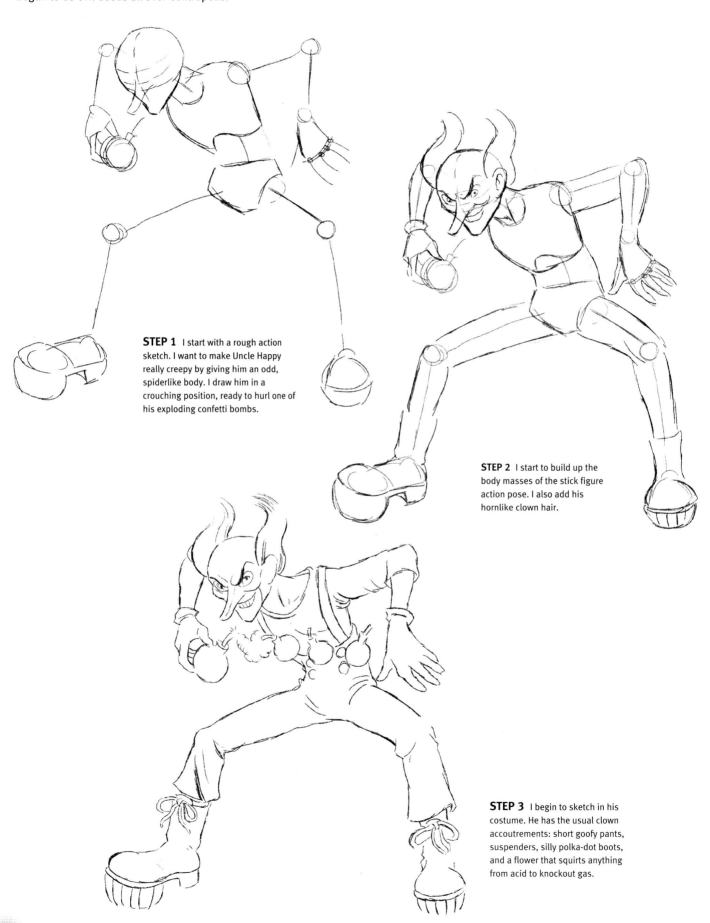

STEP 1 I start with a rough action sketch. I want to make Uncle Happy really creepy by giving him an odd, spiderlike body. I draw him in a crouching position, ready to hurl one of his exploding confetti bombs.

STEP 2 I start to build up the body masses of the stick figure action pose. I also add his hornlike clown hair.

STEP 3 I begin to sketch in his costume. He has the usual clown accoutrements: short goofy pants, suspenders, silly polka-dot boots, and a flower that squirts anything from acid to knockout gas.

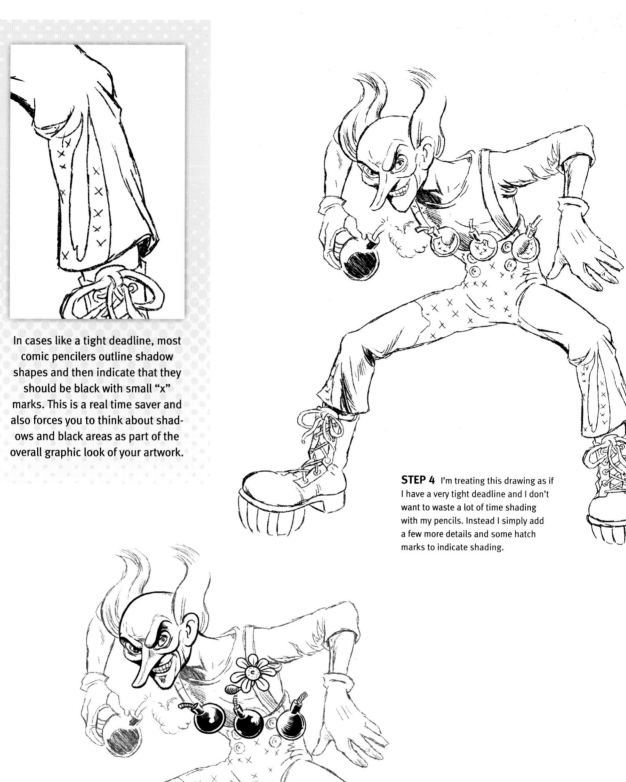

In cases like a tight deadline, most comic pencilers outline shadow shapes and then indicate that they should be black with small "x" marks. This is a real time saver and also forces you to think about shadows and black areas as part of the overall graphic look of your artwork.

STEP 4 I'm treating this drawing as if I have a very tight deadline and I don't want to waste a lot of time shading with my pencils. Instead I simply add a few more details and some hatch marks to indicate shading.

STEP 5 I begin to ink the Kriminal Klown with my usual tools: ink, brushes, quill pens, and markers. I start with his head to capture the essence of his diabolical expression. Then I ink his confetti bombs and squirting flower. It's important to ink the small shapes on top of his costume so they don't get lost.

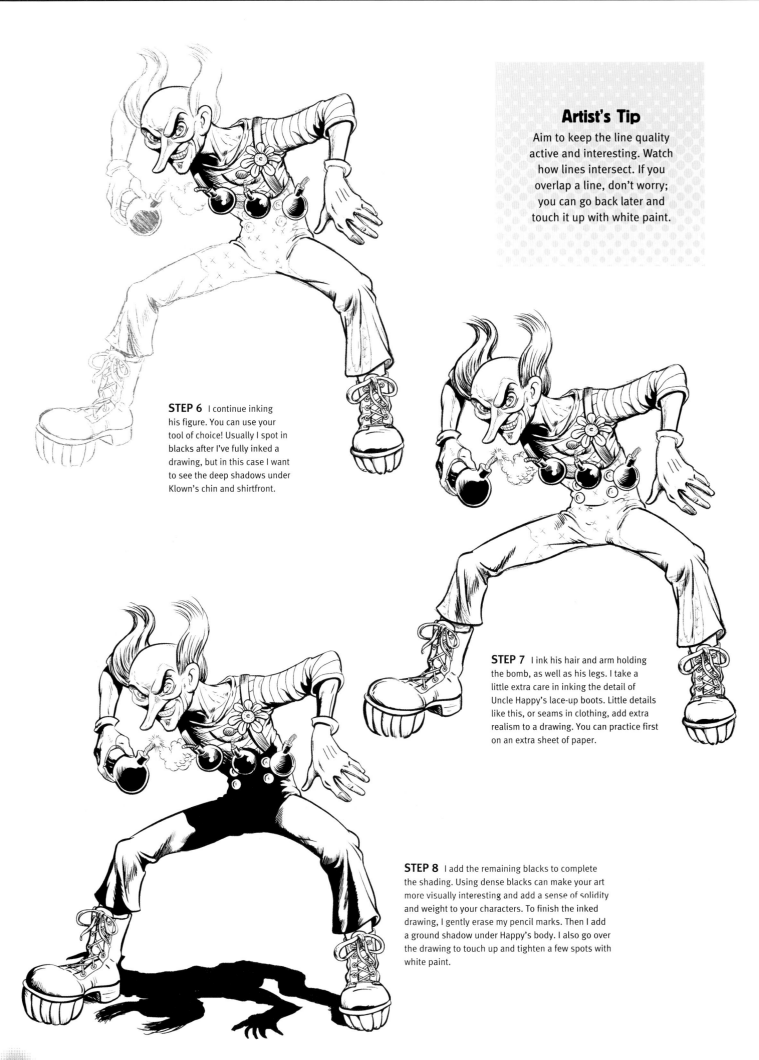

Artist's Tip

Aim to keep the line quality active and interesting. Watch how lines intersect. If you overlap a line, don't worry; you can go back later and touch it up with white paint.

STEP 6 I continue inking his figure. You can use your tool of choice! Usually I spot in blacks after I've fully inked a drawing, but in this case I want to see the deep shadows under Klown's chin and shirtfront.

STEP 7 I ink his hair and arm holding the bomb, as well as his legs. I take a little extra care in inking the detail of Uncle Happy's lace-up boots. Little details like this, or seams in clothing, add extra realism to a drawing. You can practice first on an extra sheet of paper.

STEP 8 I add the remaining blacks to complete the shading. Using dense blacks can make your art more visually interesting and add a sense of solidity and weight to your characters. To finish the inked drawing, I gently erase my pencil marks. Then I add a ground shadow under Happy's body. I also go over the drawing to touch up and tighten a few spots with white paint.

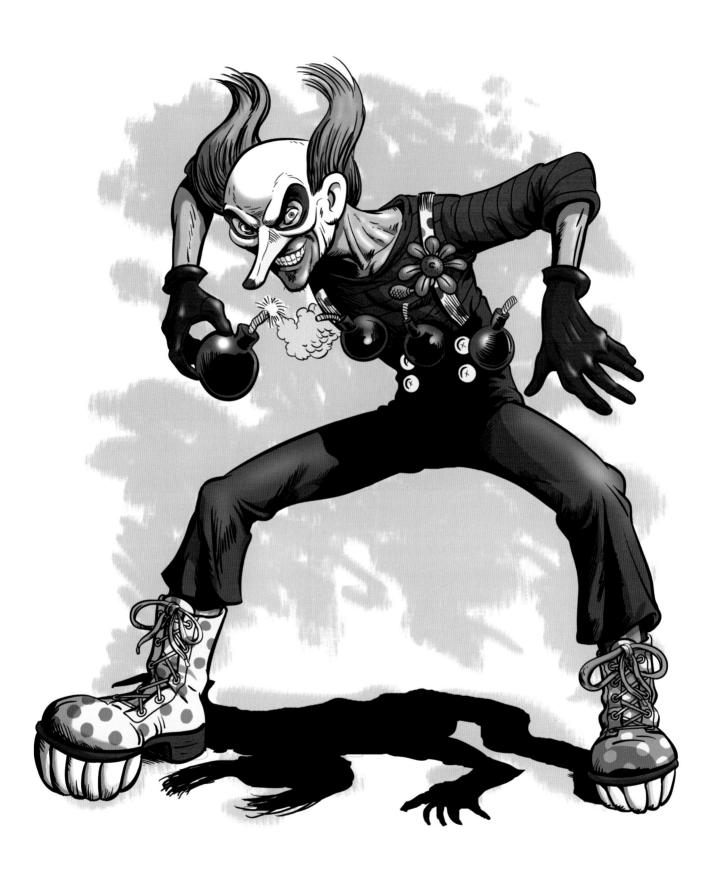

STEP 9 I add color to my Kriminal Klown using primary and bold secondary colors. Even for evil clowns, the more color the better. Party on, Uncle Happy!

MEGAGUY

Look! Up in the clouds! It's a sparrow, it's a frisbee…no, it's MegaGuy! We don't know if there are any more at home like him, but we're guessing not since his home world got sucked into a black hole minutes before his tiny rocket blasted off. What luck that he landed here on Earth, where his alien physique gives him incredible abilities far beyond those of mere mortals. With his chiseled features, colorful togs, and ability to fly, he can easily have a career in professional wrestling. But he opts to be everybody's super Samaritan, rescuing cats from trees and thwarting evil arch villains.

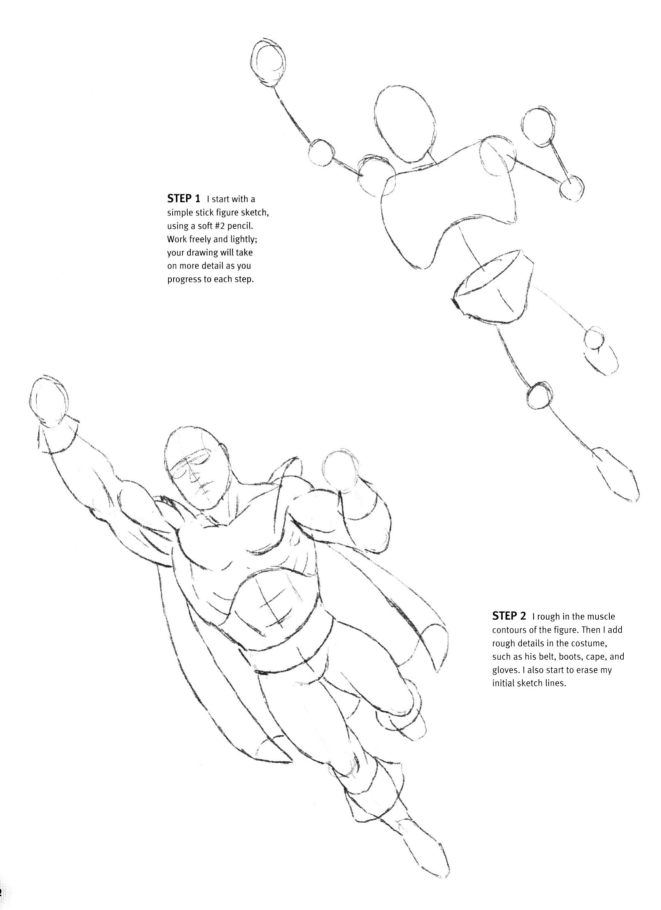

STEP 1 I start with a simple stick figure sketch, using a soft #2 pencil. Work freely and lightly; your drawing will take on more detail as you progress to each step.

STEP 2 I rough in the muscle contours of the figure. Then I add rough details in the costume, such as his belt, boots, cape, and gloves. I also start to erase my initial sketch lines.

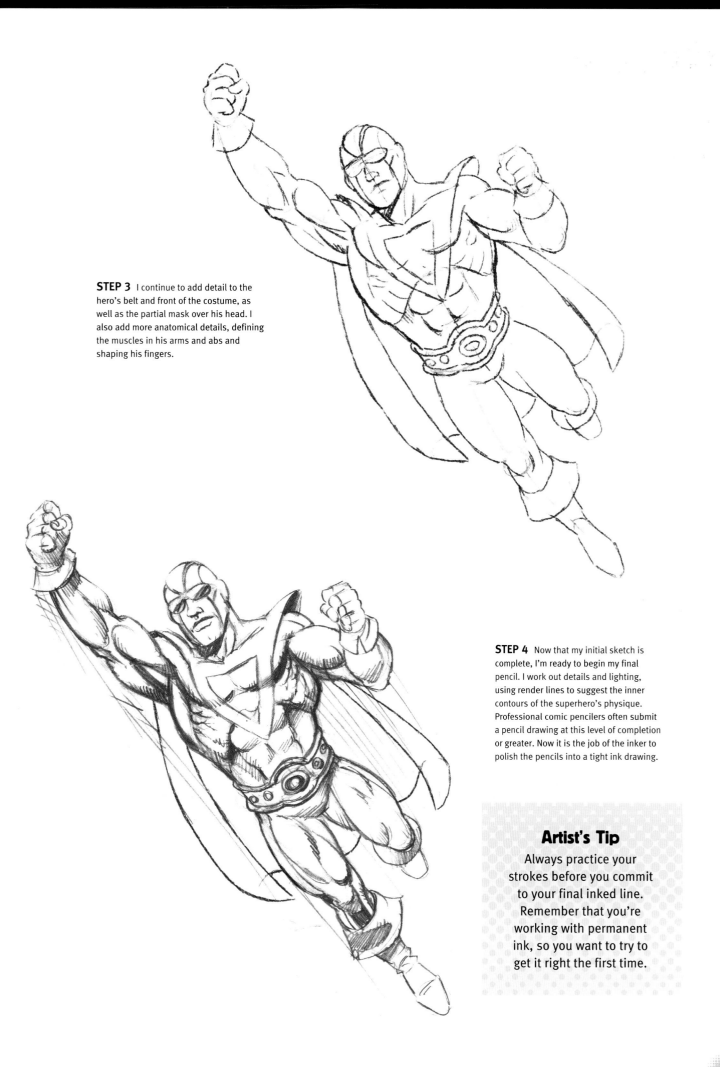

STEP 3 I continue to add detail to the hero's belt and front of the costume, as well as the partial mask over his head. I also add more anatomical details, defining the muscles in his arms and abs and shaping his fingers.

STEP 4 Now that my initial sketch is complete, I'm ready to begin my final pencil. I work out details and lighting, using render lines to suggest the inner contours of the superhero's physique. Professional comic pencilers often submit a pencil drawing at this level of completion or greater. Now it is the job of the inker to polish the pencils into a tight ink drawing.

Artist's Tip

Always practice your strokes before you commit to your final inked line. Remember that you're working with permanent ink, so you want to try to get it right the first time.

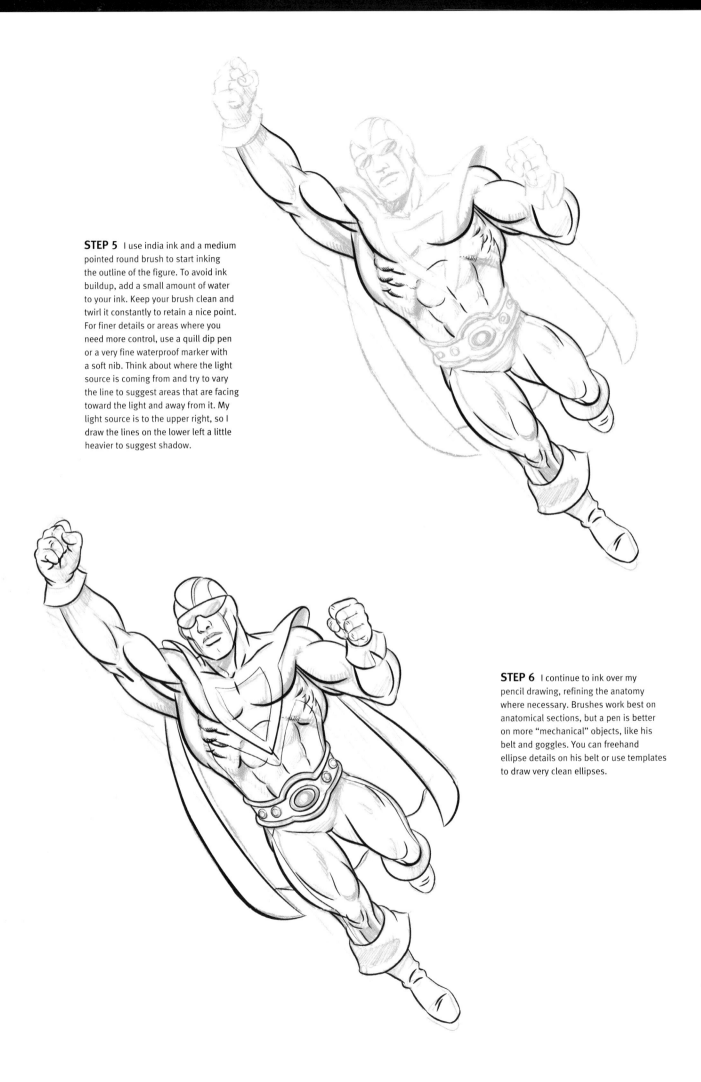

STEP 5 I use india ink and a medium pointed round brush to start inking the outline of the figure. To avoid ink buildup, add a small amount of water to your ink. Keep your brush clean and twirl it constantly to retain a nice point. For finer details or areas where you need more control, use a quill dip pen or a very fine waterproof marker with a soft nib. Think about where the light source is coming from and try to vary the line to suggest areas that are facing toward the light and away from it. My light source is to the upper right, so I draw the lines on the lower left a little heavier to suggest shadow.

STEP 6 I continue to ink over my pencil drawing, refining the anatomy where necessary. Brushes work best on anatomical sections, but a pen is better on more "mechanical" objects, like his belt and goggles. You can freehand ellipse details on his belt or use templates to draw very clean ellipses.

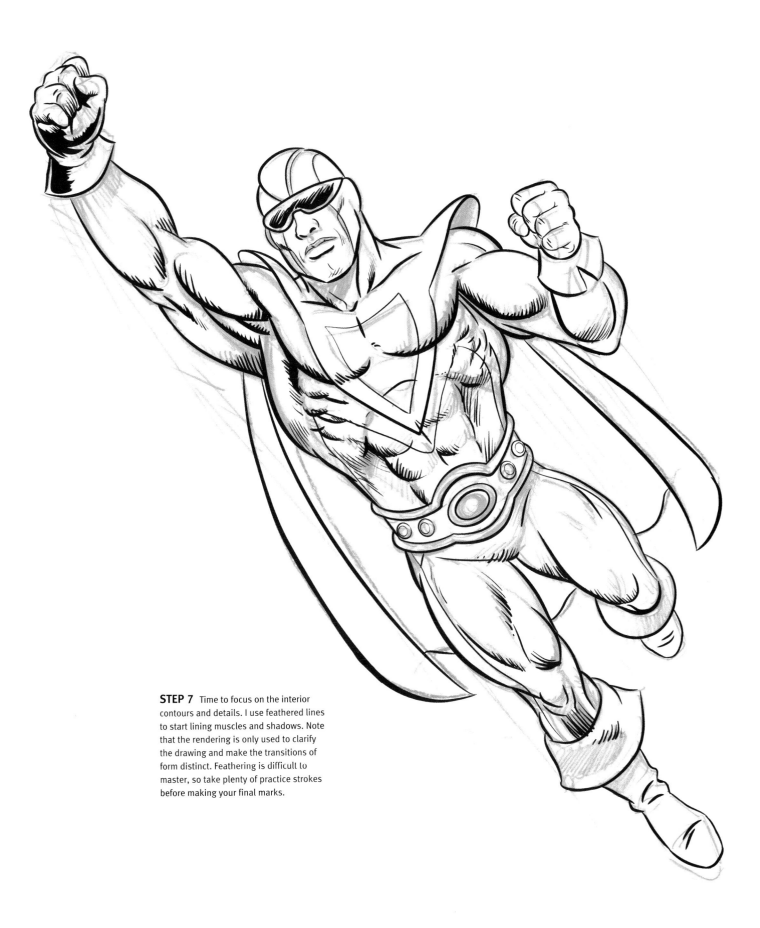

STEP 7 Time to focus on the interior contours and details. I use feathered lines to start lining muscles and shadows. Note that the rendering is only used to clarify the drawing and make the transitions of form distinct. Feathering is difficult to master, so take plenty of practice strokes before making your final marks.

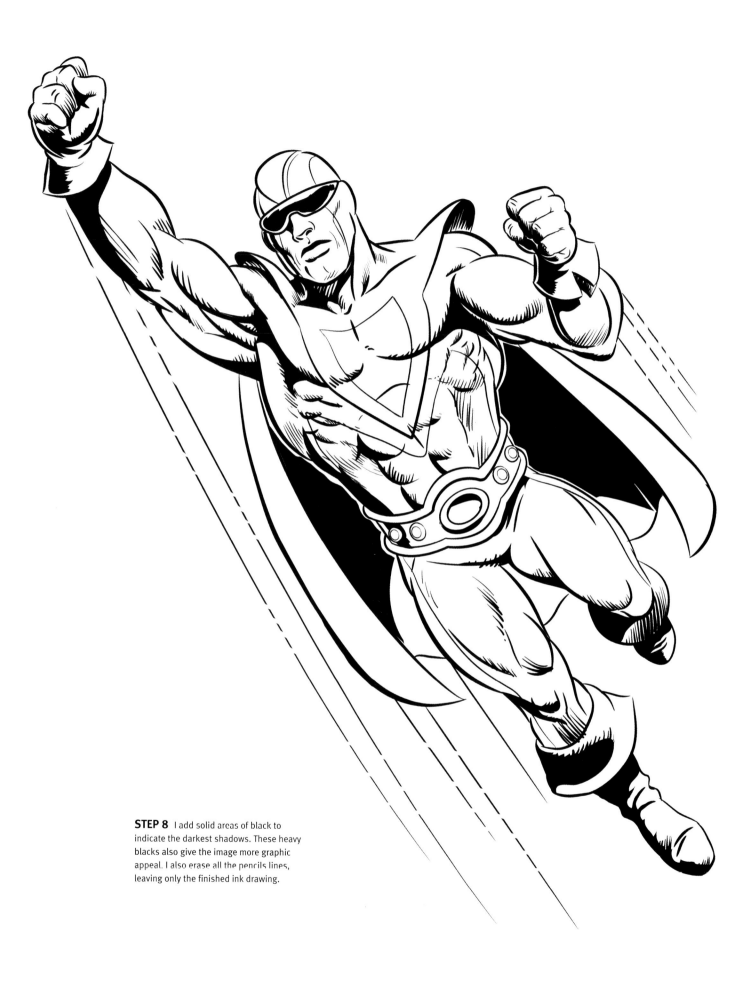

STEP 8 I add solid areas of black to indicate the darkest shadows. These heavy blacks also give the image more graphic appeal. I also erase all the pencils lines, leaving only the finished ink drawing.

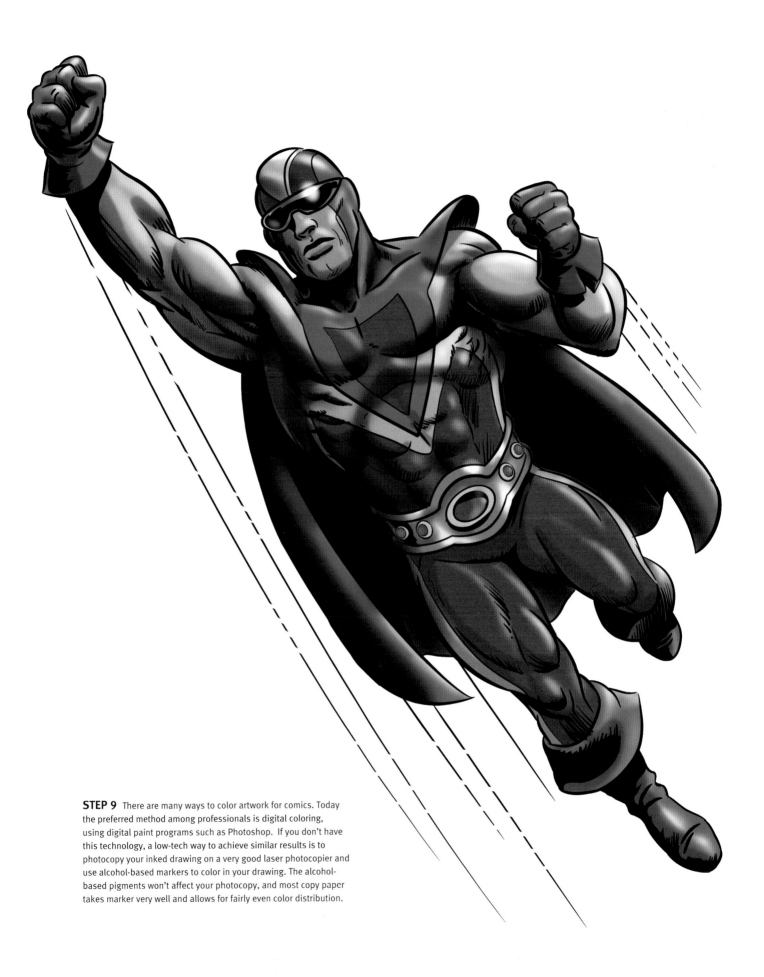

STEP 9 There are many ways to color artwork for comics. Today the preferred method among professionals is digital coloring, using digital paint programs such as Photoshop. If you don't have this technology, a low-tech way to achieve similar results is to photocopy your inked drawing on a very good laser photocopier and use alcohol-based markers to color in your drawing. The alcohol-based pigments won't affect your photocopy, and most copy paper takes marker very well and allows for fairly even color distribution.

MS. MEGA

Let's try an iconic comic scene. This is a split-second moment in time when Ms. Mega rescues a young boy. Just mere seconds before, the boy chases after his pet cat, not realizing that he has placed himself and his pet in the path of an out-of-control vehicle. Ms. Mega swoops in in the nick of time to hoist the car up in the air, saving the boy and his cat!

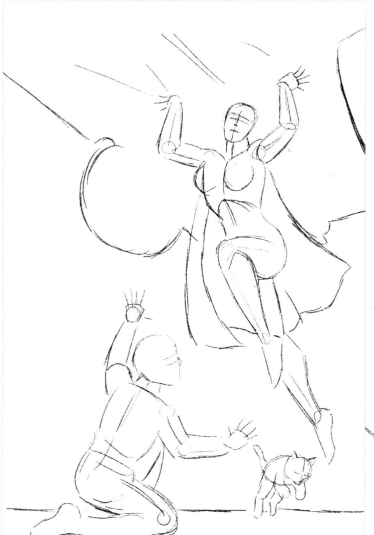

STEP 1 After so many projects under our proverbial utility belts, I start drawing this action sketch using more complete masses and cylinder shapes. By trying a more "holistic" sketching technique, I can realize the drama of the scene a lot faster.

STEP 2 Next I start adding clothing and capes to the characters. This allows me to better visualize the flow of motion. I use a reference photo to add some details to the underside of the car. I photocopied and enlarged the reference and used a light box to trace over it directly onto my illustration board. This is a useful "cheat" to capture mechanical and background elements quickly and accurately.

STEP 3 I erase my more sketchy lines while I refine my drawing. At this point I capture the expressions of the characters in the scene and rough in most of the costume and clothing detail. I also trace in a few more details on the car.

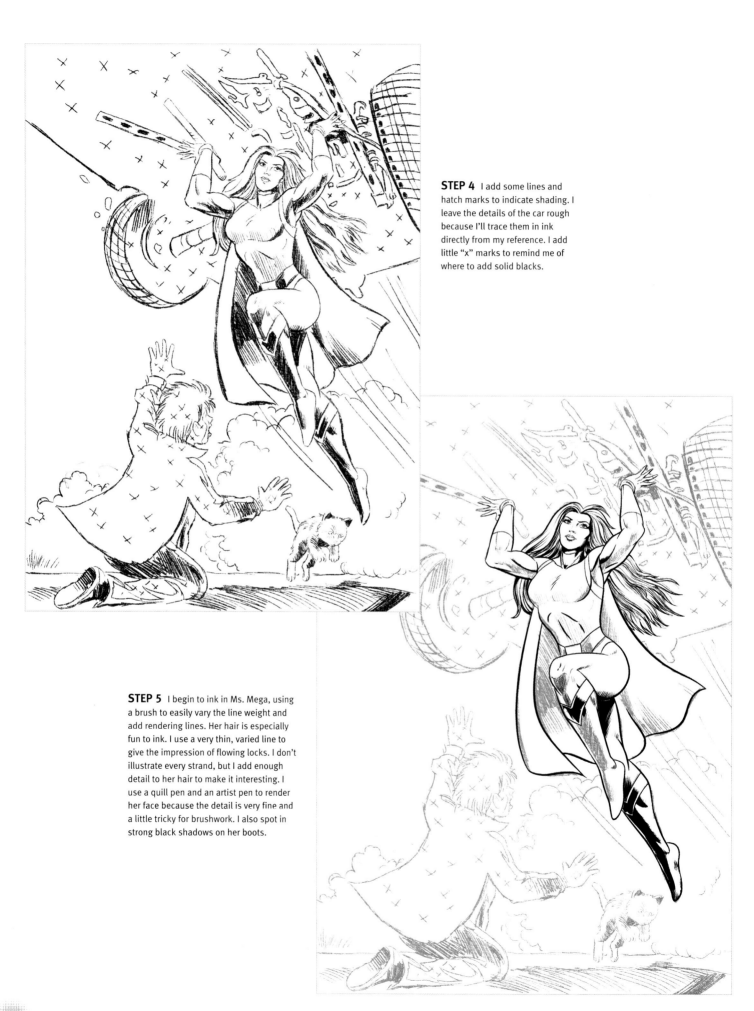

STEP 4 I add some lines and hatch marks to indicate shading. I leave the details of the car rough because I'll trace them in ink directly from my reference. I add little "x" marks to remind me of where to add solid blacks.

STEP 5 I begin to ink in Ms. Mega, using a brush to easily vary the line weight and add rendering lines. Her hair is especially fun to ink. I use a very thin, varied line to give the impression of flowing locks. I don't illustrate every strand, but I add enough detail to her hair to make it interesting. I use a quill pen and an artist pen to render her face because the detail is very fine and a little tricky for brushwork. I also spot in strong black shadows on her boots.

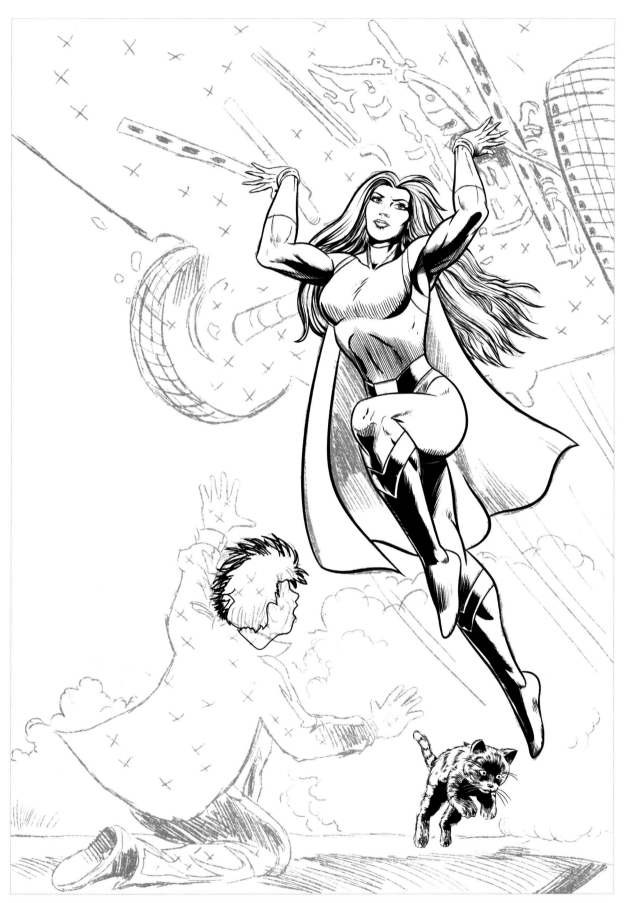

STEP 6 I use a slightly dry #2 brush with a fine point and make short, rapid brushstrokes to evenly hatch around her torso. I make a lot of practice strokes first to get the rhythm down. Then I use the same technique on the undersides of her arms. This kind of hatch work suggests softer shadows with a lot of reflected light. I spot dense black shadows on the very underside of her uplifted arms, which detail the musculature in her arms as well as make her figure look bold and powerful.

STEP 7 With Ms. Mega completed, I move on to the boy. I outline the areas of deep shadow and fill them with solid black in his upper body. I also outline the lower body. I use white paint to bring out the details of the boy's hair and face; this is easier than trying to ink around small areas. There is a strong time factor in drawing comics professionally, so use any trick you can to achieve the results you're aiming for!

Artist's Tip
It's important to balance the blacks, whites, and grays of shading as you render your figures...use shading sparingly and effectively.

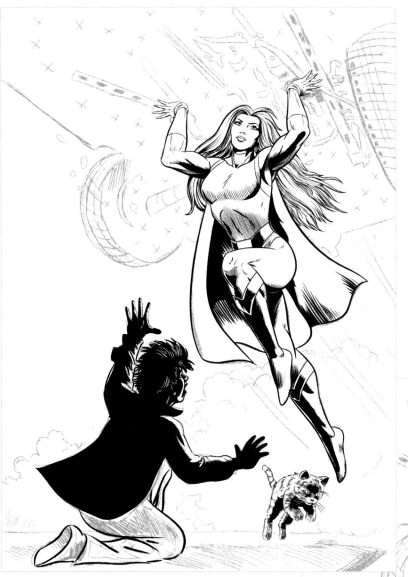

STEP 8 I fill in the shadows of the boy's legs and quickly ink in the road surface and the billowing cloud of dust left by the car. I use a brush in a very loose, free motion.

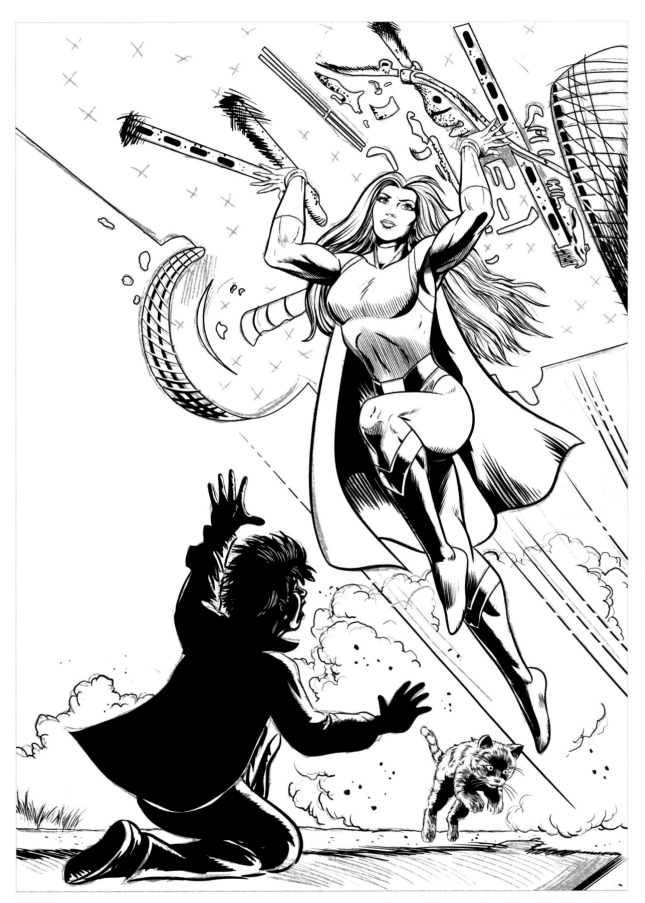

STEP 9 Now I want to suggest the complex workings of the car's undercarriage without drawing something too complicated. The trick to doing so is to only render a few details and let deep black shadows and a few mechanical highlights create the illusion. I switch on my light box so I can see the photocopy of the undercarriage taped to the back of my drawing. Using an art pen, I begin outlining some of the more "automotive-looking" details: axles, springs, some struts, and brake lines. These elements don't look like much just as outlines, but that will change when I carefully paint in solid black around these shapes. To facilitate the effect, I add some crosshatching where the details will blend into the black shadows.

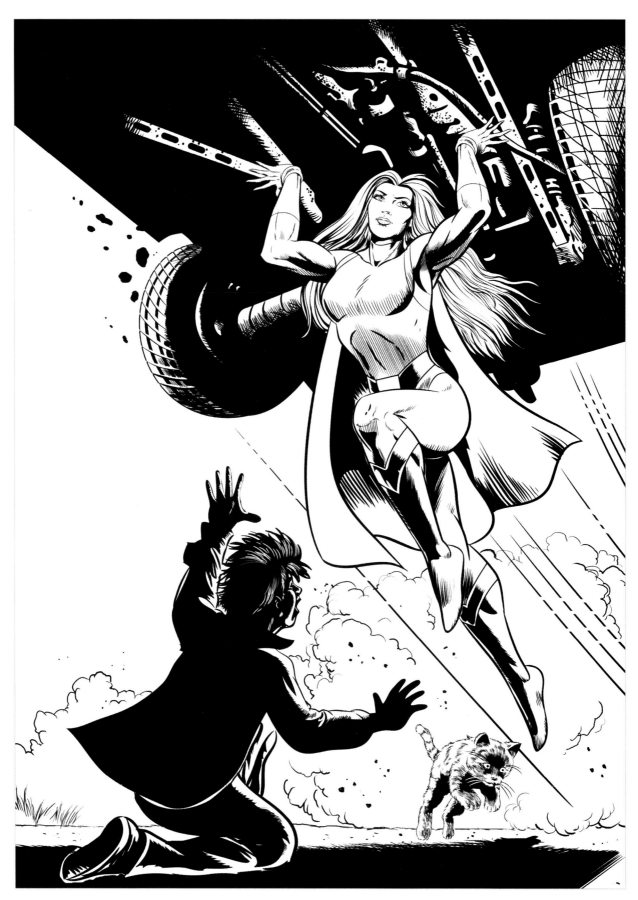

STEP 9 I fill in the large area of the car's undercarriage with black ink and erase all my pencil lines. Note how the small amount of detail I drew in the previous step really gives the impression of complex machinery. I add a few more hatch lines around the wheels and other places to complete the effect.

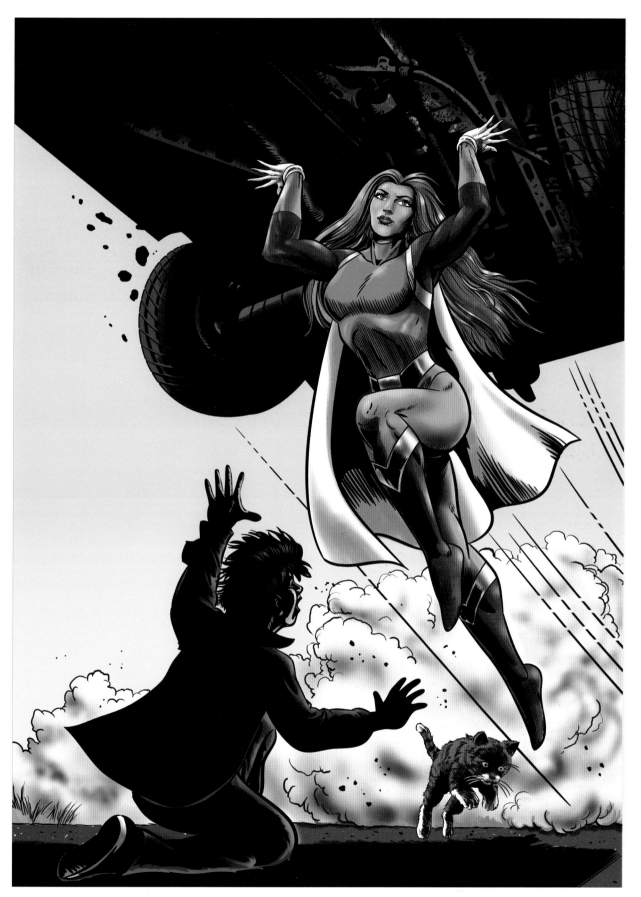

STEP 10 Next I scan my finished ink into Photoshop and add color. You can also use markers for a more vibrant look!

THORN

This superhero mutant is half-human and half-plant. Besides having incredible strength and being impervious to guns and other instruments of destruction, this hero has the ability to grow super-sharp and strong thorns that can cut through nearly anything! I draw him disarming an enemy tank using his amazing powers and showcasing his spiky arm in a powerful sweep as he slices through the tank's main gun.

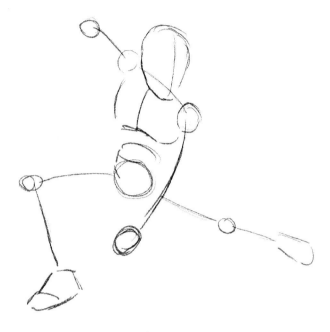

STEP 1 I sketch Thorn in a powerful, dynamic pose. Wide-leg stances are a good start for powerful poses.

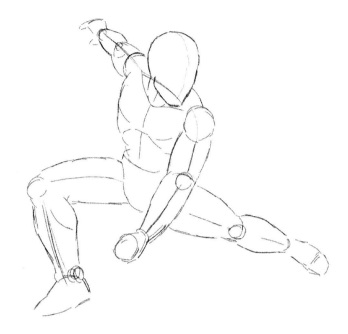

STEP 2 After the gestural pose, I start to sketch out some of the mass and volume of Thorn's figure to add depth and volume to his body, arms, and legs.

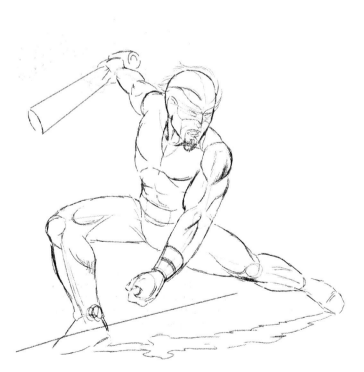

STEP 3 Now I'm ready to start adding details. I start drawing the suggestion of his facial features and the muscles of his body.

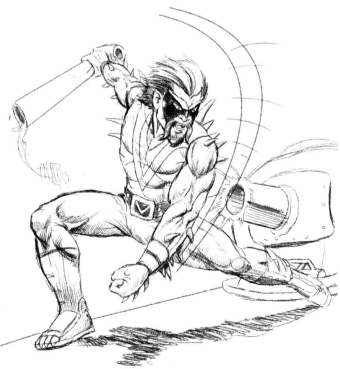

STEP 4 I sketch in the rest of the details. Your sketch should be nearly complete, showing all of Thorn's muscles and suggestions of shadows. I also draw a rough sketch of the tank.

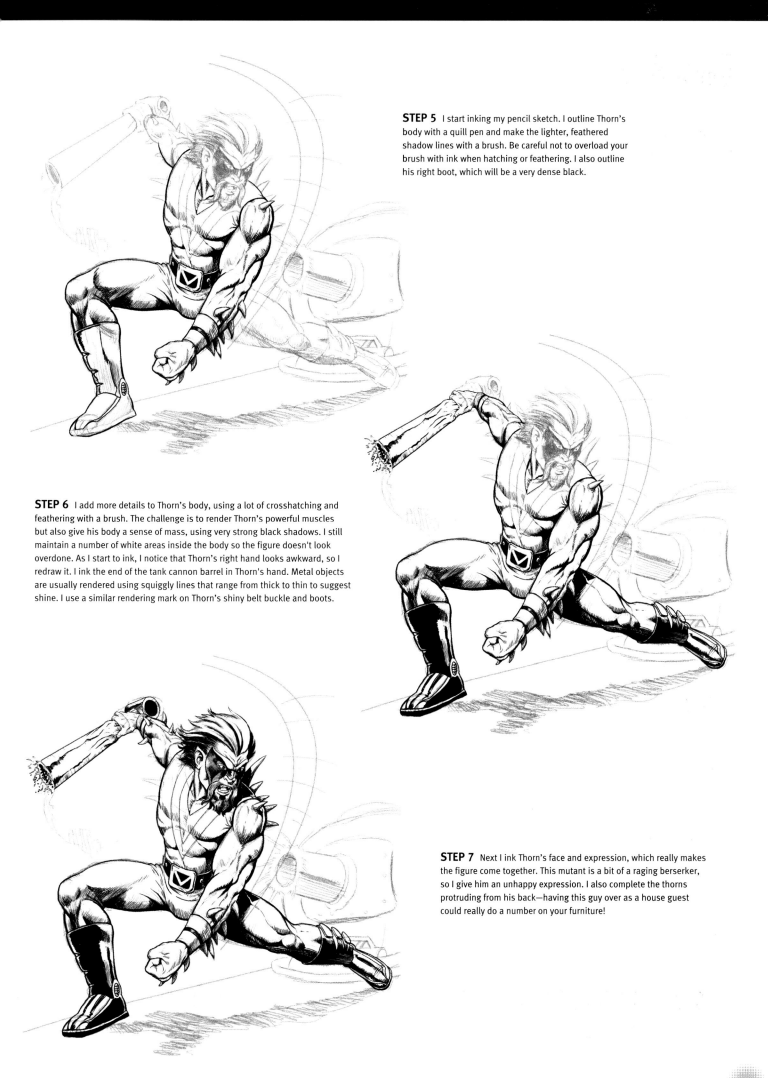

STEP 5 I start inking my pencil sketch. I outline Thorn's body with a quill pen and make the lighter, feathered shadow lines with a brush. Be careful not to overload your brush with ink when hatching or feathering. I also outline his right boot, which will be a very dense black.

STEP 6 I add more details to Thorn's body, using a lot of crosshatching and feathering with a brush. The challenge is to render Thorn's powerful muscles but also give his body a sense of mass, using very strong black shadows. I still maintain a number of white areas inside the body so the figure doesn't look overdone. As I start to ink, I notice that Thorn's right hand looks awkward, so I redraw it. I ink the end of the tank cannon barrel in Thorn's hand. Metal objects are usually rendered using squiggly lines that range from thick to thin to suggest shine. I use a similar rendering mark on Thorn's shiny belt buckle and boots.

STEP 7 Next I ink Thorn's face and expression, which really makes the figure come together. This mutant is a bit of a raging berserker, so I give him an unhappy expression. I also complete the thorns protruding from his back—having this guy over as a house guest could really do a number on your furniture!

Artist's Tip

Speed lines can be tricky! I like to use flexible guides to ink mine, especially when they span as much distance as these do. I like to use artist pens because they have a little flexibility in the nib and can render a line that gently runs from thick to thin for a more dynamic line.

STEP 8 I ink the tank turret and deck that Thorn is standing on. Although these are background elements, they are equally important to the drawing. I pay careful attention to how Thorn's shadow falls on the tank. I use crosshatching to suggest a semi-diffused shadow. I ink the tank with a permanent marker because I want a uniform line to suggest a very solid object made of hard material—in this case, steel. I use an artist pen to add speed lines to increase the sense of action.

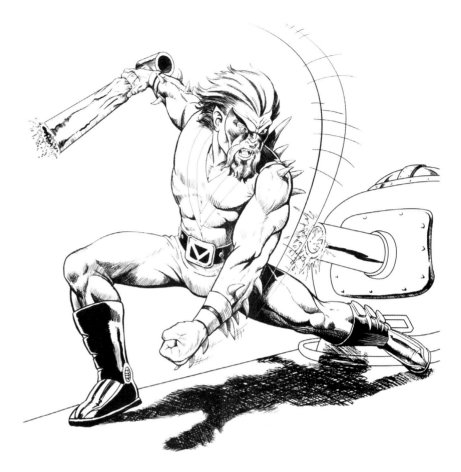

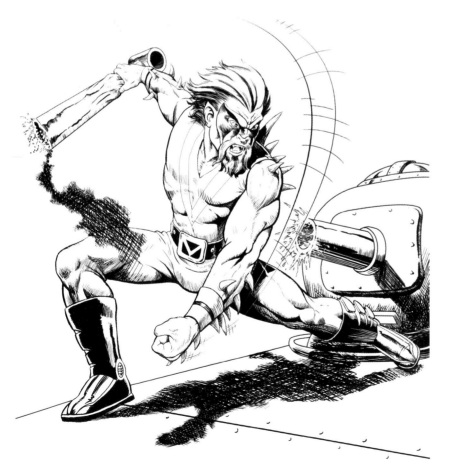

STEP 9 I add crosshatched shadows to the tank, which define the rounder form of the turret. The rendering on the tank helps to fully integrate the tank into the drawing. Because Thorn's barbs cut at the molecular level and generate a lot of heat, I render sparks on both ends of the gun barrel. I also add a stream of smoke trailing from the broken barrel to complete the effect.

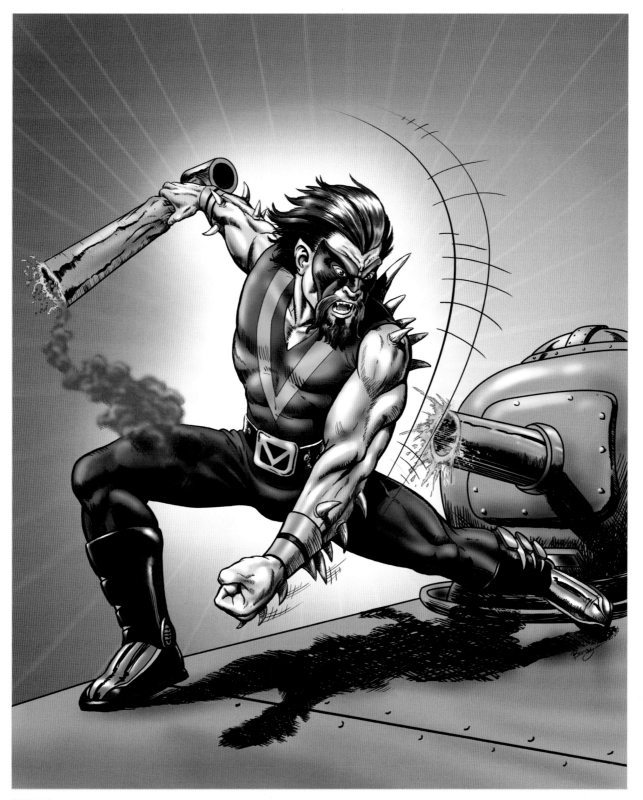

STEP 10 I scan my inked drawing into Photoshop to add color. I convert the black ink lines around the heated ends of the severed gun barrel to glowing red lines. I also add a subtle orange glow to the objects closest to the glowing metal of the gun barrels. Then I render the smoke to give it a nice, billowing feel. Finally no comic "splash" page would be complete without a nice burst around the center of action. Bursts like this are another convention that can impart action, speed, and direction to your comics.

Artist's Tip

Digital color is truly the standard in the comics industry today. Many novices own and work with Photoshop to color their art. Many also use alcohol-based markers on photocopies of their inked drawings. Both methods work extremely well, but Photoshop gives you the ability to create seamless blends and effects.

THE BULK

We're not sure if this guy was somehow transformed by being trapped in a Las Vegas elevator with the Blue Man Group, or if he accidentally fell into a vat of premium berry yogurt. But whatever happened, now he's big and blue and has a BAD attitude. Fortunately for us, he's using his bad temper and incredible strength to fight evildoers and nefarious ne'er-do-wells all over the world!

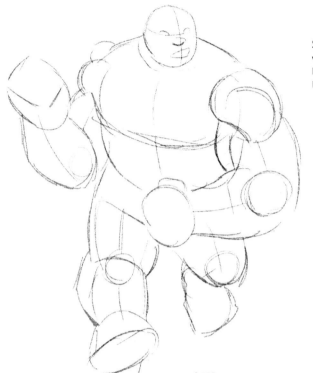

STEP 1 I start by sketching out a rough version of his figure, using full shapes for his arm and his legs. Try to sketch him using large masses.

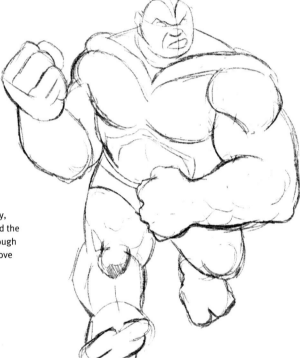

STEP 2 I start sketching details of his anatomy, indicating some of his largest muscle groups and the structure of his armor-plated shoulders. I also rough in the details of his head. I use an eraser to remove my sketch lines from step 1.

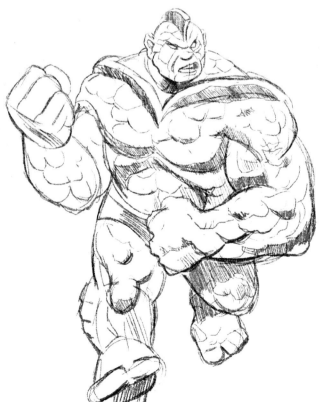

STEP 3 I sketch in his blocky skin texture. I also block in the dark solid shadow shapes, which help establish the mass of the creature.

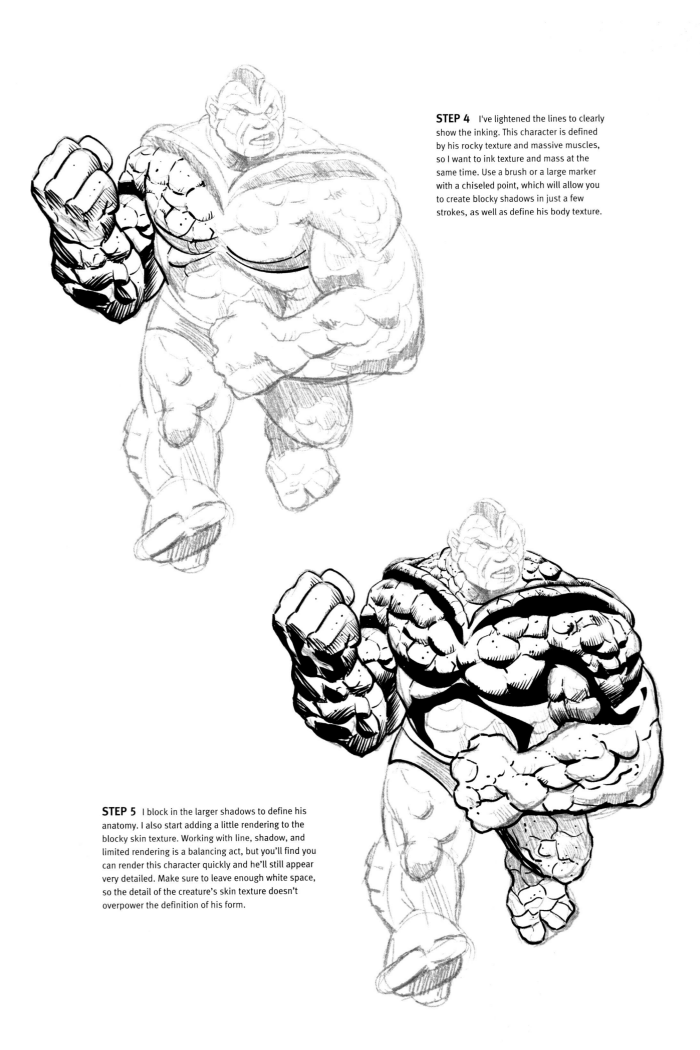

STEP 4 I've lightened the lines to clearly show the inking. This character is defined by his rocky texture and massive muscles, so I want to ink texture and mass at the same time. Use a brush or a large marker with a chiseled point, which will allow you to create blocky shadows in just a few strokes, as well as define his body texture.

STEP 5 I block in the larger shadows to define his anatomy. I also start adding a little rendering to the blocky skin texture. Working with line, shadow, and limited rendering is a balancing act, but you'll find you can render this character quickly and he'll still appear very detailed. Make sure to leave enough white space, so the detail of the creature's skin texture doesn't overpower the definition of his form.

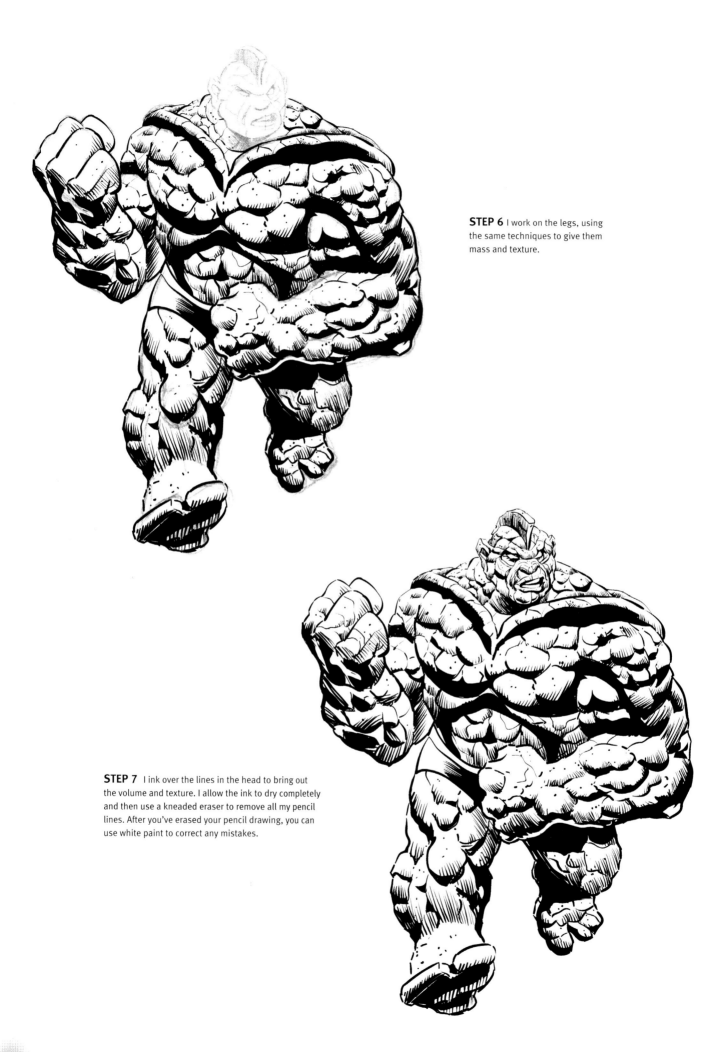

STEP 6 I work on the legs, using the same techniques to give them mass and texture.

STEP 7 I ink over the lines in the head to bring out the volume and texture. I allow the ink to dry completely and then use a kneaded eraser to remove all my pencil lines. After you've erased your pencil drawing, you can use white paint to correct any mistakes.

STEP 8 I color in the entire creature with blue. Then I overlay a darker blue on the shadows to help further define his skin texture and form. I add highlights to the upper edges of the bumps on his skin. Now this creature is ready to clobber some bad guys!

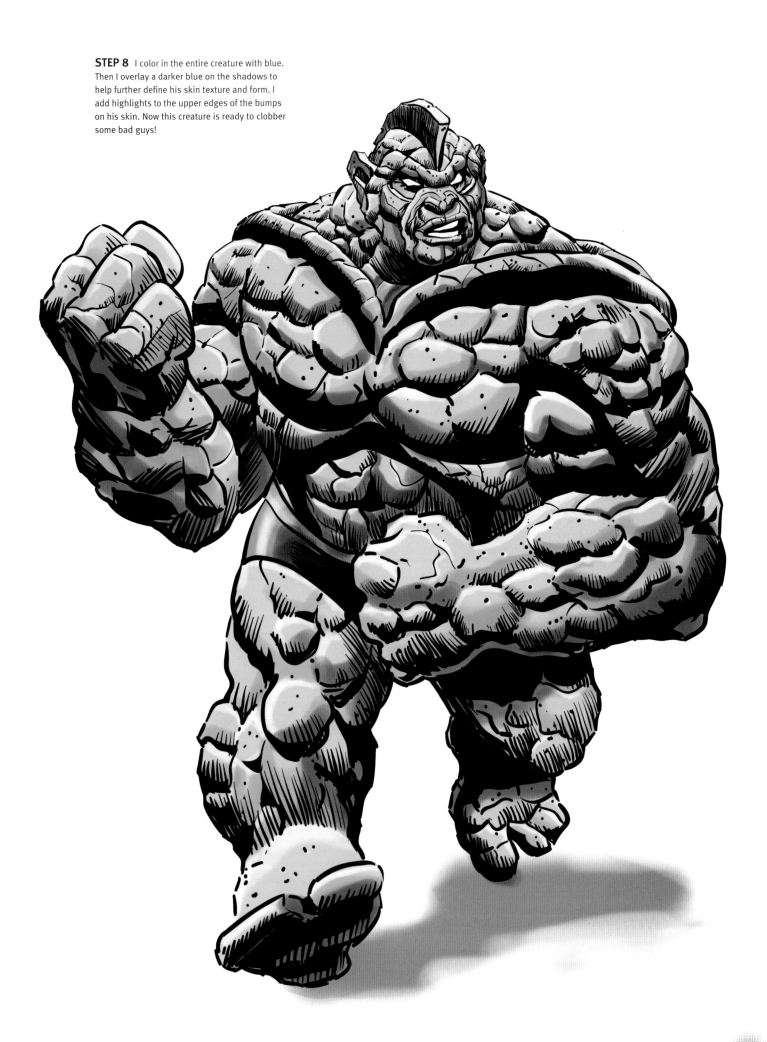

LADY ELECTRIC

Normally I'd try to make some kind of shocking quip about our next super villain, but I think that current readers might find fault with that kind of approach, so I'll just get right into the lesson. Lady Electric is the kind of super villain who can instantly take charge and electrify any room. In this lesson we're going to illustrate her throwing bolts of high-powered electricity—no doubt against one of our superheroes.

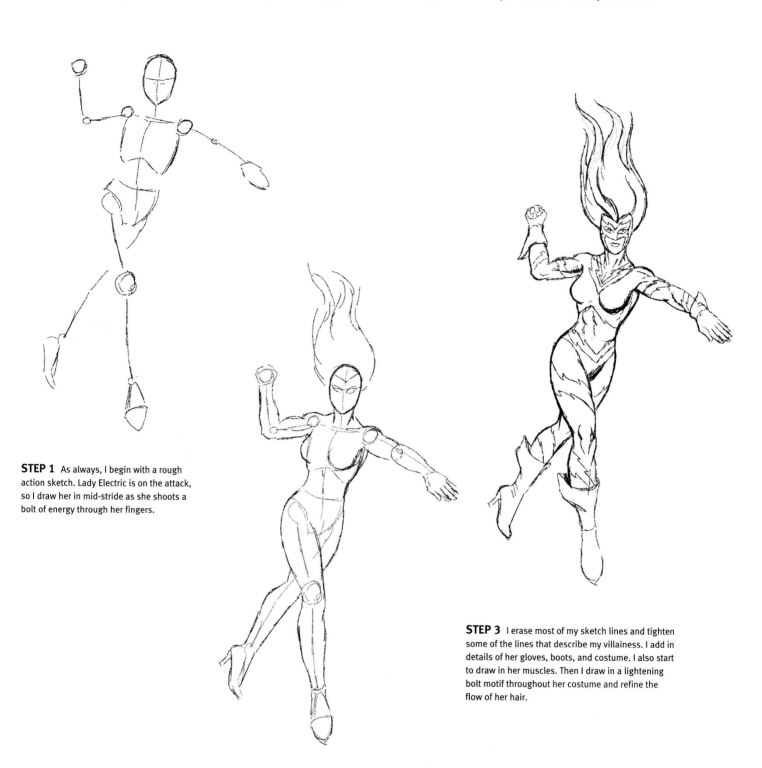

STEP 1 As always, I begin with a rough action sketch. Lady Electric is on the attack, so I draw her in mid-stride as she shoots a bolt of energy through her fingers.

STEP 2 Next I begin to embellish, adding detail and refining her anatomy and pose. Because she is electrified, her hair stands straight up! I also draw some lines suggesting the look of her mask and some details on her costume.

STEP 3 I erase most of my sketch lines and tighten some of the lines that describe my villainess. I add in details of her gloves, boots, and costume. I also start to draw in her muscles. Then I draw in a lightening bolt motif throughout her costume and refine the flow of her hair.

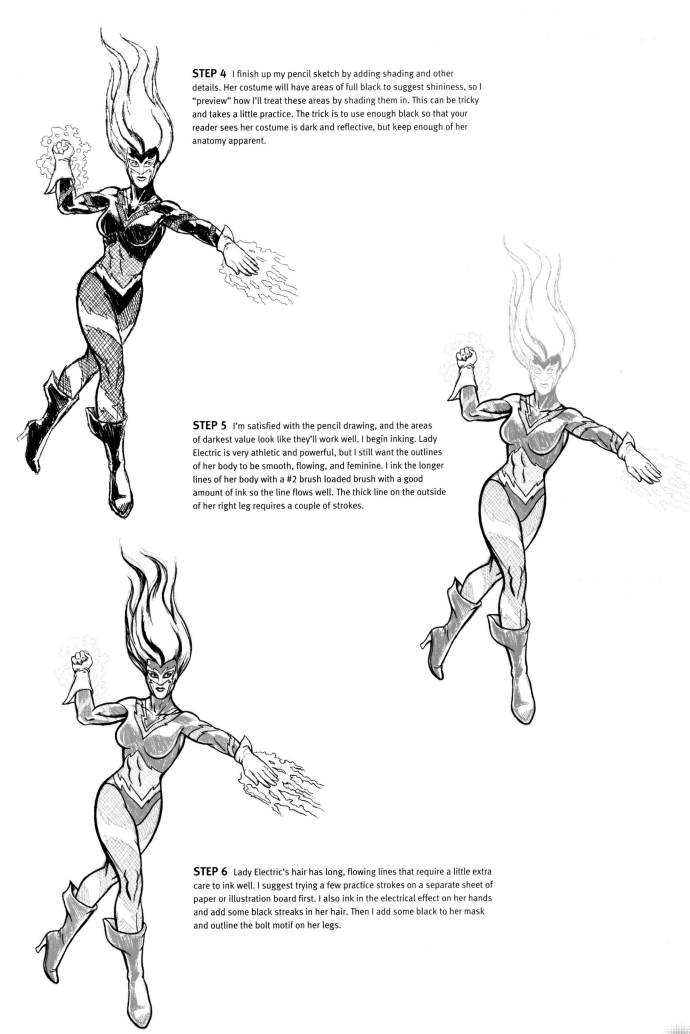

STEP 4 I finish up my pencil sketch by adding shading and other details. Her costume will have areas of full black to suggest shininess, so I "preview" how I'll treat these areas by shading them in. This can be tricky and takes a little practice. The trick is to use enough black so that your reader sees her costume is dark and reflective, but keep enough of her anatomy apparent.

STEP 5 I'm satisfied with the pencil drawing, and the areas of darkest value look like they'll work well. I begin inking. Lady Electric is very athletic and powerful, but I still want the outlines of her body to be smooth, flowing, and feminine. I ink the longer lines of her body with a #2 brush loaded brush with a good amount of ink so the line flows well. The thick line on the outside of her right leg requires a couple of strokes.

STEP 6 Lady Electric's hair has long, flowing lines that require a little extra care to ink well. I suggest trying a few practice strokes on a separate sheet of paper or illustration board first. I also ink in the electrical effect on her hands and add some black streaks in her hair. Then I add some black to her mask and outline the bolt motif on her legs.

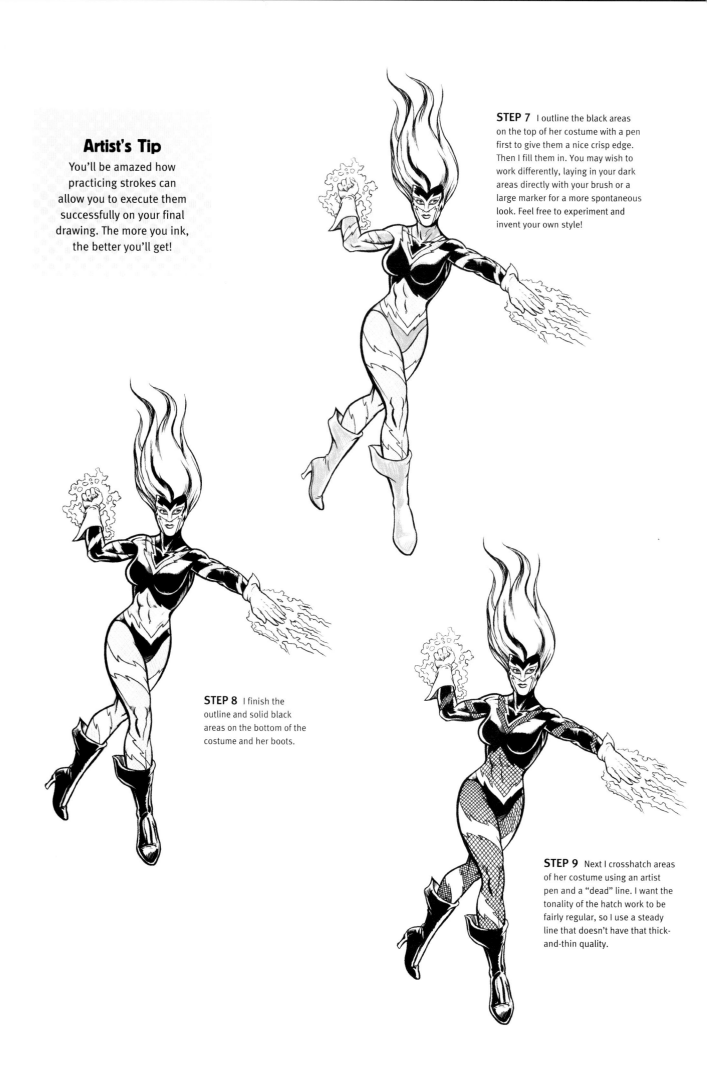

STEP 7 I outline the black areas on the top of her costume with a pen first to give them a nice crisp edge. Then I fill them in. You may wish to work differently, laying in your dark areas directly with your brush or a large marker for a more spontaneous look. Feel free to experiment and invent your own style!

STEP 8 I finish the outline and solid black areas on the bottom of the costume and her boots.

STEP 9 Next I crosshatch areas of her costume using an artist pen and a "dead" line. I want the tonality of the hatch work to be fairly regular, so I use a steady line that doesn't have that thick-and-thin quality.

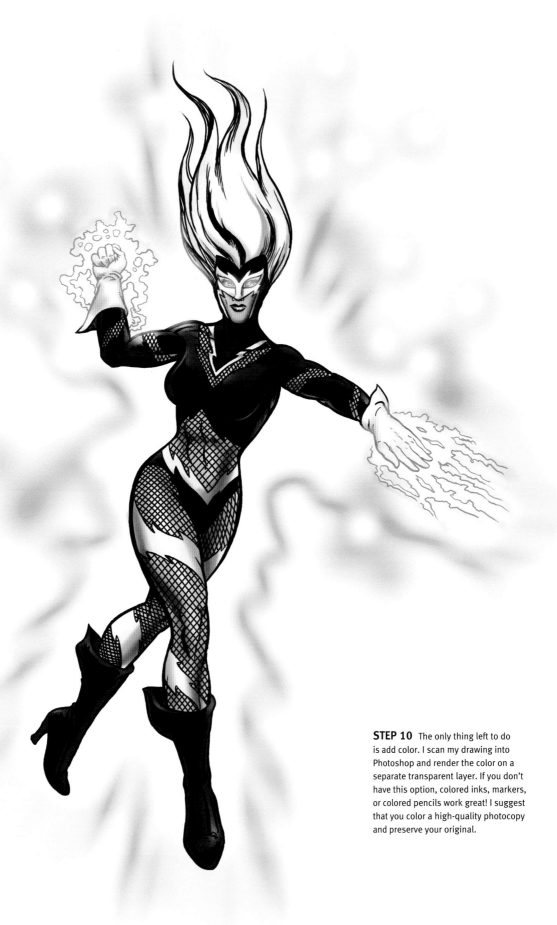

STEP 10 The only thing left to do is add color. I scan my drawing into Photoshop and render the color on a separate transparent layer. If you don't have this option, colored inks, markers, or colored pencils work great! I suggest that you color a high-quality photocopy and preserve your original.

THE SHARK & THE TADPOLE

So what does a billionaire playboy do to occupy his humdrum life? Jet off to exotic locales? Drive incredibly expensive sports cars or date super-models? Nah, if you're this particular billionaire playboy, you and your young sidekick dress up in costumes modeled after aquatic animals and swing from rooftops as you put the beat-down on every freaky criminal the city can conjure up. Glamorous? No. Fun? You betcha!

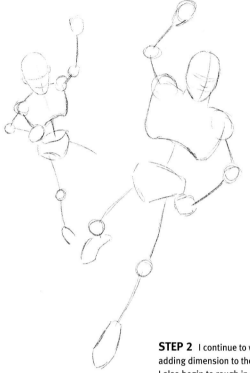

STEP 1 Starting your superhero team project with simple stick figures is a good way to capture action and body proportions quickly. I lightly sketch my scene with a soft #2 pencil. I work freely and lightly—the drawing will take on more detail in each step.

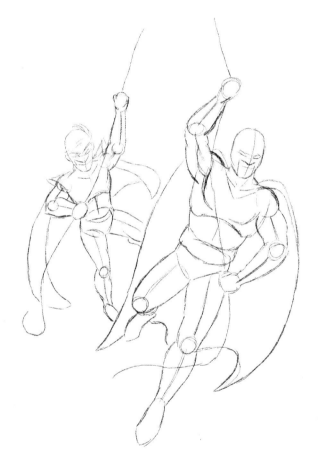

STEP 2 I continue to work lightly, adding dimension to the superheroes. I also begin to rough in the costume elements.

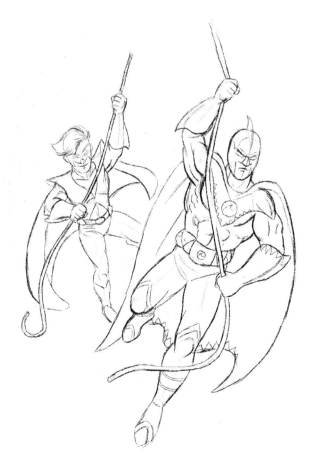

STEP 3 I erase the rough stick figures and loose pencil lines and start to draw with more weight. To achieve this, you can use a darker pencil or apply a little more pressure. I start working out costume details in greater depth and the finer points of the figures' bodies.

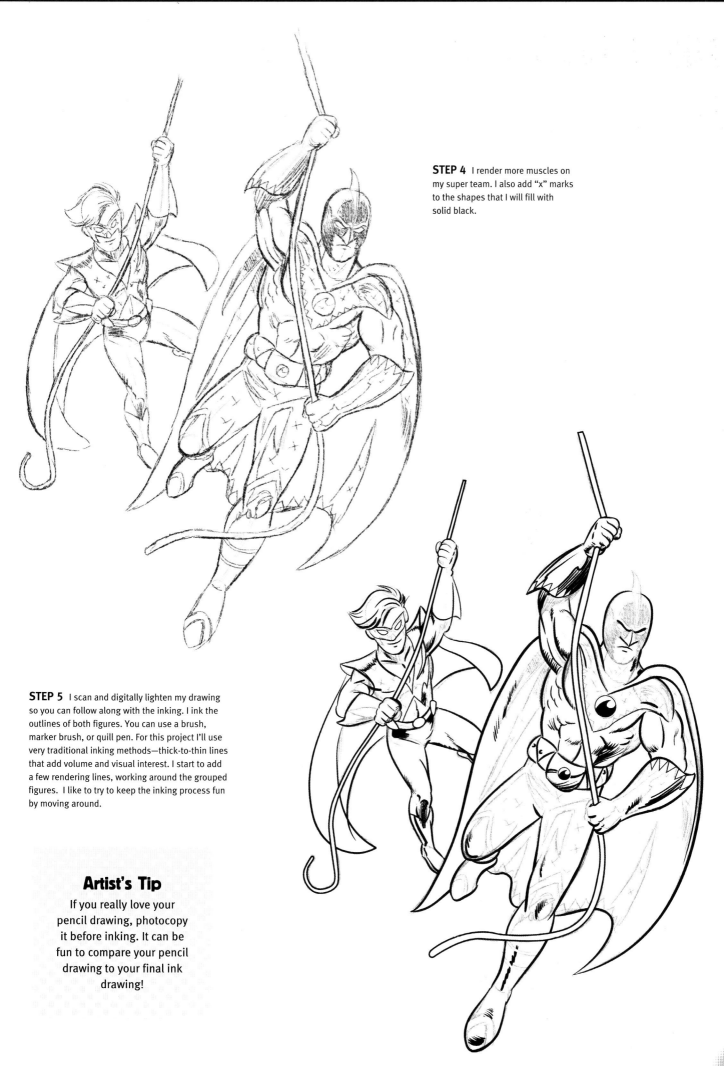

STEP 4 I render more muscles on my super team. I also add "x" marks to the shapes that I will fill with solid black.

STEP 5 I scan and digitally lighten my drawing so you can follow along with the inking. I ink the outlines of both figures. You can use a brush, marker brush, or quill pen. For this project I'll use very traditional inking methods—thick-to-thin lines that add volume and visual interest. I start to add a few rendering lines, working around the grouped figures. I like to try to keep the inking process fun by moving around.

Artist's Tip

If you really love your pencil drawing, photocopy it before inking. It can be fun to compare your pencil drawing to your final ink drawing!

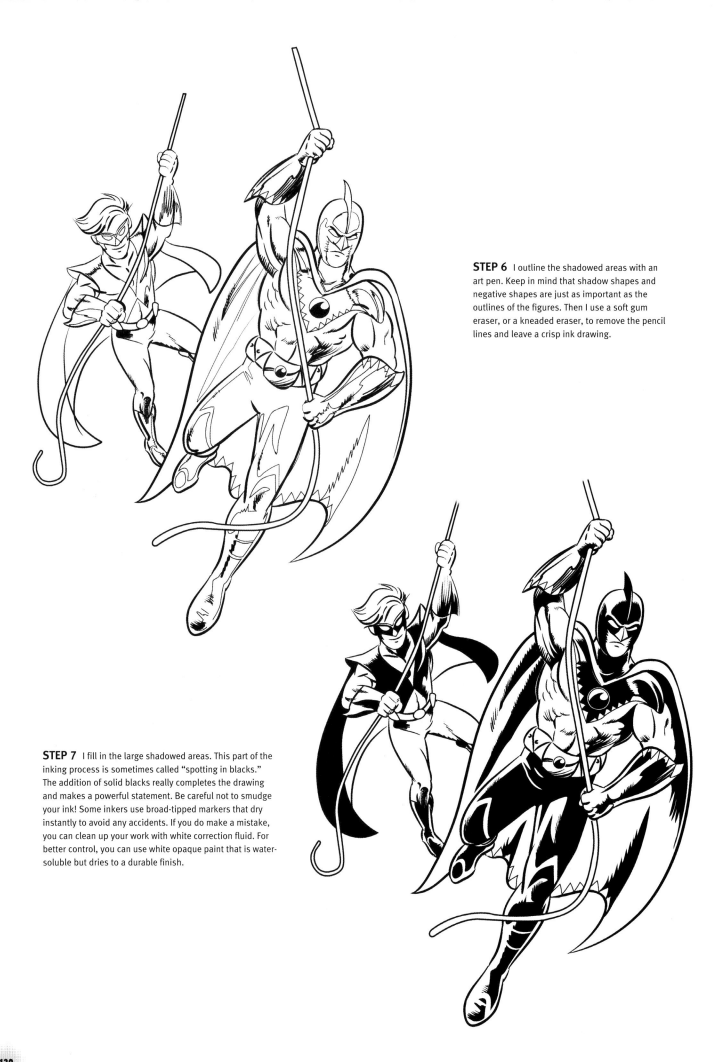

STEP 6 I outline the shadowed areas with an art pen. Keep in mind that shadow shapes and negative shapes are just as important as the outlines of the figures. Then I use a soft gum eraser, or a kneaded eraser, to remove the pencil lines and leave a crisp ink drawing.

STEP 7 I fill in the large shadowed areas. This part of the inking process is sometimes called "spotting in blacks." The addition of solid blacks really completes the drawing and makes a powerful statement. Be careful not to smudge your ink! Some inkers use broad-tipped markers that dry instantly to avoid any accidents. If you do make a mistake, you can clean up your work with white correction fluid. For better control, you can use white opaque paint that is water-soluble but dries to a durable finish.

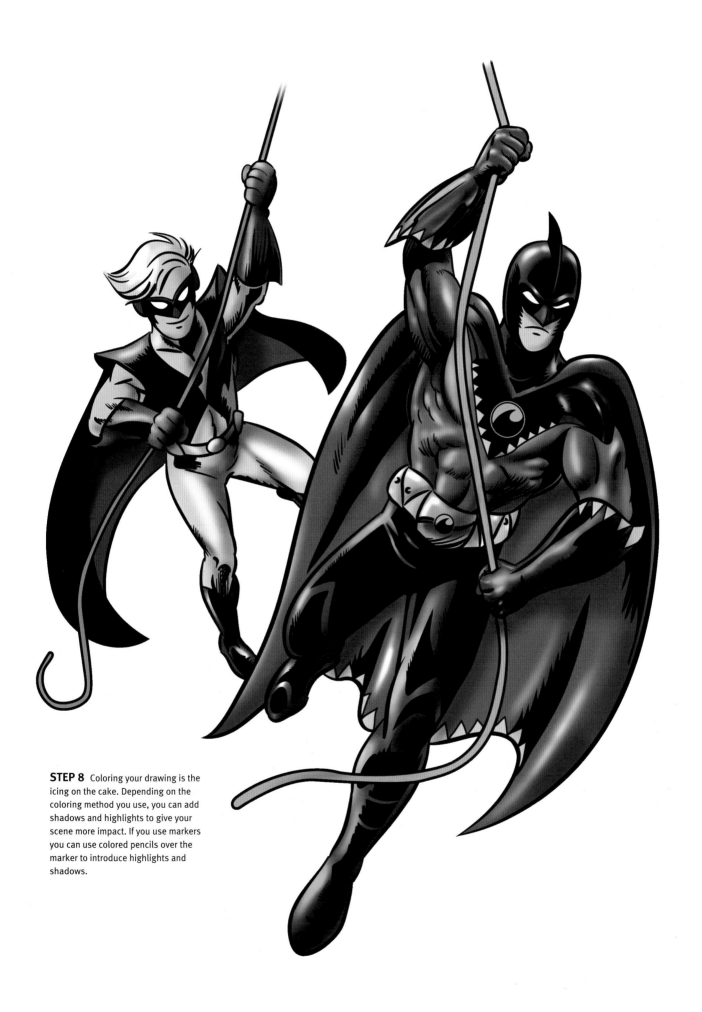

STEP 8 Coloring your drawing is the icing on the cake. Depending on the coloring method you use, you can add shadows and highlights to give your scene more impact. If you use markers you can use colored pencils over the marker to introduce highlights and shadows.

SHARK CAR

Okay, you're a superhero but you can't fly, teleport, or even run very fast. So what do you do? You invent a really cool vehicle to get you to the scene of the crime in speed and style! I've dubbed my rope-swinging super hero, The Shark. In keeping with his predatory-fish motif, I want to design a vehicle that looks shark-like and gives the impression of speed and power.

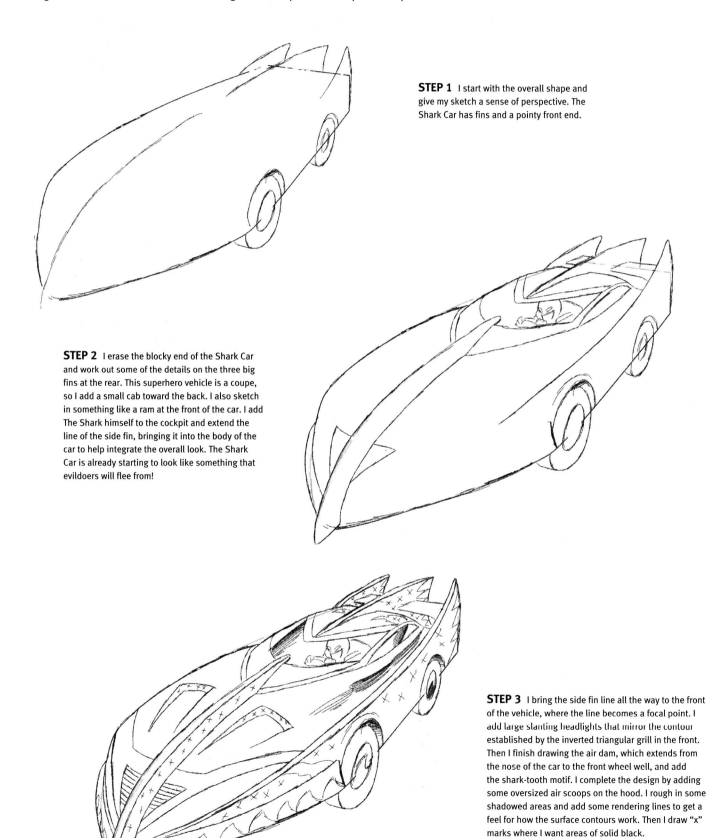

STEP 1 I start with the overall shape and give my sketch a sense of perspective. The Shark Car has fins and a pointy front end.

STEP 2 I erase the blocky end of the Shark Car and work out some of the details on the three big fins at the rear. This superhero vehicle is a coupe, so I add a small cab toward the back. I also sketch in something like a ram at the front of the car. I add The Shark himself to the cockpit and extend the line of the side fin, bringing it into the body of the car to help integrate the overall look. The Shark Car is already starting to look like something that evildoers will flee from!

STEP 3 I bring the side fin line all the way to the front of the vehicle, where the line becomes a focal point. I add large slanting headlights that mirror the contour established by the inverted triangular grill in the front. Then I finish drawing the air dam, which extends from the nose of the car to the front wheel well, and add the shark-tooth motif. I complete the design by adding some oversized air scoops on the hood. I rough in some shadowed areas and add some rendering lines to get a feel for how the surface contours work. Then I draw "x" marks where I want areas of solid black.

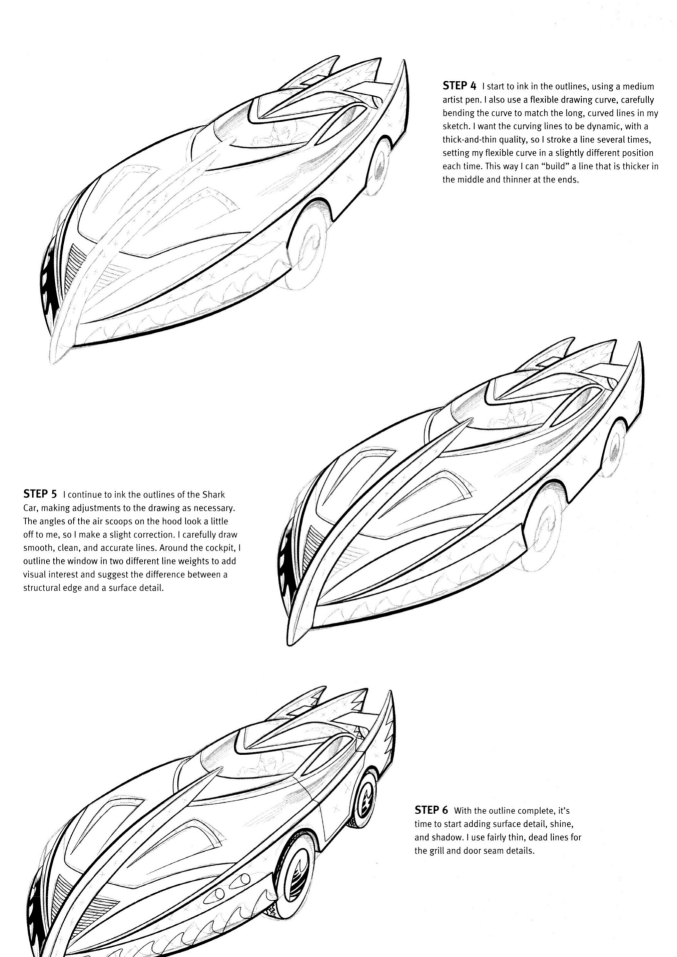

STEP 4 I start to ink in the outlines, using a medium artist pen. I also use a flexible drawing curve, carefully bending the curve to match the long, curved lines in my sketch. I want the curving lines to be dynamic, with a thick-and-thin quality, so I stroke a line several times, setting my flexible curve in a slightly different position each time. This way I can "build" a line that is thicker in the middle and thinner at the ends.

STEP 5 I continue to ink the outlines of the Shark Car, making adjustments to the drawing as necessary. The angles of the air scoops on the hood look a little off to me, so I make a slight correction. I carefully draw smooth, clean, and accurate lines. Around the cockpit, I outline the window in two different line weights to add visual interest and suggest the difference between a structural edge and a surface detail.

STEP 6 With the outline complete, it's time to start adding surface detail, shine, and shadow. I use fairly thin, dead lines for the grill and door seam details.

133

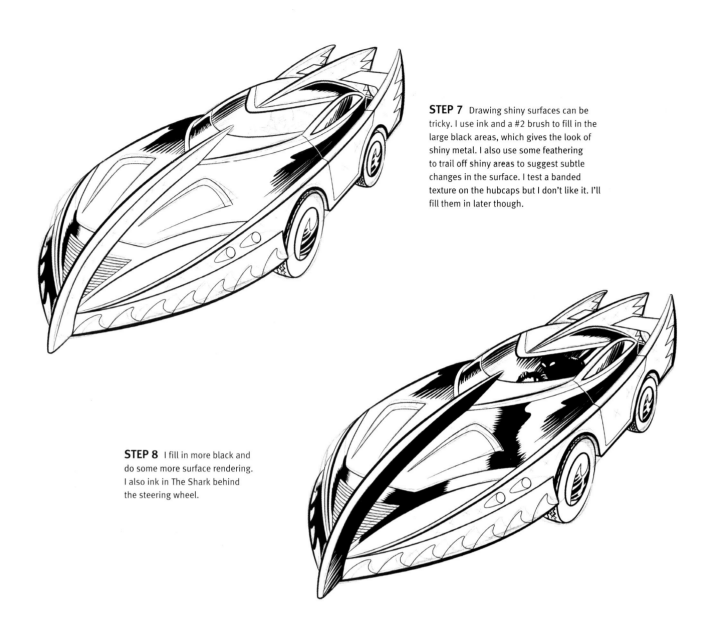

STEP 7 Drawing shiny surfaces can be tricky. I use ink and a #2 brush to fill in the large black areas, which gives the look of shiny metal. I also use some feathering to trail off shiny areas to suggest subtle changes in the surface. I test a banded texture on the hubcaps but I don't like it. I'll fill them in later though.

STEP 8 I fill in more black and do some more surface rendering. I also ink in The Shark behind the steering wheel.

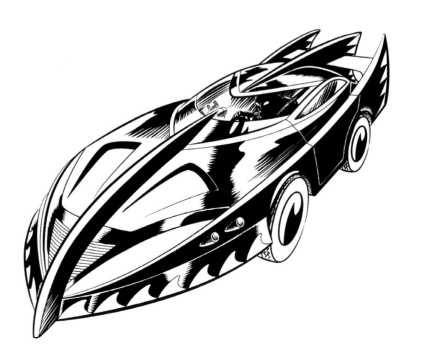

STEP 9 I fill in the areas with the most shadow in solid black, using feathering to suggest contour and a slight transition from dark to light. Once the ink is dry, I erase my pencil lines.

STEP 10 I scan my drawing into Photoshop to start coloring. I place the black-and-white drawing on one layer and create a separate color layer, set to the "Multiply" setting. This allows color to be placed over the drawing without affecting it. Next I start to paint bucket areas of color, using a palette similar to The Shark's costume. The paint bucket is prone to spilling into places I may not want, so I set it at a tolerance of 20 pixels and then dump the color into a closed shape. If there is a little anti-aliasing and the color doesn't completely fall within the black line, I go over it with a brush loaded with the same color. Once all the color fills are complete, I use the dodge tool to add highlights to simulate metallic shine. I want some opaque highlights on the metal and a glow around the headlights. To do this, I create another layer set to the normal mode. On the new layer, I use the airbrush tool to spray an orange glow around the headlights, and I add little white highlights to the shiniest portions of the car's surface. Once the car is colored, I create another layer below the color and ink layers. I use the freehand selection tool to draw an angular shadow shape that I fill with a gray and texturize with noise. I roughen the edge with a textured eraser and use my burn tool to add a little extra shadow beneath the body of the car.

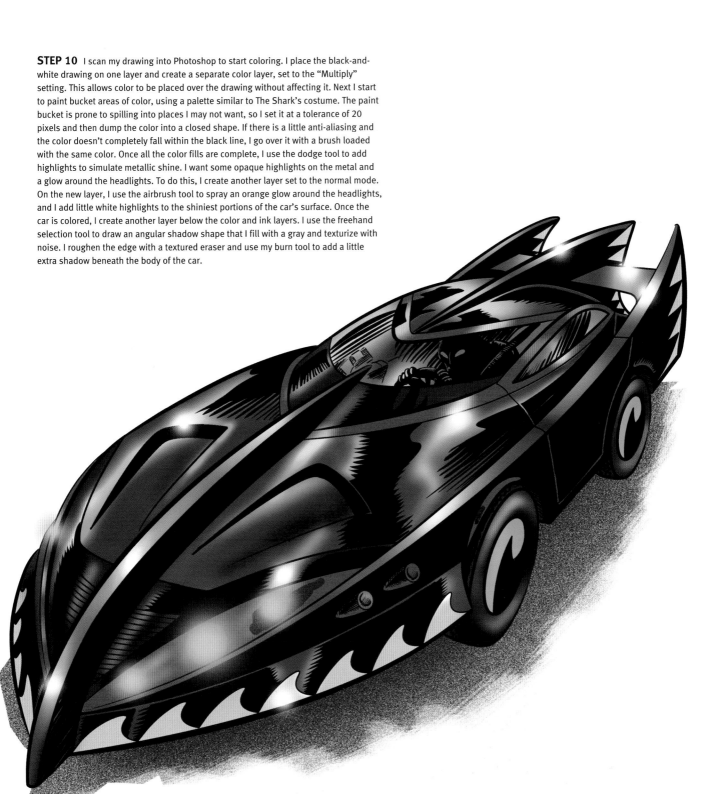

Artist's Tip

There are many ways to color your comic art. My preferred method is Photoshop, or a combination of alcohol-based markers and colored pencils (for additional opaque color effects over the marker). If you use the marker method, be sure to use a black-and-white photocopy of your original.

CREATING A STORY SEGMENT

Comics can be any length, from rambling epics to quick, action-packed episodes. Stories are typically several pages long and describe a segment of the action and of the larger story arc. For this demonstration, I'll show two concurrent segments that tell one story, or sequence of events.

I usually pencil on pre-cut, professional, blue-lined comic illustration board. These are convenient because the sizing and borders are all set for you. They can be expensive, so you can also purchase illustration board in pads and rule your own margins and trim marks.

Comics generally follow the same format. Full-sized boards measure 12"x16" with a *live* area of 10"x15". The live area is where all the art and copy goes. Comics haven't always followed this format and were often drawn on much larger boards. You don't have to use this format either; you can use any format you wish! I do recommend that you work larger than your final printed size. This makes adding detail easier, and your drawing will look tighter when you print it in the reduced size.

THE PREMISE

PAGE 1 The mutant Thorn has been captured by the evil Dr. Genius, who has shackled him in his lab in mutant-proof restraints.

PAGE 2: Meanwhile, Ninja Girl is stealthily skydiving from an airplane into Dr. Genius's base, located on an island in the middle of a huge volcanic crater.

PAGE 3: We see Ninja Girl subdue one of the island guards and notify Thorn through a hidden communicator that she is on the island. This entire breakout has been a set up to get our heroes behind the lines of Dr. Genius's hideout.

PAGE 4: Thorn uses his mutant ability to break out of his bonds, while Ninja Girl fights her way through numerous guards to join him. The last panel is a cliffhanger, where Dr. Genius has donned his super-powerful exo-suit, ready to battle Thorn to the death.

PAGE 1, STEP 1 Thorn has been captured by Dr. Genius, who has shackled him with mutant-proof restraints in his lab. I like to do all my preliminary sketches right on the final boards in non-photo blue pencil. This is a holdover from the days when comic art was photographed with high-contrast black-and-white film in preparation for printing the art. Black-and-white film couldn't record the non-photo blue pencil, so it was invisible! Today it still doesn't pick up well on scanners and photocopiers, yet allows me to work and rework my sketches on the final art boards without a lot of pencil dirt that would interfere with the final graphite drawings and subsequent inks. My initial layouts are rough. At this point, I'm only trying to tell the story, establishing a nice flow of action and working out how best to break up the page in a visually interesting layout.

Which comes first—the copy or the art?

By "copy," we mean the text. In the past, it was standard for a writer to provide a script much like a screenplay, and a penciler would draw sequential images to visually tell the story. Today the lines between writer and artist have blurred, and most comic creators often prefer to let the images tell the story with minimum text. Writers often work out the story line in small, rough thumbnail sketches. Sometimes the writer supplies an overview, like the premise above, to a penciler to work out the details and action. Then the writer and artist collaborate to fine-tune the action and how the story plays out. Upon completion of the art, the writer custom-fits the dialog and captions to the art. There is no one way to work, and the only measure of a successful process is the finished comic. For this sequence, we're going to use the original method—working from the written premise.

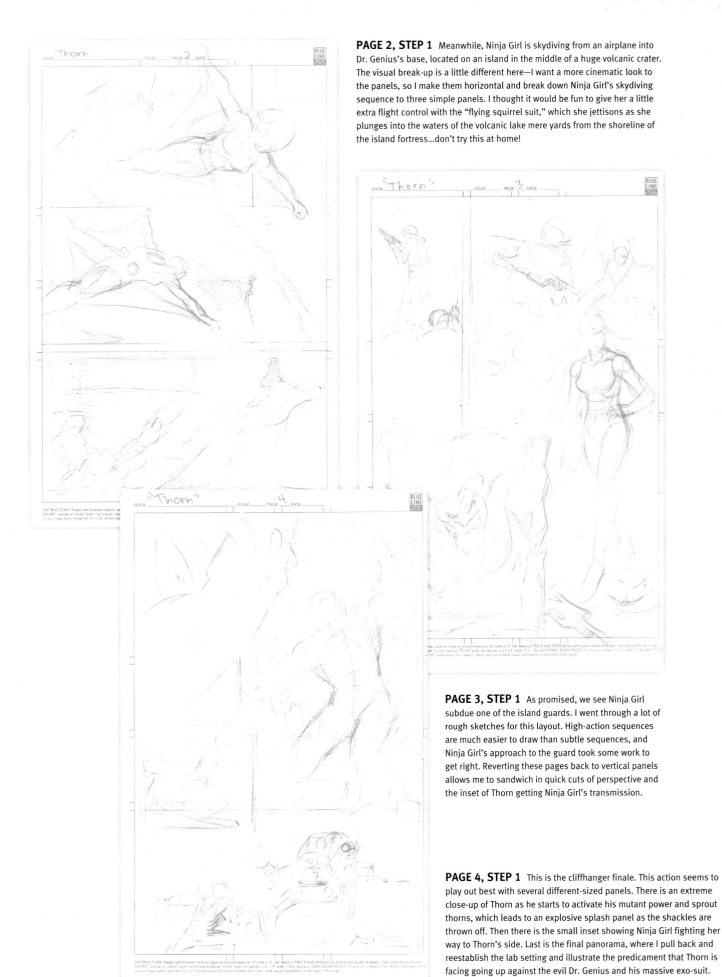

PAGE 2, STEP 1 Meanwhile, Ninja Girl is skydiving from an airplane into Dr. Genius's base, located on an island in the middle of a huge volcanic crater. The visual break-up is a little different here—I want a more cinematic look to the panels, so I make them horizontal and break down Ninja Girl's skydiving sequence to three simple panels. I thought it would be fun to give her a little extra flight control with the "flying squirrel suit," which she jettisons as she plunges into the waters of the volcanic lake mere yards from the shoreline of the island fortress...don't try this at home!

PAGE 3, STEP 1 As promised, we see Ninja Girl subdue one of the island guards. I went through a lot of rough sketches for this layout. High-action sequences are much easier to draw than subtle sequences, and Ninja Girl's approach to the guard took some work to get right. Reverting these pages back to vertical panels allows me to sandwich in quick cuts of perspective and the inset of Thorn getting Ninja Girl's transmission.

PAGE 4, STEP 1 This is the cliffhanger finale. This action seems to play out best with several different-sized panels. There is an extreme close-up of Thorn as he starts to activate his mutant power and sprout thorns, which leads to an explosive splash panel as the shackles are thrown off. Then there is the small inset showing Ninja Girl fighting her way to Thorn's side. Last is the final panorama, where I pull back and reestablish the lab setting and illustrate the predicament that Thorn is facing going up against the evil Dr. Genius and his massive exo-suit.

THE NEXT STEP

Now that I have the preliminary elements of my story sequence in place, it's time to work out some of the finer details. I continue to work with non-photo blue pencil for now because I know that I'll probably make some major revisions as I fine-tune the layouts and the poses of some of the characters.

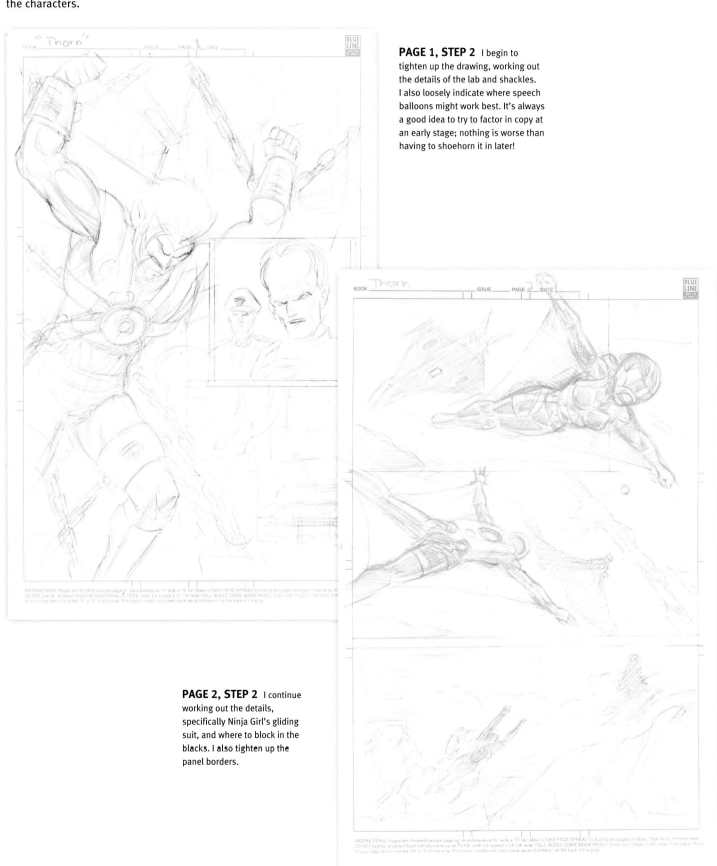

PAGE 1, STEP 2 I begin to tighten up the drawing, working out the details of the lab and shackles. I also loosely indicate where speech balloons might work best. It's always a good idea to try to factor in copy at an early stage; nothing is worse than having to shoehorn it in later!

PAGE 2, STEP 2 I continue working out the details, specifically Ninja Girl's gliding suit, and where to block in the blacks. I also tighten up the panel borders.

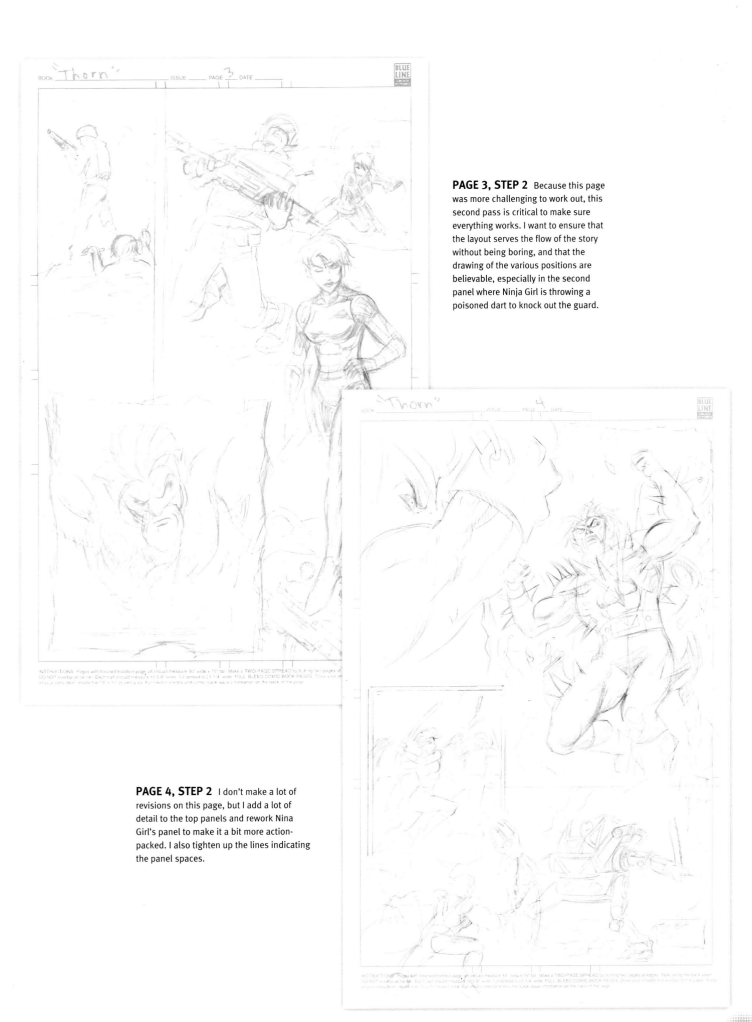

PAGE 3, STEP 2 Because this page was more challenging to work out, this second pass is critical to make sure everything works. I want to ensure that the layout serves the flow of the story without being boring, and that the drawing of the various positions are believable, especially in the second panel where Ninja Girl is throwing a poisoned dart to knock out the guard.

PAGE 4, STEP 2 I don't make a lot of revisions on this page, but I add a lot of detail to the top panels and rework Nina Girl's panel to make it a bit more action-packed. I also tighten up the lines indicating the panel spaces.

TIGHT PENCILS

The following images are the final graphite pencil drawings, which I will eventually ink either traditionally, using inking tools (pen and brush), or digitally, using graphics software like Adobe Illustrator® or Photoshop. Although I won't complete the final step for this section, I have written and placed the dialog and captions in the final form of this sequence. I created the type in Adobe Illustrator, directly over scans of my pencil drawings. I also make minor changes, but for the most part the final pencil drawings are close to my blue lines.

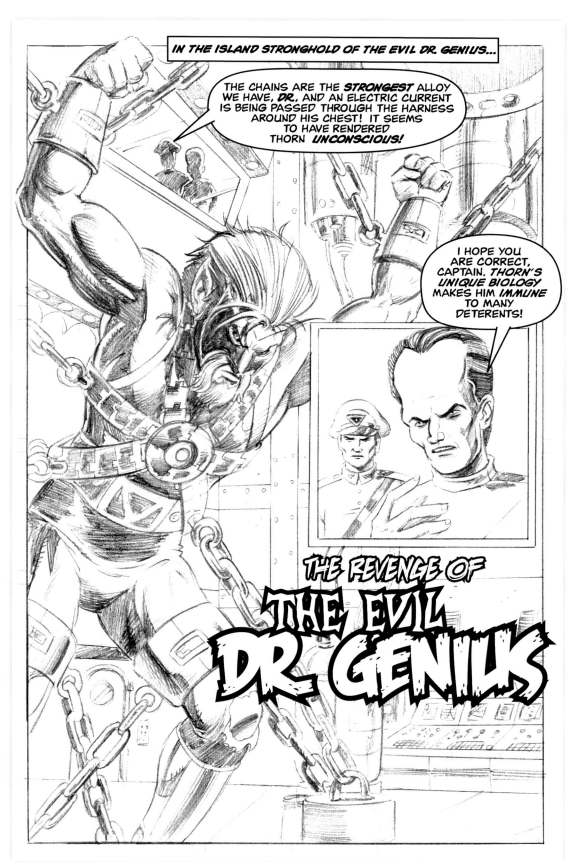

PAGE 1, STEP 3 The greatest changes in the drawings are the defined shadows and details of the various background elements. Whenever possible, I like to pencil as if someone else were inking my work. I keep the details very tight, and I shade in the areas that will be fully inked in the final step. This gives me a chance to review the piece and see how the play of dark and light areas works on my page. The most important changes and refinements are made at this stage.

Artist's Tip

I like to have my characters, captions, and speech balloons break out of the borders. This helps unify the entire page, and it also blends scenes together when appropriate. It also gives the figures an additional dynamic and dimensional quality.

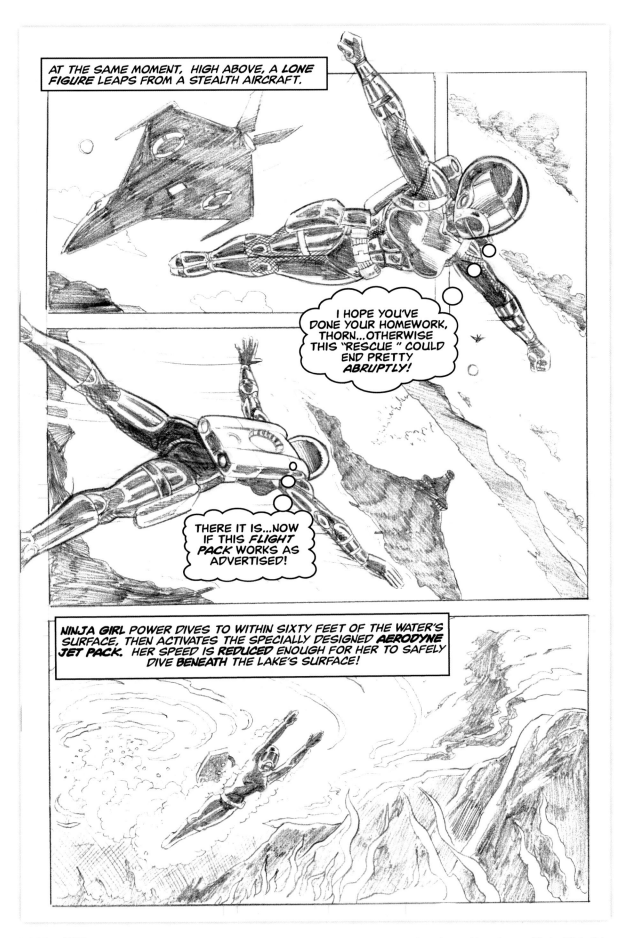

PAGE 2, STEP 3 The biggest change here is the deletion of Ninja Girl's glider suit. I felt that the wings detracted from the overall look of Ninja Girl and covered some very important background elements. With the wings gone, she takes on more of a superhero look.

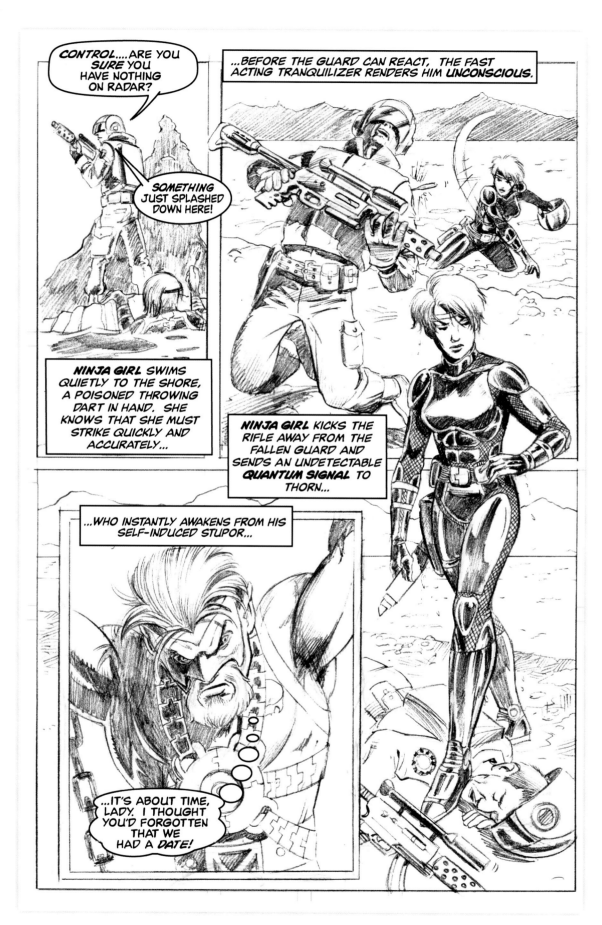

PAGE 3, STEP 3 In addition to shading in dark areas, I determine the exact placement of the borders. The combination of light and dark, the placement of the captions and speech balloons, and the drawing of the borders transforms this page into a strong comic book scene.

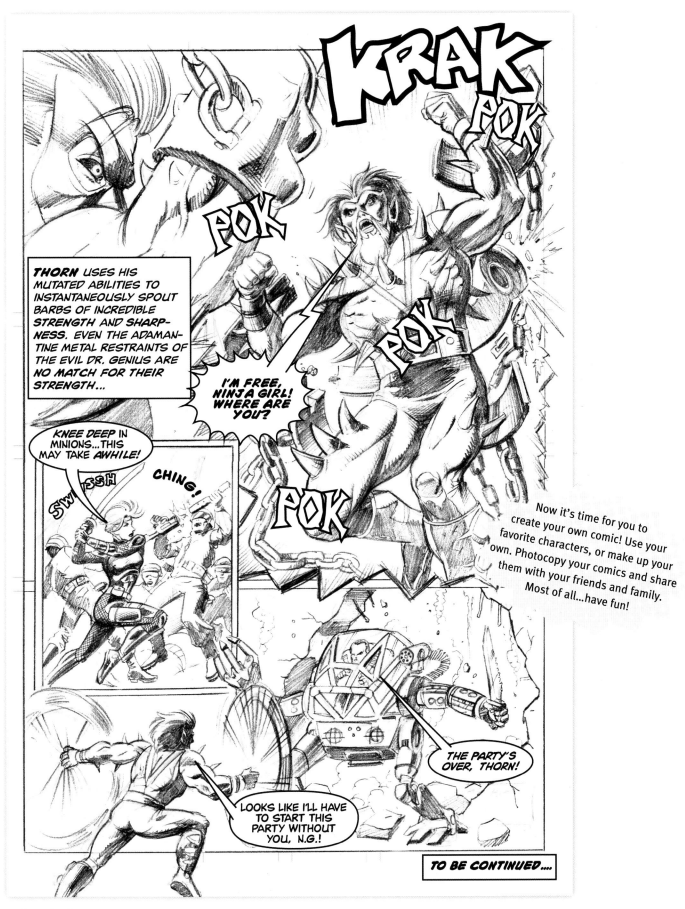

PAGE 4, STEP 3 On the final page I make heavy use of sound effects. When done correctly, sound elements can give your comic pages additional punch. But you need to consider carefully when and where you use them. I encourage you to be inventive—coming up with new and interesting sound effects can be fun!

ABOUT THE ARTISTS

BOB BERRY

Bob Berry, of Bob Berry Illustration & Design, has been an artist all his life, or at least since he was able to hold a pencil.

While the mainstay of Bob Berry Illustration & Design is for children's publishing and textbooks, Bob has also provided art and illustration services for interactive CDs, the Web, children's games and toy packaging, and character and costume design for the sports entertainment industry.

Bob is primarily self-taught, copying the techniques of his favorite comic book artists, like Russ Manning and Alex Toth, when he was growing up. His formal art education came later when he majored in painting and graphic design at The State University of New York at Purchase. After graduating he worked as a paste-up artist on the weekends and as a draftsman during the week. In his search for more creative work he landed a job art directing magazines for a small publisher. After that he opened up his own graphics firm with a fellow artist and has been in business for himself ever since. Visit www.bobberryillustration.com.

JEANNIE LEE

Jeannie Lee considers herself an artist with many interests. She started drawing at a young age and eventually trained under contemporary fine artist Ji Young Oh for more than a decade. Jeannie studied traditional character animation at California Institute of the Arts, has held positions at Udon Entertainment and Marvel Comics, and has illustrated for Gaia Online. She currently works as a lead artist at a small but growing company specializing in mobile games.